THE MATERIALS
OF
MEDIEVAL PAINTING

THE MATERIALS AND
TECHNIQUES
OF MEDIEVAL PAINTING

by

DANIEL V. THOMPSON

WITH A FOREWORD
BY BERNARD BERENSON

*. . . nec pro alia causa fiunt pulchra,
nisi delicando et deligendo confecta.—*
ANONYMUS BERNENSIS, *saec.* XI.

George Allen & Unwin Ltd., London

This new Dover edition first published in 1956 is an unabridged and unaltered republication of the first edition. It is published through special arrangement with Allen & Unwin.

Manufactured in the United States of America

FOREWORD

To my ideal history of art all sorts of servants would bring tribute, all sorts of workmen would be summoned to help. The delver in archives surely would be among them. So would the student of the materials and techniques; but neither singly nor collectively would they constitute a history of art.

Taken together, the history of the arts should be the history of the humanization of the completely bipedized anthropoid. In so far as the representational arts like painting, sculpture, and literature are concerned, their business is to teach man how to hold himself, how to look, what gestures to make, what attitudes to take, and so on; all of which react violently on his psychosis and tend to make of him the civilized being we hope he may at some far distant day become. It is the business of the same arts to teach him not only all that, but also what kind of a world he should live in.

We must not mistake the history of techniques, or the history of artists, for the history of art. I dream of a history of art in which the name of an artist would never be mentioned. I regard all questions of technique as ancillary to the aesthetic experience. Human energy is limited, or at least mine is; but if I had greatly more, there is nothing about all the ancillary aids to the understanding of a work of art that I should not try to master.

BERNHARD BERENSON

PREFACE

Possum ergo sane redargui quia ad talia
vacco scilicet scribendo puerilia seu in-
utilia. . . .—*Anonymus Bernensis, saec.* XI

Where do you suppose he *got* those colours?
I think he *evolved* them out of his Inner Con-
sciousness.—*Dear Old Lady to a young copyist
in the National Gallery,* A.D. 1922

THIS volume is designed for those who care for what my
dearest enemy calls "the cookery of art," for those
who wonder about the natures and the sources of the
materials out of which painters in the Middle Ages com-
pounded objects that we still cherish. I have developed
elsewhere the thesis that style and technique are inseparable,
and this inquiry into cookery, this sojourn in the kitchen,
would be unwarranted if it did not lead to some slightly
more keen or intelligent appreciation of the finished dishes.
" 'Style and technique are inseparable,' " writes my learned
friend M. Henri Focillon: "Voilâ la vérité, que méconnais-
sent seuls ceux qui travaillent *du dehors.*"

The functions of technique in the development of styles
of architecture have long been recognized. The technical
bases of design and ornament in pottery, glass, textiles, and
metalwork are regularly seen in something like their true
perspective. The late Dr. Josef Meder of Vienna brought
great judgment and penetration to the unit study of tech-
nique and style in drawings; and the considerations of
material and manipulation which affected the evolution of
style in early woodcuts have been set forth brilliantly and

9

estimated sagaciously by Mr. Arthur Hind of the British Museum within the last few months. It is not possible as yet to see the relationships of style and technique in medieval painting with such clarity; for the technical elements are more complicated and more obscure. This little book can by no means make them clear; but it may answer some of the questions which acquaintance with medieval paintings always raises. I hope that the answers will be found free both from pedantry and from romantic surmise.

Postponing the great issues of technical manipulation, I have discussed here only the materials of painting in medieval Europe. I have tried to assess the present state of our knowledge, and to incorporate some measure of new understanding drawn from a study of many unpublished medieval documents, as well as to review the content of such medieval writings on art-technology as have been edited. This literary evidence has been examined wherever possible in the light of experimental and analytical evidence. By far the largest and most orderly body of analytical observation of medieval painting materials so far available has been presented by Dr. A. P. Laurie, whose studies in the physical nature of medieval paintings provide invaluable assistance in the interpretation and estimation of the documents. A large part of this book is based upon a course of lectures, "Technique in Medieval Art," given in the autumn of 1935 at the Courtauld Institute of Art in the University of London, and I owe to that Institute's Director, Professor W. G. Constable, both the incentive to formulate this study and encouragement to publish it.

LONDON, D. V. T.
January 1, 1936

CONTENTS

CONTENTS

INTRODUCTION

Non solum autem in magnis rebus, verum
etiam in minutissimo opere, floret in-
genium, viget intellectus, valet ratio.—
Anonymus Bernensis

BEFORE beginning to review the restricted subject of
medieval painting materials it may be worth while to
consider what we should have to contemplate if we were to
attempt a survey of technique in medieval art without
restriction. Even if we left out of account the arts of
architecture and literature and music, we should still have
to investigate works in metal, the operations of metallurgy,
the extraction of metals from their ores, refining, parting,
alloying; and their conversion into works of art by the
technical operations of casting, die-stamping, carving, turn-
ing, beating, cutting, punching, engraving, soldering, weld-
ing, damascening, plating, pickling, gilding, painting,
lacquering, enamelling, and niello. And even then, if we
found a beaded wire on a reliquary, we might have no
notion of how the medieval craftsman made it.

We should have to investigate works in vitreous materials,
clear and opaque and coloured glass; glass for mosaics,
coloured and gilded; glass for gems, for beads, for rings;
glass blown into vessels, embellished with gold, and colours
enamelled or spun upon thèm out of other glass; glass for
windows, pot metals, and flashings, and colours to modify
the light that these window-glasses transmit, and the
methods of their application; the staining of glasses; glasses
for the embellishment of earthenware (glazes), clear and

opaque, coloured, lustred, gilded; the glasses which we call enamels, fired upon metal grounds; and many other matters of this kind.

We could not ignore the lapidary's arts, the preparation and uses of gems, real and artificial, precious and semi-precious; how they were cut and carved and engraved and coloured and backed and mounted. We should have to look into works with stone and wood to see how those materials were carved and inlaid and cemented and painted and gilded. We should have to think of bone and ivory and horn; for they played their parts in medieval art, and they were carved and dyed and gilded and glued together and bent and shaped and moulded by a great number of technical processes. I wish we might do that. I like the attitude toward medieval art that stops to wonder what lies behind the ball of crimson ivory upon the crozier. What zeal brought together there ivory from Africa and a dyewood from Ceylon? But we should have to turn our attention to skins and leathers; to tanning, dyeing, gilding, painting, embossing, and blocking leathers; and inquire into the manufacture and uses of parchment and paper. A chapter would not be too much to devote to the techniques of spinning and weaving, to the preparation of textile fibres: dyeing, cleaning, bleaching, fulling; making gold and silver threads, and recovering the metals from discarded textiles; to gilding, staining, blocking, and painting. We should need to examine the processes of tapestry weaving and brocading and damask weaving and velvet weaving, weaving with multiple warps, for brocatelles and voided velvets, and the whole technique of the draw-loom, which is a lifetime's study in itself.

Still we should not be through. If we wanted to explore

the part played by technique in medieval art we should still have to probe into curious works with wax and plaster and sulphur, casts and seals and masks. We should have to study all manner of adhesives and cements, waterproof, weatherproof, fireproof; glues for combining and mending every sort of material or combination of materials. We should have to take account of all sorts of tools, lathes, polishing-wheels, chisels, files, punches, dies, brushes, pens; and all sorts of materials, especially the immediate elements of coloured embellishment, inks, stains, pigments, metals in foil, leaf, and powder, vehicles, mordants, glazes, and varnishes, as we shall do, to some extent, in the chapters which follow here.

And above all, along with these studies of the materials and instruments of medieval craftsmanship, we should be obliged to reflect upon the manner of their employment; for technique means materials and tools in action, and the essence of technical study is the recognition of those systematic methods which combine taste and knowledge and competence, born of professional and individual experience. In this brief study we are concerned primarily with materials, and shall deal with the methods by which they were made into works of art only incidentally, as far as may be necessary to explain the materials employed in painting.

There is no real use in rehearsing such a programme as this, with which we cannot deal, unless perhaps it serves to remind us that Art has many faces—and a pair of hands for each. Painting is a small part indeed of the whole subject of medieval art; yet even that small part is too complex to be summarized in this survey. I must confess (somewhat

apologetically) that I shall not go into the question of the origins of oil painting, or the practice of early oil painting by the Flemings and their followers in Italy, or into the stages transitional between tempera and oil painting, though there are no matters in the period before 1500 about which I myself should like so much to be enlightened. There is a certain amount of evidence, of one kind or another, about the "Secret of the Van Eycks," about the early experiments of Baldovinetti and Andrea del Castagno, and the triumphs of Antonello, and the effects of the Portinari altarpiece upon Ghirlandaio and his fellows in Florence; but I do not know what it all means. I hope, as I say, for enlightenment; but I do not understand the problems concerned in the "invention" of oil painting, and as I do not understand the evidence myself, I cannot explain it. Ever so many people can. I have had it all settled for me by any number of enthusiasts; but no two explanations are the same, and they cannot very well all be right.

Many of the functions of medieval art have been usurped in modern times by the machine. The two most extensive fields of medieval art production—books and textiles—have been taken over almost entirely nowadays by the forces of mechanical production. We need not raise the question here of whether there is any loss for us in that, but only remember that we must make a conscious effort to judge medieval works by their own standards, and to reject the concept of the "minor art" in dealing with a time when every manufactured thing was a work potentially of art.

In the Middle Ages, artists very generally did more than they had to. They indulged the impulse to embellish (which

is the great symptom of luxury) and built up a tremendous range of technical powers for executing their embellishments. The tendency of medieval craftsmanship is strongly toward elaboration. Not only in design, but also in execution, the medieval craftsman tends to become more and more ambitious and more and more resourceful. In the eleventh century a craftsman writing on the tempering of colours for books remarks that "every master of an earthly profession is overjoyed to hear of a new product of anyone's invention; for he yearns to achieve perfection in his calling." This passion of the handworkman, to be able to do anything that anyone in his line can do, and preferably to be able to do something that no one else can do, is responsible on the one hand for a great many important stylistic and technical developments, and on the other, for the circulation about Europe of a large number of books of technical secrets, a good many of which have come down to us.

Technique in medieval art may be studied in the monuments of medieval art, or in medieval documents about technique; but best of all, in both. Technique, in the kinetic sense, must be studied in the actual works of those who practised it. The static elements of technique, the materials in which techniques are exercised, can be described, and often were described by medieval authors; and there is some interest, perhaps some value, to be derived from knowledge of these materials which the eye alone cannot give. Technique means the synthesis of many sorts of element, physical and otherwise, and the raw materials of painting are no more than dross; but they are necessary dross, and not without influence upon the other

factors in the art. It needs our best observation, and as many sorts of knowledge as we can bring to it, to appreciate "the flowering of genius, the intellect's control, and the power of reason, in the smallest work as well as in the great things" of medieval painting.

The
MATERIALS OF MEDIEVAL PAINTING

CARRIERS AND GROUNDS

Technique in painting is the sum-total of all the methods by which coloured bodies are fastened upon supporting grounds according to the wish and plan of the painter. In this volume we shall examine some of the grounds, some of the coloured bodies, fastening agents, binding media, and, incidentally, some of the methods, which make up the dominant painting techniques of Europe in the Middle Ages.

Terminology

The word "ground" in connection with paintings is a little ambiguous. If a picture is painted on a brick wall covered with plaster, either the brick or the plaster might be called the ground. By common consent, however, nowadays, the plaster in this case is usually called the ground, and the brick wall the "carrier." So in a panel painting the wooden panel is called the carrier, and the layer of gesso, or plaster, or whatever there may be between the wood and the painting, is called the ground. (Grounds on canvas are still usually called "primings.") Sometimes there is no distinction. Sometimes the carrier itself is also

the ground, most obviously so in writings or drawings or paintings on paper or parchment.

The Importance of Book Painting

It is a quaint custom of our time to class the productions of artists which touched the lives of other ages most closely as Minor Arts, among them (along with the vase paintings of Greece, the carpets of Persia, and the ceramics of the Far East) the book paintings of medieval Europe. Let us not be deceived by the phrase. More compositions were planned and executed by illuminators than by any other class of medieval painter. The writing and illuminating of books were the major preoccupation of many artists, and constituted in some respects the greatest of all the medieval arts. It is not easy for us to see the book paintings of the Middle Ages with medieval eyes; for the pictures and the writings were generally meant to be read together. Books were made to be read, and illumination was built in, with all the forces of *Ingenium*, *Intellectus*, and *Ratio*, not sprinkled on the top like candied violets or hundreds-and-thousands on a dish of trifle.

More medieval paintings were done on parchment than on any other material; for most medieval books of any pretension were written on parchment. Parchment provided an agreeable, beautiful, and durable ground not only for the writing but also for painting and gilding.

Parchment-making

Parchments in the Middle Ages were a standard article of commerce, prepared by specialists; and the men who used them did not necessarily know very much about how they

were made. We share their ignorance. We tend to take the parchment of medieval books for granted. We know, of course, that parchment was made from the skins of animals, with the hair removed. We know that the skins were usually soaked in water to clean them up, and then in a broth of lime and water to loosen the hair. After a skin had been limed for a few days, the wool or hair could be pulled off or rubbed away quite easily, and some of the fat and oil in the skin was washed out by the lime. The skins were rinsed thoroughly in fresh water, and stretched on frames to dry.

According to a Latin text written in Germany in the thirteenth century, the parchment-makers of Bologna, who were famous for their products, used to lime their skins twice, once before and once after "pulling"; and then to wash them very thoroughly, and leave them for two days in fresh water before stretching them on hoops to dry. Nowadays, instead of hoops, rectangular frames are used. An edge of the floppy wet skin is caught over a little button and tied around with a cord. This cord is run over to a peg in the rectangular frame, and when the skin is loosely supported on all sides by cords in this way the pegs are turned around until the cords are tightened and the skin stretched evenly. Parchment shrinks a great deal in drying, and if it were tacked on frames, it would tear itself away from the tacks. When it is dry, if it has been properly stretched, the skins is as taut as a drumhead.

In modern parchment-making the skins are allowed to dry on the frames and then scraped smooth. It is not necessary to do very much scraping, because in a modern factory the wet skins will previously have been "split" to an even thickness all over by being drawn against an oscillating

knife. But in medieval times the skins were scraped on the frames while they were still wet. The wet skin was soft and pliable, and if the workman pressed a knife against it, it would give. If the knife had a straight edge and sharp corners, the corners would cut through; if the corners were rounded off, the ends of the knife would still press harder against the flexible skin than the middle of the blade. The only way to get an even pressure all along the blade was to make it moon-shaped. Paul of Prague, in the fifteenth century, gives us a list of tools in which the parchment-maker's knife is called a *lunellarium*. This must certainly have been moon-shaped. Even now, for dry scraping, a round-bladed knife is used. It has to have a special kind of edge, a "burr," made by turning over a hair's breadth of steel at the edge of the sharpened blade, just as cobblers' and leatherworkers' knives are burred.

Scraping with the knife made the skin thin and even. It was left on the stretcher until almost dry, and the flesh side was then rubbed with pumice to make it perfectly smooth. It was remoistened and rubbed with pumice several times, and finally stretched tight and allowed to dry completely.

When a skin was very fat and oily, it was necessary to draw the oil with alkalis; and ashes, or ashes and lime to-gether, were used for this purpose. They were made into a paste with water, and smeared over the skin while it was still wet on the stretcher. Sometimes the skins were treated with alum, as we learn from fifteenth-century English texts; and that must have had the effect of harden-ing the parchment, and making it more like leather. Some medieval parchments have this quality of hardness, and perhaps it was produced in this way.

Vellum

We know that calf skin was sometimes used for making the *pergamenum vitulinum,* that is, the "veal parchment" which we call vellum. It was necessary, of course, to have a large skin to begin with if a large piece of parchment was required. The huge late medieval choir-books had to be done on vellum; for a sheep or goat skin would not have yielded a double folio of such size, and single pages could not be bound satisfactorily. A curious tendency has become established in modern times to think of the word vellum as somehow more elegant and complimentary than the word parchment. Etymologically, "vellum" means calf skin and nothing else, while parchment is a general term applicable to any kind of skin, including vellum; but such is the force of refinement that the smaller and thinner a skin is, and the less the likelihood that it should be calf skin, the more likely we are to call it vellum, out of politeness.

The Latin word *abortivum* occasionally applied to fine parchment in the Middle Ages (though rarely) has given rise to another form of superstition which has become widespread, namely, that the finest medieval parchment, and particularly the very thin, flexible, opaque, small, thirteenth-century French Bible vellum was made from the skins of still-born calves. There is as nearly as possible no evidence for this belief. It may be true. I have no figures on infant mortality among livestock in the Middle Ages; but I should be inclined to think that animal husbandry must have been in a very precarious condition if enough calves were still-born in the thirteenth century to provide all the pages which pass for "uterine vellum."

Qualities of Parchment

As far as we know, the vast majority of medieval parchments were made from the skins of calves, sheep, and goats, duly slaughtered. It is essential for good parchment-making that the skins be put to soak while they are still quite fresh, soon after the animals are killed. Parchment-makers must have had regular channels of supply. They could not safely have depended on picking up a skin here and there from anyone who happened to have killed an animal for meat. Probably the meat markets and the parchment-makers were supplied through the same mechanism of distribution. Probably any city's preferences in the matter of meat diet were reflected in the local parchment industry. This is no doubt why Bologna parchment tended to be made from goat skins, while Paris parchment tended to be made from sheep skins and calf skins. It is quite possible that the skins of the deer and other game that people ate were made into parchments, too; and it would not be altogether surprising if it turned out, as a result of experiments now in progress, that some of what now masquerades as "uterine vellum" was actually rabbit or squirrel parchment.

If the skins from which parchment is made are not quite fresh, they give a spotty product. An eleventh-century manuscript in Berne describes the sheep and calf parchments of Flanders and Normandy as "all white and smooth and handsome," and the sheep parchment of Burgundy as "rough and mottled and thin and very ugly and uneven in colour, grey and black and white." That may have been caused by some defect in the sheep. Fat sheep make good mutton but poor parchment, and the pasturage of Burgundy may have been too rich for the sheep to grow the sort of

skins that make the best parchments. But the bad qualities ascribed to the Burgundian product sound like those caused by carelessness in the matter of getting the skins to the parchment-maker promptly.

Preparations

Parchment is sometimes ready for use as soon as it has been trimmed or cut to size. Quite often, however, the surface is a little greasy, or horny, or absorbent, and it needs to be rubbed over with powdered pumice, chalk, rosin, or colophony to make it take the ink and colours nicely. This operation is called pouncing. Natural pumice was an imported product in England, and English workers often used instead a material which is described as "better than twenty other pumices": a sort of bread largely composed of powdered glass. Powdered glass and flour and brewers' yeast were mixed and allowed to rise like bread, made into loaves, and baked in the oven.

Sometimes, when the illuminator wanted to be quite sure that his colours and gold would not run any danger of flaking off the skin (as they might if the skin were unduly hard and smooth), a little thin glue was rubbed over the parts which were to be gilded or painted. Parchment was sometimes stretched and given eight or ten coats of thin white lead oil paint, and then cut up and made into blocks. These little tablets were used by merchants in Italy and in Germany for calculating sums, and they were also used for drawing; but few if any drawings on this sort of material have survived. For the most sumptuous manuscripts, parchment was dyed purple with the shellfish dye, whelk red, the classic purple; and sometimes, in imitation of that, with

other materials. And for a different kind of splendour of the same general sort, skins were sometimes dyed green with verdigris. Gilding on these coloured parchments is incomparably more effective than on white, and it is with gilding that they were generally used. For drawing, parchment and rag paper as well were often coloured green or pink or grey or buff with several coats of pigment mixed with thin size. Sometimes, in the fifteenth century, quite strong or dark colours were put on as grounds. Leonardo da Vinci sometimes used what seems to be pure vermilion, and Dürer, a dark greenish blue. Drawings done on these tinted papers with washes of ink and lighter values applied with white are often really paintings, and belong properly in any discussion of medieval painting techniques.

Wooden Surfaces

After parchment the most important carriers for medieval paintings are walls and wood. The reasons for the widespread use of wood are first, that it is comparatively easy to make things out of wood, and second, that things made out of wood generally call for a decorative finish of some sort. It is quite a simple matter to make a flat wooden surface, suitable for painting; and indeed flat surfaces naturally develop in the construction of almost any sort of woodwork, in doors and screens and chests, which invite people to do something in the way of embellishment. By nailing and gluing pieces of wood together, and cutting and carving them, almost any sort of shape can be made quite easily; and mouldings and ornaments can be devised in wood which it would be laborious or impossible to execute in stone or metal.

For large flat surfaces, of course, gluing up was necessary; and the Middle Ages, fortunately for themselves and for us, knew the very best material to use: a sort of cement, half like a glue and half like a cement, made out of lime and cheese. If a bit of rather poor, lean cheese is soaked in water, and crumbled up and ground with lime and a little water, it makes a sticky, treacly mixture which dries as hard as stone and which, when it is once dry, is not affected by moisture. (Very much the same sort of glue is used now for putting together the wooden parts of aeroplanes.) Among the many troubles which beset medieval paintings in our time, one of the rarest is for the glued joints of the wood to separate; and their strength is largely due to the use of this strange, homely adhesive.

The Functions of Gesso

The untreated surface of wood is not ideal for any kind of painting, except perhaps plain housepainting. It cannot always be made perfectly smooth and even, and different parts of the grain take the paint differently. In carving, too, the grain presents some difficulties. To finish a carved moulding highly in the wood means a great deal of labour, and even when it is done it is not ready to be gilded. The wooden surface is neither hard enough nor smooth enough for gilding. So it was usual to prepare the object, whether it was to be plane or carved, roughly in some fairly soft wood, and then to make the final surface on it in gesso. Gesso has no grain to make the carving difficult. On flat surfaces it can be made smooth and even without trouble. All parts of a gessoed surface are equally absorbent. And it is a perfect ground, firm, even, and resilient, for any sort of gilding.

The Use of Gesso

Gesso is simply a kind of thick white water paint, with chalk or gypsum or plaster, or something of that sort, as the pigment, and glue or gelatine as the binding medium. It is put on fairly thickly, in several coats, so that the surface, when it is dry, can be worked and carved and modelled, as much as the case requires. To make the gesso mixture adhere securely to the wooden carrier, a coat or two of glue is usually put on first. The glue sticks to the wood, and the gesso sticks to the glue. Sometimes medieval panel-makers put the glue on the panel, and then glued on strips of linen or pieces of parchment (sometimes, alas! illuminated parchment), so that if the panel cracked, or any joints came apart, the linen or parchment would still hold the gesso ground together.

Mixing good gesso is an art which the Middle Ages developed to a high degree, especially in Italy. It calls for knowledge and experience as well as the right materials. The finest, sleekest gesso is called in Italian *gesso sottile*, which means "thin gesso." It has the great advantage for certain purposes of shrinking down so much in drying that it hardly obscures the form to which it is applied. That quality is not important on a flat surface; but it is very important indeed on a carved moulding. If a gesso mixture is made with chalk (as it very often was, and usually is nowadays) one or two coats of it will be enough to fill up the hollows of a finely wrought moulding or carving, and spoil the shape entirely; so a "thick gesso" of this sort has to be smoothed up with templets as it is put on, or carved away after it is dry. Even six or eight coats of gesso sottile, on the other hand, may be put on a finely carved surface without hiding

the carving. This means, of course, that there is no use putting it on unless the surface underneath is nearly finished; for if it will not conceal qualities, neither will it hide defects. On a rough, flat panel, or on a roughly carved moulding, gesso sottile would not have enough body to make the surface smooth. So the forms were evened up to begin with with another kind of gesso, called in Italian, *gesso grosso*, "thick gesso." When the surfaces had been made almost perfect in this material, they were coated with the thin gesso, gesso sottile, which finished them nicely.

The Construction of a Polyptych

Suppose a Gothic painter in Italy wanted to make a great polyptych, with panels set in carved frames, with foliage ornaments and mouldings and crockets and all the trimmings. He would glue up his panels first with cheese glue, and build the skeleton of the framework. He would do all the carvings (or, more likely, have them done), some of them in place, and others to be glued or pegged or nailed where they were to go. He would run his mouldings with planes and chisels and gouges, and carve out roughly any little water-leaf or egg-and-dart or other embellishments that his design called for. He would fix up little niches, perhaps, with carved figures in them, or turn any free-standing columns, or cut in any little rose windows or ornaments of that sort in the wood, without taking any particular pains to finish them up in detail. Then he would assemble the whole thing. He would glue it up with cheese-lime glue; and where he put in nails, he would cover their heads with bits of tinfoil glued over them, so that no rust should come through to stain his gesso. He would brush a

a coat or two of thin hot size or glue over all the woodwork; and follow that, after a day or two, with a stronger coating of the same material. When that was dry, he might glue bits of linen all over the flat panels, to strengthen them in case of cracks.

Then he would make up a great kettleful of size, by boiling bits of skin or parchment in water, and prepare his *gesso grosso*, the thick foundation gesso, by grinding plaster of Paris with this size. He would apply several coats of this gesso mixture all over his polyptych with a brush; and on the flat surfaces he would put it on with a spatula, to get it thick and even.

When mixed with size, plaster of Paris dries slowly, but it dries extremely hard. When it was thoroughly dry and hard, the workman would go all over the surface, shaping everything up nicely, as he had not troubled to do in carving the wooden foundation. He would clean out all the mouldings, and work up the detail of the carvings, and scrape the flat surfaces as smooth as possible, in the layer of gesso grosso. They would not be absolutely smooth because the gesso grosso always keeps a little roughness of grain, a little tooth, rather like that of unpolished marble. To get the surface perfectly smooth, so that it could be gilded properly, he would put on coat after coat of gesso sottile mixed and ground to a thin paste with some of the same size that he used for the gesso grosso. The gesso sottile was made from plaster of Paris by soaking it in water. If plaster of Paris is mixed with so much water that it cannot set, and stirred, and kept wet for a month or more, it seems to rot, and changes character entirely. It makes the silkiest smooth white material imaginable. This thin gesso is ground and

mixed with size, and then laid over the gesso grosso with a brush. Not less than six or eight coat will be needed. When it is dry, it requires only a little gentle scraping to even it up; and the result is a surface as white as newly cut ivory, and just as smooth and crisp. By this means the whole structure of the polyptych was converted, as it were, into a single piece of uniform white material.

Variations of Method

All this, however, was a long, laborious performance, and the whole process was probably not carried out except for important works, and even then, probably only in Italy. For simpler works, simpler methods were employed. It is of course only in Italy that we find these very elaborate accompaniments of highly finished carving and gilding as a regular routine. The only medieval written account of this process in all its full details is Italian: the work of Cennino d'Andrea Cennini of Colle di Val d'Elsa, a pupil of Agnolo Gaddi. (Cennino, luckily for us, wrote a book about the way he and his contemporaries in Italy used to paint; and he describes the Giottesque practice of gessoing fully.) The smooth, even, pure white springy grounds of gesso play an essential part in the gilding and painting of medieval panels and their settings; but this process of Cennino's was probably, even in Italy, a sort of full-dress affair. It is possible to obtain a perfect ground on a smooth wooden panel with gesso sottile alone; and it is quite certain that a very large number of medieval panels had grounds made with chalk.

Chemically, chalk consists chiefly of calcium carbonate; while plaster of Paris is calcium sulphate. Calcium sulphate

occurs in nature as alabaster or gypsum. Gypsum may be ground up and used for gesso; and certain French texts suggest that this was a method used in medieval times. When gypsum or alabaster is roasted, and some of its water of crystallization driven off, it becomes what we call plaster of Paris. If a little water is added to it, it recrystallizes in the form familiar in plaster casts. If instead of water, size is added to it, it recrystallizes more slowly, and in a much harder and more durable form, as in the gesso grosso layers of a panel. If instead of a little water, much water is added to it, so much that the particles are kept separate, so that they cannot set into a solid mass, it becomes the material called gesso sottile. All this roasting was troublesome and expensive, and when possible (that is, for painting grounds, where the gilding was relatively unimportant), the gypsum was probably used raw, in its native state. And when there was a good supply of chalk, as in England and Northern France, no doubt that was used instead. Gesso could be made with chalk and size which would satisfy all ordinary requirements.

Other Grounds

Sometimes, in place of the gesso grosso, wood ashes were used, mixed with size, to true up the wooden surfaces and prepare them for a final coating of thin gesso. Cennino describes this process, and I have seen it employed in some provincial works. The thick gesso grounds with highly finished surfaces, such as one must have for elaborate gilding, are found in Italy, France, and Spain; but seldom in English panel paintings, which are usually less pretentious. In many French paintings where there is little or

no burnished gilding, and very commonly in Flemish paintings, the ground is thinner. For a gilding ground which is to be stamped and engraved, two millimeters of gesso is not exceptional; but often the Northern painting grounds are hardly thicker than paper. There is some evidence that these very thin grounds sometimes consisted simply of a few coats of white lead mixed with oil.

Canvas

Canvas, that is, hemp or linen cloth, was not very much used as a carrier for permanent paintings in the Middle Ages. It was not at all unusual, especially in the fifteenth century, to do painting on cloth; but in general this was done, as far as we can judge, usually for some special occasion. The commonest occasions were probably provided by the plague ceremonies of Umbria, when ecclesiastical procession required the accompaniment of banners painted with representations of the plague saints, or by the military and civil demonstrations which called for banners of too fugitive significance to warrant the expense of embroidery. There are a good many of the plague banners still in existence, with figures of St. Sebastian, or St. Roch interceding with the Virgin for the plague-stricken Umbrians, or portrayals of appropriate miracles. Other medieval banners, ecclesiastical, military, and civil, are more rare. The uses to which these paintings on cloth were put were often occasional and temporary; and as they were generally made for outdoor use (where the lightness of canvas made it preferable to other carriers), they often suffered from the effects of sun and wind and rain.

Perhaps the earliest important example of large-scale

painting on canvas for indoor decoration is Botticelli's *Birth of Venus*, painted presumably in the eighties of the fifteenth century. From about that time on, canvas becomes gradually more significant. Both Mantegna and Dürer did a good deal of work on cloth; but almost all of it rather small, and much of it in a limited palette, entirely, or almost, in grisaille. We do not know what sort of consideration led them to choose cloth for these works; for panels would have been suitable. The popularity of canvas in later times is easy to understand: for large paintings it is cheaper, lighter, and more portable than wood. Canvas, however, has not the quality of furniture; and a great many medieval paintings were furniture of a handsome sort, ecclesiastic or domestic. Altarpieces were the furniture of churches or chapels, *cassoni* were the furniture of houses. The various *deschi* and *coffanetti* and reliquaries and presses (like the great linen-press of Fra Angelico and Alessio Baldovinetti) all served some purpose as furniture in churches or houses. They were decorative, sometimes primarily, sometimes incidentally, but almost never exclusively.

Walls and Plasters

For pure decoration in the Middle Ages we should have to look to wall painting. Even wall painting often exercised a didactic or a votive function; but one of its chief purposes was always to decorate, to embellish, the architecture to which it was applied. Two great systems of mural decoration lie beyond our present range: the characteristically Eastern and Southern process of mosaic painting, and the characteristically Northern process of tapestry-weaving. Nor can we deal with glass painting, which is another form of mural

decoration. We shall consider only brush painting on walls.

The walls, almost invariably of brick or stone in Europe, are the carrier for the painting; and occasionally, as in the Chapel at Eton, they act as the ground as well. Usually, however, the masonry is too imperfect to serve without some preparation, and the surface of the wall is dressed with a ground of plaster. The usual ingredients of wall plasters were sand and lime, calcium hydroxide, made into a mortar with water. As the water evaporates from a mixture of this sort, the lime crystallizes around the sand, and its crystals penetrate into the brick or stone of the wall to which it is applied. The formation of the crystals secures the cohesion of the sand and lime, but adhesion to the wall usually depends upon mechanical bonds provided by roughnesses in the wall surface or open joints in the masonry into which the plaster penetrates. In the course of time, lime plasters take up carbon dioxide from the air, and become converted from calcium hydroxide into calcium carbonate. They are then reasonably resistant to the solvent action of water. Water on the surface of a fresco painting does not hurt it; but a wet wall behind it ruins the painting entirely. The moisture penetrates the plaster ground and carries salts in solution to the surface. There they crystallize out, in white or coloured efflorescence, upon the painting, or produce spots of discoloration. Moisture breeds moulds, too, and is on every account disastrous to lime paintings on walls.

Elaborate precautions in the way of copings, gutters, and drains, were taken by medieval painters to ensure the dryness of a wall which was to be plastered and painted. Sometimes even the inner face of the wall had to be waterproofed

with tar before the plaster was applied. In spite of all precautions many medieval wall paintings have been injured or destroyed by dampness. Even interior walls, not exposed on either side to the weather, sometimes become damp from moisture drawn up through their foundations; but the chief danger which medieval wall painters sought to avoid was rain water collecting on the top of a wall or at its foot.

Plaster grounds served two purposes: first, to even out the wall surfaces to which they were applied, and second, to provide uniform grounds beneath the painting. If a wall was very rough indeed a coarse powder of pounded bricks was sometimes used to mix the first coats of plaster, instead of sand, so that the mortar should have more bulk. As the wall surface became truer the fineness of the plaster was increased; a larger proportion of lime was used, and finer sand, or even marble dust, was mixed with it. Medieval painters were often indifferent to undulations of the wall surface, and did not trouble to get the plaster flat, if the masonry underneath was very far out of truth. The plaster was used to soften irregular contours, but not to reduce them to a severe, abstract, mechanical perfection; and much of the harmony of medieval wall painting with medieval architecture is due to the adaptability of the plaster surface to the masonry beneath it. Whereas a canvas must be stretched severely smooth, plaster could and did take on something of the character of the walls to which it was applied, as a glove takes on the character of the hand that wears it. Lime plaster, too, is essentially an architectural material, and identifies itself with the visible elements of architectural structure as canvas can seldom do.

Structural Woodwork

Finally, half-way between panel painting and wall painting may be mentioned the painting of structural wood, as in the flat wooden ceilings such as we see in great beauty at St. Albans, or the members of a trussed roof such as that of San Zeno at Verona. Structural woodwork was generally painted without any special preparation, or with merely a preliminary coat of size or oil paint to equalize any gross differences of colour or absorbency in its surface. The elaborate preparation with gesso which a small work on wood required to fit it for painting and gilding on a small scale in high perfection, was unnecessary for the bolder effects which were sought in the decoration of the larger wooden elements of architectural design.

CHAPTER 1

BINDING MEDIA

THERE are some coloured substances which naturally penetrate other materials and impart colour to them. Substances which possess this property of identifying themselves with other substances, and sharing their colour with their hosts, are known as dyes or stains. In contrast to these, pigments, in the ordinary sense, simply lie on the surface of other materials and stay there only as long as nothing causes them to come away, unless they are deliberately attached in some way with the binding medium.

The Three Orders of Binding

The binding of the pigments may be performed in any of three ways. First, the binding medium may be supplied and then the pigment. (This might be called the tar-and-feathers method.) In fresco painting, and in mordant gilding, the medium is present before the coloured bodies are put in place. Second, the binding medium and the pigment may be mixed together. That is, of course, the normal method in most kinds of painting. Pigment and medium are mixed together, and applied in a liquid or plastic state. Then when the medium is dry and hard, it holds the pigment safely in place. The third possible method is to apply the pigment and then the medium. This is seldom done deliberately; but it does sometimes come about. A pastel painting is really practically plain pigment. (There is a little binder in the pastels to keep them in shape before they are used; but not

enough to bind the colour when it has been rubbed out on paper or canvas.) In a pastel, the pigment simply lies on the ground, and can very easily be brushed off. To hold it firmly, the surface is sometimes sprayed with a fixative, often a thin solution of shellac, which surrounds the particles of pigment and holds them in place. This fixing usually robs the pastel of its greatest charm, the "bloom" and freshness of the colour; but it serves to illustrate the third possible method of combining pigments with binding media.

Functions of Vehicles

Binding media serve a double function. They hold the pigment in place; but that is not all. They have besides a certain effect on the appearance of the pigment, an effect which, though it varies with the particular pigment, depends chiefly on the nature of the medium and the proportion of medium present in the pigment mixture. The addition of a binding medium to a pigment modifies it, *tempers* it; and it is convenient to speak of the process of mixing media with pigments as "tempering." Tempering means supplying a binding agent, and, at the same time, modifying the optical properties of the pigment. Anything which will serve these purposes may be called a tempera, even oil. We usually mean something fairly definite when we speak of tempera painting; but fundamentally the term is so general that we have no right to expect a specific meaning to be understood unless it is defined by agreement, or by our context. The process of tempering is not specific at all; and pigments may be tempered with an almost infinite variety of materials and mixtures.

43

Viscosity Effects

We shall examine briefly the materials which were used for tempering pigments in medieval painting; but first we must consider certain effects of tempering in general. We may take for granted the power of the media to hold the pigments in place. Let us see what other qualities they possess. The most obvious point of difference among temperas is, perhaps, the quality of viscosity, the thickness or thinness of the medium, its stickiness, or wateriness, or oiliness, or soupiness, or other similar character. This makes a tremendous difference to the painter. Generally speaking, if he wants to work on a very small scale, the medium must flow very freely even when it is fairly concentrated; or he will find it impossible to make fine strokes with a mixture which contains enough of the medium for his purpose. (The one exception is this: that if a medium is very viscid indeed, so that it pulls out in fine threads, like sugar candy, it has another kind of usefulness for very minute works.) If the scale of painting is not so small, it is rather an advantage for the painter to have a medium which gives a little bulk and body to his pigment mixtures. There are very wide differences among media in these respects, in viscosity or fluidity, in "tack" or "pull," in the crispness of their working, in their tendencies to pile up or "load" under the brush: differences which it is almost impossible to describe in words, which one must experience personally to understand, and which are among the most vital factors in the study of the effects of technique upon style. Compare the liquid grace of Botticelli's brushstrokes with the lean crispness of Domenico Veneziano's "St. Lucy," in the Uffizi; compare the thin, brilliant precision of a Mantegna with the

melting, crusted painting of the pearls in Piero's portrait of Battista Sforza. Compare the fuzzy saccharinity of Lorenzo di Credi with the sleek smoothness of Vermeer, or with the rich, appetizing, luscious, fruit-cake loading of the lights on a really succulent Rembrandt. And then try to think back to the alpine freshness of the cool, thin fresco paintings in the Arena Chapel! Of course, there are ten thousand other elements in this wild journey of the inward eye; but it is wise not to forget viscosity.

Effects of Transparency

Viscosity is fairly easy to understand. Everyone knows the different kinds of viscosity represented by water and oil and jelly and treacle and tar; and it is quite easy to picture to oneself a whole range of different feeling kinds of paint. The optical effects of tempering are not quite so readily imagined, for they are more complex. One of these effects is transparency.

No pigment is in itself wholly transparent or wholly opaque. Any pigment mixture, unless it is applied very thickly, will be affected in some degree by what it covers. If it is darker than the surface beneath it, it will appear to some extent transparent; if it is lighter, it will appear to some extent opaque. But binding media always have a certain influence upon a pigment's behaviour in this respect, sometimes small (as in the case of white lead), and sometimes very pronounced (as in the case of a lake pigment). The transparency of any pigment is affected by the medium which surrounds its particles; but some pigments are more susceptible than others to the influence of binding media, and some binding media are more potent than others in the

optical changes which they work upon the normal pigment. A given pigment in one medium may be quite opaque, and in another quite transparent. This is well illustrated by pure alumina (a material of no importance in itself as a pigment, but an essential constituent of an important group of pigments). Alumina is a pure white powder. If it is mixed with size and painted out, it dries pure white. If it is mixed with oil, it becomes transparent, invisible, and cannot be seen at all. Plain chalk mixed with size dries white and opaque; but mixed with oil it turns dark and almost transparent. Terre verte is much more transparent in oil than in egg tempera. These transparency effects depend partly on the nature of the pigment, and partly on the nature of the medium.

Quantity Relations

There is another sort of optical effect which depends upon the proportion of medium to pigment. If some terre verte or lake or black, for example, is mixed with white, and tempered with a very little yolk of egg and painted out, it dries quite light. If much more yolk of egg is added to the mixture, and that again painted out, it dries much darker, though the proportions of the colours present are the same. This shows that the appearance of the pigment is affected by the amount of medium mixed with it. In the first case, there is perhaps only enough medium to bind the pigment; in the second, there is enough to bind it, and also to produce the full optical effect of the medium upon it. The medium surrounds the pigment particles, and the effect of the whole combined system is seen in the behaviour of the light which falls upon the painted surface. Actually, this

sort of change is limited: when the full influence of the medium has been exerted, further additions of medium do not increase the effect.

This phenomenon is of importance in several connections. Sometimes medieval paintings were executed in media which were not intended to assert these strong optical influences upon the appearance of the pigments. Sometimes materials were used as binders and as binders only, simply with the intention of holding the pigment particles in place. Sometimes media have been added afterwards which have changed the original appearance strongly. Paintings have been oiled or varnished or waxed which were never intended to show surfaces of fully tempered pigment, and their effects have been altered gravely by these subsequent unintended temperings. Sometimes the opposite effect has taken place: binding media have decayed, varnishes have lost their transparency, and the original appearance of the paintings has been correspondingly modified.

Optics and Art History

It is perhaps worth while to dwell at some length upon one or two curious (and even tragic) circumstances which have been brought about through failure to realize these simple facts about the relations of pigments and media. Years ago, the great Russian copyist, Nicholas Lochoff, asserted that the Tintorettos in the Scuola di San Rocco were originally painted in a colour scheme of light greys, blues, reds, greens, and yellows; that Tintoretto had painted those huge canvases as a scene painter would do, with colours mixed with size; and that their blackness was not native and original, but due to oil or varnish applied after

47

they were done, by some later hand. Colours tempered with size become darker when they are oiled or varnished; for the varnish becomes the dominant medium, as a fixative does when applied to a painting in pastel, and it exercises a stronger optical effect upon pigments than size does. Furthermore, oil and varnish darken with age, as size does not. Lochoff held that the blackness of these Tintorettos (which is exceeded by the blackness of few other paintings) was false; but he found few to believe him. Long afterwards, during the war, the Tintorettos were taken down from the walls for safe keeping; and it was then discovered that one of the canvases had been too large for its place, and one side had been folded under. That hidden portion of the painting had never been varnished; and it showed just such a colour scheme and just such a high value range as Lochoff had predicted.

That disastrous varnishing or oiling of the Tintorettos took place long ago, and our generation is not to blame for the false evidence that it caused the Scuola di San Rocco to give us about Tintoretto's large-scale decorations. Lochoff's perception, confirmed by a happy accident, has corrected our misapprehension of Tintoretto's work. But the same sort of thing goes on.

Some fifty or sixty years ago, a very high-minded but mis-guided Englishman who admired greatly the seventh-century paintings on the walls of the cave temples at Ajanta, the matchless Buddhist monastery in Hyderabad State in Central India, undertook to protect and improve some of his favourites there by applying to them a coat of really good coach varnish. It was the best varnish. But those paintings (as we could tell until recently from the ceiling of Cave I,

which he did not touch) were as nearly as possible pure pigment, almost as fresh and delicate as pastel, and putting varnish on them most unhappily made oil paintings of them, *ex post facto*. The varnish, in that half-lit cave, turned very dark indeed, and those responsible for the upkeep of the caves determined to try to remove it. An expert in the treatment of frescoes was called in from Italy. I saw the work partly done in 1924, and realized how hopeless it was to hope for restitution. The damage could not be undone. But I did not foresee what I am told has since then taken place: that the paintings which escaped the varnish brush of the nineteenth century would fall under the wax pot of the twentieth. Wax is as foreign to those delicate paintings as coach varnish. It will not darken as the varnish did; but its optical effects are just as out of place.

Abuses of Wax

Waxing fresco paintings and paintings done in size has become a mania in our generation. Acres of Italian frescoes have been "protected" in this way; and if the process is allowed to continue, we shall soon have to do frescoes of our own if we want to see what a fresco surface looks like. Long ago someone started to oil the Piero "Resurrection" in Borgo San Sepolcro. Happily he did not finish the job, and his mischief-making caused no more damage than a large dark stain. But report has it that since I was last in Borgo that fresco has had a coat of wax. The great "Simone Majestas" in Siena has suffered recently from treatment with waxy or oily substances.

Used with discretion, where it belongs, wax is a most useful, even indispensable instrument in the hands of a

restorer. It is also a splendid, though troublesome, painting medium in itself. But it produces optical effects entirely different from those of fresco painting, lime painting, size painting, and gouache; and applied to any of these it tends to nullify the original medium and impose its own optical qualities. At the worst, the effect is unpleasantly greasy (as in the Mantegnas at Hampton Court); at the best, it is deceptive, in the same way, if not in the same degree, as the varnish on the Tintorettos in the Scuola di San Rocco. It is in examples such as these that we may see most clearly—and painfully—the proof of the principle that the colour and value and transparency of pigments depend not only upon the pigments themselves but also upon the nature and amount of the media with which they are surrounded.

Media for Illumination—Glair

The more important medieval binding media may conveniently be reviewed according to the classes of work for which they were employed: first, those employed in the illumination of manuscripts.

The basic, standard medium for illumination was glair. Glair is the name given to white of egg which has been deprived of its natural stringiness by any of several methods. White of egg in its original state does not mix readily with water, but tends to preserve its structure. If it is whipped to a froth and allowed to stand, it turns into a watery liquid which flows smoothly from a brush or pen, and can be mixed in any proportion with water. It was sometimes prepared in the Middle Ages by squeezing the white of egg in and out of a sponge, instead of whipping it; and sometimes by the use of a wool or cloth filter. An anonymous

eleventh-century tract in Berne, called *De clarea*, weighs the relative merits of the different preparations:

There are two kinds of glair, one of which is made by beating and the other by pressing. The one made by pressing is considerably more brittle or weak than the beaten kind, and is, moreover, contaminated; since, being repeatedly squeezed or filtered through wool or cloth, it picks up dirt from the hand of the person who presses it. . . . And anyone who wants to convince himself of this by experiment may try out each sort, that is, the beaten glair and the squeezed kind, and he will see plainly how very clear the former is and how turbid the latter. So now, not to dwell at greater length upon disparaging or extolling either of them, let us now discuss the more useful one, which is the gift of God, the Master and Dispenser of all crafts. Both colour and glair, therefore, should always be handled very cleanly; for there is no other way to make things beautiful than by being choice and careful about materials.

This text explains the beating of the glair in great detail. Its author warns against the use of the platter on which glair is beaten for any other purpose (lest a trace of grease interfere with the perfect beating of the white of egg), warns too against making the glair in a brass vessel, for fear of contamination by the metal, and scoffs at people who attempt to beat glair with a bent stick or with a spoon. "Unless glair is well beaten," he says, "colour cannot possibly be tempered with it properly; and with implements like these it hardly gets beaten, if at all." He describes a special little wooden whip as the best tool for the purpose, and says that the egg-white must be "converted as it were into a water-froth, or into the likeness of snow, so that it sticks to the platter and loses the power of running or shifting in any direction, even if you turn it bottom side up (that is, the bottom of the platter on top and the glair underneath)." Even when this is done, his standard

51

of perfection is not satisfied. "You must still know this," he says:

If you were to beat seven or ten times after it sticks to the platter as described above, it would be improved. Indeed, that insufficient beating of the glair proves a pitfall to many; and when it is whipped too little it becomes practically a glue, and when mixed with the colour it makes that colour string like a thread, and the colour is utterly ruined, and cannot even flow from the writer's pen without great difficulty. And when it is laid on parchment it appears very unsightly.

Craftsmanship and Aesthetic

This is perfectionism; but so is a great deal of medieval art. I will not undertake to defend the thesis that taking endless trouble over materials makes the product any finer aesthetically. I cannot argue that the use of rare and intrinsically precious materials, and wanton extravagance of thought and labour in their preparation and application, make a more beautiful piece of work. I can argue, and will gladly do so, that this point of view about craftsmanship does lend a certain interest to objects which, if they had not a certain nobility of material and craftsmanship, would be plain rubbish. I can argue, even, that this sort of technical perfectionism, if it does not add to the aesthetic value of a fine object, does represent another parallel value to anyone who can appreciate it. If the big and little panels of the "Duccio Majestas" had nothing else to commend them (instead of being some of the most enthralling expressions of one of the most complex and splendid traditions of the graphic arts), their workmanship would still command the reverence of anyone who knew enough about it to feel humble in the presence of mastery. To the good medieval craftsman, perfectionism was no reproach. This eleventh-century author

states the case simply: "I may," says he, "reasonably be censured for taking time, that is, in writing, for such childish and trivial matters; but God Almighty can convert these things to good fruits."

Craftsmanship and Conscience

It would be doing less than justice to the subject of technique in medieval painting not to point out that one of its essential qualities, one of the few factors which are common to almost all the arts in almost all parts of Europe in the Middle Ages, is the character of service. Very little medieval painting was free-born. Painters, like architects, worked on commission, worked to order, for employers; though they quite generally had the vision to look beyond their immediate paymasters to the ultimate sources of their commissions. A man of property may feel himself entitled to be rude, or careless, or untidy, and even fancy that his independence is in some way demonstrated or flattered by these exercises of it; but his servant may not indulge himself in such ways. I sometimes think that modern painting (in the sense of painting since the Academies) suffers a little from its freedom, bears its freedom less gracefully than medieval painting bore its servitude. Just as the really good domestic servant finds satisfaction in devising ingenious comforts for his employers, so the medieval painter exerted himself constantly, for interest or devotion, to devise new and more perfect forms of service for his employers' and his own soul's good. He took pains for their sake because it was in the perfection of his service that he found his own, his artist's freedom.

Craftsmanship and Industry

It would be doing less than justice to technique in medieval painting not to stress this point; for it is the mainspring of the whole study. It is the reason why techniques grew and flowered under the medieval painter's hands, and it is the reason why it is worth while for us to inquire into them. It would, I confess, be doing more than justice to the character of some medieval craftsmen (like the poor much-abused factory superintendent, Sano di Pietro) to suggest that this complete devotion to good craftsmanship was universal. It certainly was not; but it would be hard to find a case in which these motives did not play some part. We have no certain paintings by Cennino Cennini, and I have always supposed that he must have been quite a bad painter. (There are two reasons for thinking so: first, that he was a third-generation follower of Giotto, and second, that he was so much interested in technique that he wrote a book about it.) But good or bad, he sums up in the ninety-sixth chapter of the *Libro dell'Arte* the case for honest workmanship, on grounds of conscience and expediency, as follows:

Most people make a practice of embellishing a wall with tin glazed with yellow in imitation of gold, because it is less costly than gold leaf. But I give you this urgent advice: to make an effort always to embellish with fine gold and with good colours, especially in the figure of Our Lady. And if you try to tell me that a poor person cannot afford the outlay, I will answer that if you do your work well, and spend time on your paintings, and good colours, you will get such a reputation that a wealthy person will come to compensate you for your poor clients; and your standing will be so good as a person who uses good colours that if a master is getting one ducat for a figure, you will be offered two; and you will end by gaining your ambition. As the old saying goes, "Good work, good pay." And even if you were not adequately paid, God and Our Lady will reward you for it, body and soul.

Preservation of Glair

It would nevertheless be wrong to suppose that every painter in the Middle Ages entertained the same exalted standards of glair-beating as the Anonymus Bernensis. There were a great many adherents of the treatments which he despised, particularly of the preparation with a sponge. The main thing was to get the glair liquid. The next thing was to preserve it; for it dries up and goes bad (quite obviously bad) in a fairly short time if no precautions are taken. To keep it from drying up, one method was to put the glair in one half of an egg-shell, and to cover it with the other half. To prevent putrefaction, it seems to have been a regular practice in fourteenth- and fifteenth-century Italy to put a little of the red sulphide of arsenic called realgar into the vessel containing the glair. This system was used also in the sixteenth century in Germany, as we know from the *Illuminirbuch* of Valentin Boltz von Ruffach; and it must also have been known in England, because the *Art of Limming*, published in London in 1573, tells how to avoid it, in a chapter on "How to kepe whites of egges as longe as you wil without corrupting or putting of Arsenicke to them." (The substitute method proposed is to put in a little vinegar.)

Glair v. Gums

As a medium, glair is extremely fresh, crisp, and clean working. It is a delicate binder, very modest and retiring and inconspicuous; and it preserves the individual quality of a pigment beautifully. It does not, however, saturate and surround the pigment particles when used in the concentrations common in the Middle Ages. Colours applied with

glair were therefore sometimes "varnished," in and after the fourteenth century, with mixtures of strong glair and honey or sugar, to increase their depth and richness. In the fifteenth century, gum benzoin came to be used for "varnishes" of this sort in books; and occasionally mixtures of gum arabic. Glair is rather weak and brittle, especially when newly made, and partly for this reason (which militated against its use in strong concentrations), partly because it was not dense enough to bring out the full quality of some pigments, it was often supplemented in book painting by gum arabic. Gum arabic is a much stronger tempera than glair, and develops the transparency and saturation of pigments mixed with it much more fully.

There was quite a strong difference of opinion in the Middle Ages as to the relative merits of gum and glair tempering. There seems to have been two distinct schools of thought, with another, more moderate school, inter-mediate between them; but in general the tendency seems to have been for gum to displace glair, especially in and after the fourteenth century. This is particularly marked in the treatment of blues; for the use of gum made it possible to bring out the richness of a dark blue as glair alone would not serve to do. For light blues, or blues mixed with white, glair or weak gum water would serve; though for getting the maximum depth out of a poor quality of blue, strong gum water was a help. Ambrogio di Ser Pietro of Siena wrote in 1463: "If the blue is full coloured, the tempera wants to be weaker in gum; and if the blue is weak, the tempera wants to be stronger in gum." A Portuguese work called the *Livro de como se fazen as côres* (written in the Portuguese language, but in Hebrew characters, in the

fifteenth century, or perhaps earlier) says to temper dark blues with gum; but for light blues to add white lead and temper with glair. Mixtures of gums and glair were often concocted, and no doubt partook of the advantages of each component.

Gum Arabic

Gum arabic can be used much more generously than glair, if a little sugar or honey is put into it to keep it from becoming brittle. Colours prepared with a generous amount of gum are what we know as water colours. The use of gum produces a more transparent effect than that of glair; the colour tends to be laid more thinly, and to appear richer and darker. The surface is often shiny, from a deliberate excess of gum. To prepare gum arabic for use it was only necessary to soak it in water until it was dissolved, and then to add sugar or honey until it was found by experiment that the gum dried flexible but not sticky.

Just what gum arabic is, even nowadays, is something of a question; and what it was in the Middle Ages is still more uncertain. For our purposes it does not particularly matter what kind of acacia yielded it, whether it was what we call *Acacia arabica* or what we call *Acacia senegal*, or some other, quite possibly some variety now extinct. It is quite clear that some gums that were not "arabic" at all passed under this name in medieval Europe. It is hard for us to realize how very superficial the identification of raw materials used to be. If the gum of a cherry-tree, or a plum-tree, looked enough like gum arabic, gum arabic it became in medieval trade. Cherry-trees and plum-trees and almond-trees all yielded gums which were used in place of

gum arabic and along with it, though their solutions are quite different from solutions of gum arabic. These gums swell up in water and form thin jellies, but never become quite so liquid and manageable as real gum arabic. (We should not allow ourselves to feel too superior to the Middle Ages about this business of nomenclature; for there is a good deal of so-called gum arabic in trade to-day that has never seen an acacia bush, but is made from dextrin in imitation of the natural product.)

Gum Tragacanth

There is another kind of gum which was used to some extent as a medium in medieval books, gum tragacanth, which comes from the *Astragalus*, *A. gummifer*, *A. eriostylus*, and other varieties. This gum has the power of taking up almost unlimited quantities of water. It does not really dissolve; but an ounce of it will absorb enough water to produce about a gallon of a sort of thin jelly. Used by itself, there is not really enough of the gum in a workable mixture to bind the colours securely; but it was used in mixed temperas, blended with other gums. "You can't use it by itself," says Valentin Boltz, "but it is quite nice when you mix it with other gums, and gives fine light tones." As far as we can tell, gum tragacanth was not very important as a medieval binding medium; but we know that it was used to some extent in the late Middle Ages.

Size

Size was sometimes used as a medium in books, especially for blues. Blue pigments often had to be laid quite thickly, and it was important to have a strong binding medium

which would not be too brittle when used in quantity. Size (which is practically pure gelatine) used to be made by boiling bits of parchment with water. Sometimes it was made with the trimmings that were left when the sheets of parchment were cut out of the whole skin, sometimes with the fine scrapings which were produced when the parchment was scraped down on the stretchers. These scrapings were the source of the size most esteemed for tempering blues. Sometimes the medieval workman made a point of preparing his size from fragments of the very parchment on which he meant to use it, as if he had some feeling that the kinship between his materials would be beneficial. If parchment cuttings or waste or scrapings are soaked in water until they are soft, and then boiled for some time in fresh water, they undergo a chemical change, dissolve in the water, and form a solution of gelatine; and this solution is called size. When bits of cartilage, tendons, for example, as well as skin, are boiled up in this way, the result is a solution of glue. Either size or glue will set to a jelly when it is cold; and this jelly can be sliced up, the slices dried, and the material kept in dry condition indefinitely. Fish glue was made in the same way from the sounds of stockfish and sturgeon, and was used for mending parchments and occasionally as a medium. The chief importance of both size and fish glue in illumination was to act as binders for the grounds upon which gold leaf was laid.

Adjuncts to Glair

Two other materials must be considered, not because they were used as binders in illumination (though one of them did serve this purpose), but as adjuncts to the binders

which have already been mentioned, especially to glair. Yolk of egg had little importance as an independent medium in book painting. It contains about a third of oil, and is, as the little eleventh-century tract in Berne says, "almost greasy with fatness. And by reason of that fatness every red colour becomes lustrous the more readily; but on the other hand it is not so adhesive, but more fragile and more easily smudged." Used by itself, yolk of egg gives much too soft and tender a surface for painting in books. The friction of one page against another might easily mar the beauty of painting done in pure yolk; but mixed with glair, it supplied enough fatness to give a lustre to vermilion and other reds, a lustre quite different from the gloss produced by using gum. The "Anonymus Bernensis" goes on to tell exactly how to control the mixture so as to get just the right degree of lustre "according to your wish, so that it will shine, or not shine; or, wherever it is not shiny enough, or wherever it is too much so," he tells just what should be done to correct it. A fourteenth-century French author, Master Peter of St. Omer, describes his methods, which are crude in comparison with the eleventh-century standard, and says: "But if after doing all this your work should still not be lustrous, you will know that it is the fault of the air or the weather." The glossiness of rubrics was an important consideration in medieval books; and the chief instrument in controlling it was the modification of the glair binder by the addition of yolk of egg.

The other important auxiliary addition to the main binding media in books is ear wax. When white of egg is first beaten, it becomes a froth. When this is allowed to stand, it distils into a clear liquid, glair. But if this liquid is

very much disturbed as, for example, by grinding colours with it, it tends to get frothy again and to develop little air bubbles which make little holes in the mixtures after they dry. Someone, somehow, discovered that adding a little ear wax would keep these bubbles from forming, presumably by changing the surface tension of the mixture. This curious bit of knowledge spread all over Europe, and affected the practice of illuminators everywhere. Its chief importance was in tempering vermilion and in preparing gold grounds.

Some other adjuncts to the standard media have already been mentioned, sugar and honey, employed to prevent the gums and glair from drying out completely and becoming brittle. We need not attempt a list of every binder which was used to paint in books; but we may note that green washes were sometimes made by dissolving green colours in wine; that stale beer was just sticky enough to do some jobs extremely well; and that sometimes fresh juices of plants and fruits were used for certain colours instead of gums or glair. The green extract of spinach may have been used in this way; cabbage juice was considered good for certain greens; and so was the milky, sticky juice of some spurge, one of the *Euphorbias*. And in fourteenth-century England there seems to have been a passing fashion for tempering greens with the juice of rotten apples. These are all materials which we cannot see when we look at illuminated manuscripts, but which may just possibly prove to be detectable in the laboratory, and which might (again just possibly) put us on the track of some interesting technical relationships among the medieval schools of manuscript illumination.

Media for Panel Painting—Egg Tempera

For painting on gessoed panels, egg was the standard medieval medium in most parts of Europe. It was gradually supplanted in the fifteenth century by oils and combinations of oils and resins, which first modified and then replaced the traditional egg medium. Egg tempera passed out of general use in Europe in the sixteenth century, though it continued to be used in Russia and elsewhere under the traditions of the Greek Church. It was revived early in the nineteenth century by the "discovery" and publication of the *Libro dell'Arte* of Cennino Cennini, and particularly by the translation of that work into English by Mrs. Mary Philadelphia Merrifield in 1844.

The nineteenth century witnessed a gradual growth of interest among painters in the practice of egg tempera painting, and in 1899 Lady Christiana J. Herringham put at their disposal a new and improved translation, *The Book of the Art*. Lady Herringham's translation of Cennino served as the almost sole basis for a widespread revival of tempera technique in England, under the enlightened guidance of Lady Herringham herself and a small group of associated researchers. Through the initial influence of Fairfax Murray upon Edward Waldo Forbes, the study of Cennino and related works was begun early in the twentieth century by Professor Forbes and his pupils at Harvard University; and through the influence of Professor Forbes' practice and teaching, the techniques of tempera and fresco have undergone a similar revival in the United States. The notable developments which have recently taken place in the practice of these techniques in Mexico are, I believe, based directly upon the work of Lady Herringham. The School of

the Fine Arts at Yale University has become, through the teaching of Professor Lewis York, a focal point in the redevelopment of tempera practice; and its work is to some extent based upon my re-edition of Cennino's *Libro dell'Arte* and my translation of it under the title *The Craftsman's Handbook*, first published in 1933 by the Yale University Press.

Egg-yolk diluted with water makes an admirable painting medium. It is often supposed that the yellowness of the yolk would affect the colours; but in practice its influence is so slight that it may be disregarded. Colours tempered with egg dry quickly and can be painted over at once. The second coat does not pick up the first coat as it does in water colour. The viscosity of the mixtures may be varied readily by adding more or less water. The optical effects of the medium upon pigments are intermediate between those of size and those of oil: it yields moderate transparency and saturation. When applied to a smooth gesso ground, colours tempered with egg produce enamel-like surfaces of beautiful texture. When dry, and a little aged, this egg painting becomes very hard and durable, and almost waterproof. It does not discolour with age, as oil painting usually does. A well-made painting with egg is about as nearly permanent as any kind of painting that mankind has yet invented. Under their dirt and varnish, many medieval works in egg tempera are as fresh and bright as when they were first done. When they have altered, the causes of change are to be seen in the grounds, or in the pigments, or in external conditions, but not in the medium. Paintings in egg tempera have generally changed less in five hundred years than oil paintings do in thirty.

Egg-yolk was mixed with water and added to the colours as they were used. The colours were prepared in the form of a wet paste by grinding the pigments with water. A little vinegar was sometimes added to the egg-yolk partly to preserve it and partly to offset the natural greasiness of the yolk and make it more agreeable under the brush in painting. Sometimes, instead of the yolk alone, the whole egg was used, the yolk and white together. In Italy, when painters used the whole egg (as they seem to have done chiefly for painting on walls), they used to introduce a little fig-tree sap by stirring the egg with fresh cuttings of young growths from a fig-tree. Opinions differ as to just what effect this addition may have produced; but presumably it blended the white and yolk together, and reduced any tendency to brittleness which might have resulted from the use of so large a proportion of egg-white in the medium.

Size

As in books so also on panels, size was used to some extent as a binding medium; again, probably, chiefly for blues. (One able modern English tempera painter is convinced by his observations and experiments that size painting is very much commoner on medieval panels than has been supposed; but he has not yet presented documentary or objective evidence in support of his views.) Size was used as a binder for white paint in one particular connection: for covering up burnished gold which overlapped areas of a panel which were to be painted in egg tempera. Egg tempera does not adhere very securely to a burnished metal surface, and size colour was better for this purpose. It is possible that a wash of size was used also to bind egg tempera

colours to the gold when, for any reason, they were deliberately applied over burnished gilding.

Size was used also for another purpose on panels in connection with egg tempera. If a painter found that he had used too little of his egg medium in any colour mixture, either so little that the colour was inadequately bound, or a smaller deficiency, so that the optical effects produced by the medium were uneven in different parts of the painting (if, for example, he had used so little tempera in some parts that his colours dried out lighter than he intended), then he would put a coat or two of weak size over the surface, to supplement the tempering already performed. It was important to have enough medium in the colours, because otherwise, when the painting was varnished, the varnish would penetrate into the painting and affect its appearance seriously; but any deficiency of egg medium could, if necessary, be made up by the application of size to the surface. A little size on the top of any doubtful passages, or indeed over the whole painting, would keep the varnish where it belonged, so that the painting could be given the protection of a varnished surface without injury to the effect that the painter had planned.

Oil Glazes

Without entering upon the controversial questions of "oil painting" as it is generally understood, some mention must be made of the uses of drying oils in medieval painting. Long before the elaboration of the developed techniques of fifteenth- and sixteenth-century oil painting, oils were used in connection with painting in other media. Transparent colours are much more transparent and rich in oil than in

water colour or egg tempera, and a certain amount of oil glazing was certainly used along with tempera painting from quite early times. We do not know accurately how much it was used, and we are not always sure of being able to recognize it in paintings now. One connection in which oil media were quite regularly employed was the glazing of metal surfaces, particularly red over gold (as may be seen in the Paolo Uccello Battlepiece in the National Gallery), and over silver and tin as well, and green too over these metals. We know that from remote ages oil and varnish glazes of yellow colour were applied to tin to make it look like gold, to silver, also, and even to gold itself, to make it look still more like gold. Medieval examples of glazes of this sort are known, though they are not common until the Renaissance. The inside of the dome in the central panel of Giovanni Bellini's Frari Altarpiece was gilded, and then shaded down with rich, warm oil glazes; and this technical device, which is quite common in Rennaissance painting, especially in sixteenth-century Germany, must look back to the ancient tradition of gold-coloured lacquering in oil varnishes on metals.

How far oil glazes were used over tempera painting, and how far tempera painting glazed with oil media was repainted in tempera colours, and what the materials of these combined operations may have been, are questions still to be settled. A vast amount of evidence will have to be weighed and sifted laboriously before any attempt to solve these problems can be regarded as in any degree authoritative. The modern tendency is to regard the development of oil techniques as an evolution of manipulative methods primarily, rather than a sudden adoption of new materials.

We may be quite sure that the "Secret of the Van Eycks" was not merely something which could be kept in a bottle; but we cannot pretend to adequate knowledge of the physical elements of Flemish or, for that matter, of any fifteenth-century oil painting, at the present time.

Oils and Varnishes

We do know something about medieval oils and varnishes in general. We know that linseed oil, hempseed oil, and walnut oil (possibly also poppyseed oil) were known and used in painting. We know that the normal painting oils of fourteenth-century Italy were what we now call "fat oils," that is, oils which have stood in the sun in shallow vessels until a thick skin of dried oil has formed on the surface. These fat oils, which are left behind when that skin is removed, are about the consistency of honey. For some purposes the oils were cooked, boiled, and thickened with various additions of resinous material, pitch from pine and larch-trees, and especially the resin known as colophony. If much resin was added the mixture became an oil varnish.

A great deal has been written on the subject of medieval oils and varnishes; but the problems remain obscure. The most comprehensive presentation of the evidence so far undertaken remains the *Materials for a History of Oil Painting*, by Sir Charles Locke Eastlake, the first director of the National Gallery, compiled almost a hundred years ago; and the most useful evaluations of the materials so far collected are to be found in the writings of the dean of modern researchers into painting techniques, Professor A. P. Laurie, of the Royal Academy.

Media for Wall Painting—Lime

The problem of the use of oil in medieval painting is by no means limited to paintings on panels. It concerns walls, too, especially, perhaps, in England. There is urgent need for serious study in that direction; but it has not yet been performed, and we must leave oil painting on walls out of account for the present, along with the techniques of mosaic painting and tapestry.

The standard medieval binding medium for wall painting was lime. If a particle of pigment is surrounded by lime water, and the water dries away, the particle of pigment gets caught in the net of lime crystals like a fly in a spider's web. This binding effect may be accomplished by two methods. One is to mix lime water with the pigments; and the other is to mix the pigments with plain water only and apply them to fresh lime plaster. In this second case, the water with which the pigments are mixed mingles with the lime-saturated moisture of the fresh plaster, and the amount of lime mixed with the colours as a result is usually the mimimum. There is no excess of lime to cloud or dull them, as there is apt to be when they are deliberately mixed with lime or lime water before they are applied. Furthermore, they dry with the plaster, as a part of it, and not as a surface layer, more or less detached from the wall itself, as in the first system.

Nevertheless, a very great deal of medieval painting was done on walls which had previously dried. The wall was damped down with lime water and a little lime or lime water was mixed with each colour as it was applied. That is the system described in the first book of the *Schedula diversarum artium* of Theophilus Presbyter, first known to us

in a twelfth-century manuscript in Wolfenbüttel; and there is abundant evidence that it was the dominant method of European wall painting in the Middle Ages. Its chief rivals, apart from mosaic painting and tapestry, were oil painting, in England and Northern Europe, and, after the beginning of the fourteenth century, in Southern Europe, the process known as *buon' fresco*—true fresco painting.

Origin of True Fresco

In the fourteenth century in Italy, and probably not much before, it became a common practice to plaster walls in bits, and to paint on the fresh plaster with untempered colours, simply mixed with water, leaving the lime of the plastered wall to act as the binder for the pigments.

This method almost certainly derived from the technique of mosaic painting, in which it was necessary to put up the cement which was to receive the coloured tesserae of the mosaic piecemeal, a small portion at a time, so that it should not set or dry before the tesserae were in place. The mosaic painter evened up his wall surface as much as necessary with a rough plaster, and drew his design upon the plaster surface. Then as he worked he covered a part of the design with his cement and, guided by the drawing which surrounded the covered portion, inserted the coloured or gilded tesserae which were to form his painting.

Many painters in Italy at the close of the thirteenth century had been brought up in the extravagant tradition of mosaic painting; and when the market for this most costly kind of work fell off, at the beginning of the fourteenth century, they naturally carried over into the

cheaper practice of brush painting the custom of finishing their works bit by bit on fresh plaster. As in mosaic painting, so also in true fresco, the artist draws his work full size on the rough plaster foundation, and covers only so much of it with fresh plaster as he hopes to be able to finish in a day. He undercuts the edge of each section as he finishes it, and dovetails the adjoining plaster neatly under the cut edge of previous days' work. True fresco may be recognized by the division of the painted surface by these joints between successive pieces of fresh plastering; and if this test is applied, many works called fresco will be found to have been executed by other means. Sometimes a few joints of this sort appear in lime paintings which are not true fresco, in which they mean simply that parts of the painting were unsatisfactory, so that they were cut away, replastered, and painted over.

True fresco is a specifically Italian technique, and is seldom if ever found practised except in Italy and in places directly subject to Italian technical influences. It is seldom if ever found even in Italy before the fourteenth century. Essentially it is still lime painting, and differs only in details of manipulation from the much older and much more universal method of painting with lime in the colours on a wall already plastered. The ancients were aware that colours applied to fresh plaster adhered better than colours applied to dry plaster; but there is no evidence that they took advantage of this principle in executing pictorial works.

Palimpsests

All too often, in the history of painting, old wall decorations have been used as carriers for new work. The old

plaster has been scored and scratched to provide a good bond for the new, and the old surface ruthlessly covered and repainted. Sometimes the older members of these palimpsests have not been roughened, but simply plastered over, or even merely whitewashed, in preparation for the new decoration. Repainting of this sort has sometimes had the effect of preserving for us paintings which might otherwise have been lost. Under the careful and appreciative hands of Professor Tristram many hidden treasures of medieval English wall painting have been uncovered to our sight. And even when they prove to have suffered injury before their original incarceration, enough often remains for Professor Tristram's eye to visualize, and his hand to reconstruct (parallel with the remains, and most commendably not upon them), admirable images of their pristine appearance. Our understanding of medieval painting, and our pleasure in it, will be vastly extended when Professor Tristram and Professor Constable complete their projected joint publication of a *Corpus of Medieval English Wall Painting*.

Secco Painting

To supplement the painting methods which depended on the binding action of lime, egg tempera was used on walls; but this method of painting was laborious and was generally confined to developing an effect already partially established. Certain colours, especially blacks and blues, were dulled and dimmed by the whiteness of the crystallized lime binder, and they were usually applied with egg or size. Lime painting, whether on a dry wall or in fresco, did not lend itself readily to the deliberate execution of fine detail;

and it was quite usual practice to depend on finishing with egg or size, until Renaissance times, when it became a popular *tour de force*, and finally a fetish, to complete a painting entirely on the wet plaster without retouching *a secco*.

Colours applied to lime paintings with size or egg have often been washed away, either in a general clean-up or in the removal of the whitewash with which wall paintings were often covered as a hygienic measure after an outbreak of the plague, or as the result of a change in fashion. Sometimes the finishing colours have been lost in the process of transferring wall paintings to other sites or to canvas. The "Andrea del Castagnos" from Legnaia were transferred from the wall to canvas, and brought to St. Apollonia in Florence, and in the process the dark-blue shadows on the dress of Pippo Spano got washed off, so that they are now almost white, much lighter than what were originally the light side of his tunic, which was painted in fresco. This is a common phenomenon. Sometimes, as in the great "Crucifixion" in the Chapter House of San Marco in Florence, the final painting, though planned, was never applied. There the sky is painted red (as things often were which were to be finished in blue), and it is still red; with the result that the gentle Fra Angelico is sometimes given credit for a dramatic instinct that he probably did not possess. In the small paintings over the doors in the cortile of San Marco, particularly in the "Pilgrims to Emmaus," hardly more than the background was painted in fresco, and almost the whole of the highly finished painting of the faces was done afterwards in tempera on the dry plaster. Until a dozen years ago this tempera painting had stood in fairly good condition; but it showed signs of some decay, and once started this decay

advanced with alarming rapidity, with the result that restorers were called in and wax applied. There is very little pleasure in it now for anyone who knew it a few years ago. To see what the "Pilgrims to Emmaus" looked like in 1920 one may turn (with thanksgiving) to the perfect reproduction made of it at that time by Lochoff.

Walls were sometimes painted in egg tempera without any foundation of lime painting. For this technique it was usual to size the wall before beginning to apply the colours, to reduce any excess of absorbency and to allow of a freer handling of the tempered mixtures. In France and England size was used probably more often than egg as a binding medium for wall painting, and oil perhaps as much as either, if not more. Walls could be painted very quickly and easily with size colours which resembled in working properties the mixtures used by painters of stage scenery to-day; but walls so decorated could not be washed with water without serious injury to the painting.

Media for Structural Wood Painting—Oil and Size

For painting on structural wood the usual media were oil, or oil varnishes, and size. So much of this painting has been renewed or refreshed since the Middle Ages that it is often hard to tell by examination what the original media may have been; but we know from documentary sources that both oil and size vehicles were used. Probably the choice often depended partly on cost (for oil painting was much more expensive) and partly on the situation (for if there was no problem of wear or dampness the decoration could be done quite as well, and much more quickly, easily, and cheaply in size).

73

PIGMENTS

We have considered the various carriers and grounds of medieval painting, and the various binding media by means of which pigments were fastened upon these surfaces. We have seen that, though there was some overlapping, each class of work had its own selection of vehicles: glair and gums chiefly for books, egg yolk chiefly for ·panels, lime chiefly for walls, and size and oil for woodwork. We shall find that each of these classes of work had, to some extent, its own special selection of pigments: that some delicate materials were good in book painting which would not do at all on walls or even on panels; that panels could be executed with materials too gross or dull for the illuminator's use; and that wall painting required still bolder, rougher pigment stuff; and also that many pigments were excluded from the wall painter's ·palette by the conditions of his work—the large scale, which limited the use of the costliest pigments; the caustic action of the lime, which prohibited the use of almost all colours of vegetable origin; and the open, exposed surface of the wall, which forbade the use of colours sensitive to light and air for wall painting, though they might be safe enough between the pages of a book, or under the varnish of a painted panel.

Classifications

Medieval writers on pigments generally divided them into two classes, natural and artificial, and in dealing with

medieval pigments we may conveniently preserve this general classification. The natural pigments comprise certain elements, compound minerals, and vegetable extracts; and the artificial, all manufactured salts, including the lake pigments which owe their colour to vegetable or insect dye-stuffs.

Elements

The most important element as a pigment is carbon. Carbon, in any of many forms, from any of several sources, is the almost universal black pigment in medieval painting. After carbon in importance come the metallic elements, gold, silver, and tin, used sometimes as pigments in the conventional sense, in the form of metallic powders which can be mixed with a binding medium and applied with a brush or pen, and sometimes in the form of leaf or foil, applied uniformly over broader areas by special methods which (not quite logically) distinguish themselves from painting. The element, mercury, had some very slight importance as a pigment, in its natural state, and sulphur was occasionally used as a yellow pigment material.

Minerals

Natural deposits of metallic salts, such as the oxides of iron and the carbonates of copper, formed important sources of painters' colours in the Middle Ages. Some minerals are found in fairly fine condition, roughly ready for use in painting, like the coloured earths, the ochres. Others, also useful as pigments, are found as stones, and have to be reduced to powder. Relatively few natural mineral deposits, however, can simply be ground up and

used for painting. There are two classes of objection to doing so: one, the presence of undesirable impurities; the other, the curious circumstance that colour often depends upon the size of the pigment particles, which makes it necessary to grade the powders of certain minerals according to the size of the grains.

Impurities are generally removed by washing by the process known as levigation, and this is often sufficient also to grade the different qualities of colour. To separate a coloured earth from the two types of undesirable impurity generally present in it, sand and humus, the earth is mixed to a thin paste with water, and allowed to settle for a short time. The sand goes to the bottom quickly, and the humus, the mould and peat and such light constituents, tends to float. The surface dross is skimmed off, and the water, which contains the coloured earth in suspension, is drained off from the sand and allowed to settle again. The purified ochre goes to the bottom, and the water which stands above it can be drawn away and the ochre dried. In practice this process needs to be repeated several times, and by a nice adjustment it is possible to remove not only such unwanted parts of a natural earth as sand, which settles rapidly, but also, to some extent, uncoloured, or slightly coloured, clays, which settle out of the suspension a little more slowly than the desired qualities of ochre.

In the same way the powder of a crushed stone can be separated into any convenient number of divisions of uniform fineness, by varying the amount of time allowed for settling out of suspension. The heaviest particles sink first; the liquid is then drawn off and time is allowed for the intermediate particles to separate, and the particles which

settle out of the final washings will naturally be the finest. Most crystalline minerals exhibit their colour to best advantage when the size of the particles is not too fine; and it is important to be able to grade crystalline pigments with some accuracy in this respect.

Sometimes the separation of coloured particles from impurities presents special difficulties, notably the separation of ultramarine blue from the indeterminate mixture of minerals found in natural lapis lazuli. Special methods for accomplishing this separation were developed in the Middle Ages. They depend chiefly upon surface-tension effects which are produced at the junction of waxy and resinous bodies with water. (It is interesting to note that the essential principle of ultramarine separation has been applied in quite modern times to the commercial treatment of certain ores which have no connection at all with painting.)

Sometimes, too, the fractional separation of grades of colour by levigation alone was too slow and tedious, and all sorts of ingenious methods were devised in the Middle Ages for accomplishing it more quickly and perfectly. Some of these methods command the admiration of modern chemists. The modern theorist cannot lightly explain the workings of some of the recipes which evolved accidentally, empirically, under the hands of the unsung ancestors of chemistry, the practical craftsmen, in ages when the science was professed largely by spinners of theories which have long since been discarded. The physical preparation of mineral pigments is a matter of more concern to the historian of science than to the historian of art; but a few of the methods used in the Middle Ages will be mentioned here in connection with some of their products.

Vegetable Extracts

Of the strictly "natural" vegetable colouring-matters saffron may be taken as the type. Saffron consists of the dried stigmas of the *Crocus sativus*, and was used as a source of yellow colour by medieval painters without any other preparation than soaking the natural product in water or glair. The colour is soluble and requires no chemical modification. Vegetable extracts of this sort are rare in medieval technology. For the most part the juices of plants and flowers need to be combined with some acid or basic material to develop their colour, or to be converted into lake pigments by a still more elaborate and "artificial" process. Green colours from the ripe berries of *Rhamnus* and the flowers of *Iris* represent the use of vegetable extracts in acid combination with alum; and the relatively unimportant blues made from violets and cornflowers may stand here for the use of vegetable extracts in alkaline combination with chalk or lime.

Manufactured Salts

The simple medieval classification of "artificial" pigments may advantageously be expanded into three subdivisions of manufactured salts: salts resulting from the direct combination of elements, salts resulting from the action of an acid on a metal; and salts resulting from the double decomposition of salts in solution. These three types of artificial product comprise most of the medieval manufactured pigments.

The most important pigment resulting from the direct synthesis of elements is vermilion, the red sulphide of mercury, which was made in medieval times by adding

mercury and sulphur together under special conditions. The manufacture of verdigris, an acetate of copper, illustrates the treatment of metals with acids to produce coloured salts. Plates of copper hung over vinegar are affected by the acetic acid vapours rising from the vinegar, and copper acetate is formed upon the surface. The most important medieval pigment products of the double decomposition of salts in solution were the pigments known as lakes.

The production of a lake depends upon the power of alkaline reagents to cause the precipitation of aluminium hydroxide, alumina, from solutions of alum. Alum is a compound sulphate of aluminium with sodium or potassium, found in nature, and essential to the medieval processes of colour-making and dyeing. If a solution of potassium carbonate is mixed with a solution of alum, a dense flocculent precipitate of aluminium hydroxide is thrown down, carbonic acid escapes as a gas, and potassium sulphate is formed in the solution. A double decomposition has taken place; for both the potassium carbonate and the alum have been converted into other salts.

The aluminium hydroxide formed in this reaction has no value as a pigment in itself. It is colourless and in most media quite transparent. But if there is any suitable vegetable or insect dyestuff present in the solutions of alum and potash when the precipitation takes place, the aluminium hydroxide takes up the colour like a sponge, and forms a coloured compound with it, often different in colour from the natural dyestuff, and often much more powerful. The compound of an organic dyestuff with alumina is called a lake, and lakes are the most important class of organic pigment.

Lakes made in this way are as transparent as the alumina on which the colour is precipitated, and they are valued chiefly nowadays for this very quality of transparency. In the Middle Ages, however, a type of lake was made which was much less transparent, and perhaps more generally useful. This was made by precipitating the alumina out of the alum solution with chalk instead of with potassium carbonate. Aluminium hydroxide is thrown down as before, carbonic acid bubbles off as a gas; but instead of the soluble potassium carbonate which remains in solution, insoluble calcium sulphate is formed as a secondary product, and this, because of its insolubility, precipitates out along with the alumina. The resulting lake, therefore, contains both the very transparent aluminium hydroxide and the relatively opaque calcium sulphate.

BLACK COLOURS

The most important black in medieval times was ink. Its chief use was, naturally, writing, and it was used only incidentally for painting in books. It was of great importance in panel painting, not as a pigment in the ordinary sense, but as the material used for working out the composition, sometimes very fully, on the gesso surface before the painting proper was begun. In this capacity ink, through limiting the reflection of white light back from the ground through the paint layers, exercised a profound effect upon the appearance of other colours and the manipulative methods of painters. Much more generally than is often realized, medieval panel paintings in tempera were begun with a monochrome rendering in ink, sometimes so detailed and

so carefully wrought that it amounted to a monochrome underpainting. (The function of this ink rendering is discussed in a volume of mine devoted to the exposition of Cennino's tempera methods.* Cennino directs its use, but does not stop to explain its effects in detail.)

Inks

Two kinds of black ink were known and used in the Middle Ages, one a suspension of carbon and the other a suspension of a black organic salt of iron mixed with other salts in solution which became black after use. The iron inks represented the common, standard writing material of medieval Europe, and were much used by painters both for preliminary drawings and for preparatory renderings on panels.

As a result of the sting of certain insects, oak-trees develop little round, nut-like swellings called galls or gall-nuts. These gall-nuts contain tannic and gallic acids which can be soaked out of the dried galls with water. The solution is clear and substantially colourless; but if it is mixed with a solution of an iron salt, a purplish-black compound is produced at once, and the ink becomes still blacker with age. Some of the salts first produced by this mixture are colourless, but turn black upon oxidation. In modern practice the solutions used are so pure that when the liquids are first combined no black colour is formed. Indeed, a modern fountain-pen ink would be colourless when new if a dye were not added to it to provide some visibility. (As this dye is often blue, such inks are often

* *The Practice of Tempera Painting*, London: Humphrey Milford, Oxford University Press, 1936. New Haven: Yale University Press.

called "blue-black." The black colour does not appear until after they have been used for writing.) Under medieval conditions some black colour was produced as soon as the decoction of galls was mixed with the iron salt, because of the imperfect purity of the chemical ingredients. To bind this black colour securely some gum arabic was added to the ink.

When well made, from good materials, and not subjected to adverse circumstances, these iron inks have proved admirably permanent. Sometimes, however, for reasons which we often do not understand, they have faded, and turned from jet black to reddish brown, or yellow, with age. In medieval manuscripts one sometimes meets with recipes for making "the finest black ink," recipes sometimes so clear and black on their ancient pages as to commend their products forcibly, but sometimes so pale and faint as to cause the utmost difficulty in deciphering and in consequence a certain scepticism in the reader's mind. Even the most faded iron inks can, when necessary, be renewed by chemical means and made legible again, and photographs can almost always be made to reveal writings done with these organic iron compounds even when chemical treatment cannot be allowed. No small part of our knowledge of history depends upon the fortunate chance that these durable materials have been used for writing.

The colouring-matter of the iron inks is formed to a large extent in the fibres of the paper or parchment after use by oxidation which takes place after writing or painting. They are, so to speak, burnt in; and the word "ink" comes from the Latin *incaustum*, which means "burnt in." The

French *encre* and Italian *inchiostro*, from the same root, show us how widely and how deeply these "burnt in" black iron salts entrenched themselves in the speech as well as in the practice of medieval Europe.

Lampblack

We are particularly concerned here, however, with pigments proper, and not dyes. One black pigment, lampblack, was often made into an ink by mixing it with gum. Lampblack was made in the Middle Ages by allowing a flame to play on a cold surface and collecting the soot which the flame deposited. Sometimes the flame came from a wax candle (not a modern wax candle, which is made of stearine or paraffin, but a candle made of beeswax) or sometimes a tallow candle. Sometimes it was the flame of a lamp burning linseed or hempseed oil or olive oil. Sometimes the flame was produced by burning incense or pitch. It makes some difference to the lampblack what the source of the flame may be; because, though the black itself is pure carbon, there is apt to be a certain amount of unburnt or partly burnt material deposited along with it which may affect both the colour and the working properties of the pigment.

One great beauty of lampblack, especially for ink-making, is that it is extremely fine in grain, and does not need to be made finer by grinding. It may be used just as it is found deposited on the cold surface of metal or earthenware, and needs only to be mixed with a little gum water to make a black ink corresponding to what we call India ink. Our black drawing inks are made by a special process which keeps the carbon permanently in suspension; but this type of ink does not seem to have been known in the Middle

Ages. Chinese stick inks are generally made with lampblack and gum, often with some additions, and depend for their quality largely upon long beating of the plastic pigment mixture. They are designed for brush-writing or painting on very absorbent surfaces, and often contain a larger proportion of gum than the medieval European carbon inks.

It is often supposed that these carbon inks are absolutely permanent; for we know that a pure carbon black will never fade. Not uncommonly, however, in medieval manuscripts written with carbon ink, the material which bound the carbon to the page has perished, or become brittle, and the writing has consequently been wholly or partially lost. The surface of parchment is so hard and close-grained that even the fine grains of lampblack may fail to penetrate it if the lampblack is suspended in a strong solution of gum. The writing stays on the surface and the very gum which holds it there may, through becoming brittle, be the cause of its falling away.

Quite often in the Middle Ages iron inks and carbon were combined, in the interests of denser blackness, however, rather than of any ideal combination of permanences. There is a recipe which appears quite frequently in late medieval English texts, "How to write with a right small pen." The secret is to burn paper (or perhaps parchment) and to mix the black ashes with an iron ink. The purpose of this secret was, of course, to make the ink more immediately black and more concentrated, so that the fine lines of writing "with a right small pen" should show up clearly. It was not unusual for an illuminator to temper his black pigments with an iron ink for painting.

Lampblack was most valued for ink-making. It was used fairly extensively for painting, but was never a favourite pigment. It is apt to be a little greasy, hard to mix with water or water media, and so light that the powder floats in the air and tends to go where it is not wanted. The colour, too, though excellent for pure blacks, is apt to be a little muddy in mixtures.

Vine-Charcoal Black

Certain kinds of charcoal were regarded as much more satisfactory for ordinary painting purposes. Charcoal made from young shoots of grape vines is repeatedly referred to in medieval recipes as the *nigrum optimum*, the best of blacks. This material is called nowadays blue-black, because of the coolness of the greys that it produces in mixtures. Medieval painters took a good deal of trouble to secure a good quality of this vine black. It was important that the vine sprigs be thoroughly burnt and reduced to carbon, because otherwise the colour was brownish and unpleasant in consistency; but they must not be burnt in the air or they might be reduced to ashes instead of to carbon. So the vine sprigs used to be packed tightly in little bundles in casseroles, covered and sealed, and baked in a slow oven. The resulting charcoal was used in sticks for drawing; or for painting it was first powdered and ground up dry, and then mixed with water and ground for a long time between two hard stones.

Colour Grinding

Most other colours were ground in the same way, first milled dry and then ground in the form of a paste with

water. For both the milling and the grinding a slab and muller were usually used. Mortars and pestles were chiefly useful for breaking up large pieces and getting them small enough for easy handling on the slab. The ideal stone for grinding was considered Egyptian porphyry, which, like granite, is hard and crystalline, and does not wear away appreciably even when hard pigments are ground with it. Marble was much more generally used, however, than porphyry, especially outside of Italy. Porphyry slabs were easy to obtain in Rome from the remains of ancient buildings, but far from common elsewhere in Europe. A smaller stone, sometimes cut, sometimes just a split pebble, was used as a muller. On one side the muller was flat and slid across the slab; on the other it was rounded so that it could be guided conveniently by the hand.

Fine grinding was considered important both to make a smooth-working paint, which would flow pleasantly from the brush, and to develop the full colour of many pigments. Vermilion, for example, and the red ochres, improve in colour greatly if they are ground very fine. A few colours, such as malachite, must be ground as little as possible or they become pale; but these are exceptional. It was part of the medieval painter's craft to know how much grinding each pigment required to exhibit its best character. Modern colour-grinding machinery produces quickly and easily colours ground more finely than any in the Middle Ages; but this is not an unmixed advantage to the modern painter. The medieval colour-grinder had an optimum in mind, and that was not always a maximum.

For painting in water media the colours were ordinarily reduced to powder by milling dry on the slab, and then

mixed to a paste with water. This paste was then ground finely, a little at a time, and the ground colour was kept wet for future use by covering it with water in a little jar. The colour could be taken from the jar as required and mixed with the medium fresh every time. Illuminators who worked with large quantities of uniform reds and blues, for letters and ornaments, made a practice of tempering a good deal of colour at a time and washing the medium away by decantation when it was time to refresh it; but the ordinary painting practice seems to have been to temper the colours in small lots as they were used. For painting in oil media the colours were milled and ground in the same way, and the water in which they were ground was then allowed to evaporate. When dry, the pigment could be kept in lumps or powder and mixed with the oil or varnish as required. Only in the fourteenth century, as far as we know, did the custom of tempering colours with glair or gum and then drying the mixture begin to have any importance; and the "water colours" which resulted from this method seem never to have become common in the Middle Ages. A few colours, such as saffron and "clothlets" (see p. 185, below), did not require grinding of any sort.

Other Carbon Blacks

Besides vine charcoal, charcoals from other sources were used for black pigments. Willow charcoal was much used, as it is now, for drawing; but it was too open and too grey to make a good pigment. The denser the original material from which the charcoal is made, the better the resulting black. A very choice black was, and still is, made from peach stones; and almond shells were sometimes charred to pro-

duce another sort. To the outsider all these blacks would seem very much alike; indeed, they would probably be quite indistinguishable. But a painter of the medieval kind becomes familiar with the little quirks of personality in his pigments, and is affected by small subtleties which it is hopeless to try to define, subtleties not so much of colour as of working quality, how the pigment feels, how it mixes, whether it tends to settle out of a colour mixture, or stays nicely in suspension, and little things like that.

Graphite

There are occasional references in fourteenth- and fifteenth-century texts to the use of a soft black stone. This stone was presumably graphite, a soft, smooth, natural deposit of carbon, which we use for our so-called lead pencils. The evidence suggests that it was used in the Middle Ages, as far as it was used at all, chiefly for drawing, and rarely as a pigment.

Ivory Black

The use of ivory black, made by charring chips of ivory, was established in antiquity by the example of Apelles; but there is no evidence that it was continued in the Middle Ages. Bone black, too, seems to have been unknown. The standard black pigments of medieval times may be taken as lampblack and charcoal, each from several sources, with lampblack from oil and charcoal from vine sprigs probably in the lead.

BROWN COLOURS

It is a striking feature of the medieval palette that it contained few if any of the nondescript dark pigments, such as

the umbers, which became so important in later days. The umbers seem not to have been introduced into general use in Europe before the close of the fifteenth century. Vasari speaks of them as rather new in his time. And many of the brown earths which play an important part in later painting seem to have been largely disregarded by medieval painters, or even unknown to them. Some of the ochres must, of course, have had a brownish cast; and we know that browns were compounded by mixtures of blacks with reds and yellows. But the prevailing fashion in much medieval paintings was to use a palette of frank, definite colours, in groups of comparable intensity, according to the work: the most vivid for books, a somewhat more discreet range for panels, and for walls a well-assorted series of less intense but well-defined colours. The intensity was fitted to the work in hand. Dull colours would not do in books; and if bright colours were used on walls, they would have to be toned down until their brightness was wasted. But for no purpose was there much interest in colourless colours. Right was right in the Middle Ages; distinctions were clear cut; and reds were red and blues were blue. If a pigment was merely dingy the medieval painter had no use for it.

WHITE PIGMENTS

In considering what sorts of white painters had in the Middle Ages we must, of course, remember that whites are not always applied. Sometimes they are the result of doing nothing to something that is already white. Parchment and paper often form whites and lights in parts of manuscript paintings. The white gesso of panels and the white plaster

of walls play important parts in medieval painting. On the whole, however, painting "on the water-colour principle" (that is, applying the darks only, and leaving the ground in the lights) was not a reigning method in the Middle Ages. White grounds told as lights; but they were ordinarily supported by white pigments. For books and panels the normal white pigment was one made from lead, called white lead, or ceruse.

Manufacture of White Lead

White lead is, and always has been, one of the most important pigments in several kinds of painting; and one might suppose that we moderns should be very well informed about it. Actually, even the chemists are still a little undecided as to just what our normal modern white lead is; and we do not know at all certainly that white lead in the Middle Ages was not somewhat different from the modern kind. There are a great many medieval recipes for making white lead, and they are all much the same except in one important respect, which we shall examine later on. Before discussing the old rules, however, let us consider the process by which a standard white lead is made to-day.

The traditional method of white-lead making, which persists in spite of many attempts to substitute quicker or cheaper systems, is called the stack process. The "stack" consists of some hundreds or thousands of earthenware pots containing vinegar and lead, embedded in fermenting tanbark or dung. The earthenware pots are especially made and so shaped that the vinegar and lead can be kept separate, so that the lead is exposed to the vapours of the vinegar, but not touched by the liquid. For the sake of convenience the

lead is coiled into a spiral and this spiral stands on a ledge inside the pot, with the vinegar below it in the bottom of the pot. The top of the pot is loosely covered with a grid of lead, which keeps the tan from falling in, but allows the carbon dioxide formed by the fermenting of the tan to enter the pot and act upon the coils and plates of lead along with the vapours of vinegar and moisture.

A thick layer of tan is spread out on the ground or, more often, at the bottom of a pit, and the pots containing the lead and vinegar are arranged upon it and covered with their leaden grids. More tan is laid over them and then usually a loose flooring of boards, followed by more pots, more tan, and so on, until all the pots have been embedded. The temperature of the stack is carefully controlled by the use of fresh tan which ferments strongly and develops a high temperature in the process, and old tan, partly spent, which does not get so hot, in such proportions as will maintain a proper heat. The heat and moisture and acetic acid vapour and carbon dioxide are allowed to do their work for a month or so and then the stack is taken down. The metallic lead by that time has been largely coverted into a crust of white lead on the coils and grid, and it is only necessary to separate this from the unconverted metal, to wash it free of acid and soluble salts, and grind it for use in painting.

This stage of the work is very simple but very dangerous; for lead is a cruel poison, and there is no more effective way of building up a permanent and incurable case of lead poisoning than by breathing in a little of the dust of white lead day after day for a long time. Once lead gets into the human system it tends to stay there, and as each new bit is

taken in the limit of the body's tolerance is gradually reached, and eventually the really dreadful symptoms of lead poisoning declare themselves. Medieval writers warn against the dangers of "apoplexy, epilepsy, and paralysis" which attend the manufacture of white lead. In modern white lead works most ingenious precautions are taken against these dangers with a high degree of success.

Modern and Medieval White Leads

It is true that we know only roughly what modern white lead is. We suppose that the acetic acid vapours from the vinegar act upon the lead coils in the stack and produce an acetate of lead; that this acetate is broken down, partly by the carbon dioxide from the tan (which changes part of the acetate into lead carbonate), and partly by the heat and moisture (which change part of it into lead hydroxide); but we do not really know much about the chemistry of the process, and chemists still disagree about whether the final product is a definite compound or a more or less accidental mixture. We do know that it contains both carbonate and hydroxide of lead.

In some medieval rules we find directions which would probably produce just this same sort of product. We find, for example, instruction to wrap up plates of lead in marc, the refuse of grape skins from the wine-press, and to expose them so wrapped up to the vapour of vinegar under the influence of heat from fermenting dung. The fermenting marc supplied both carbonic acid and moisture, we suppose, and surely some acetic acid as well. Sometimes the waste from beer vats was used, no doubt with much the same effect. White lead made in either of these ways would

probably correspond quite closely with a modern stack process white lead.

But there is another class of medieval recipe for making white lead which is definitely different, though at first glance the point of difference does not appear. According to the rules of this class (and they are very numerous indeed in and after the twelfth century), lead is to be hung over strong vinegar in a pot, and the pot then sealed up tightly and buried in hot dung. If the pot is sealed it is hard to understand how the carbon dioxide can reach the lead. It is hard to see how anything but lead acetate, more or less hydrated, can result from this method of preparation.

It is possible that this was actually the case; that lead acetate was actually formed deliberately in these medieval stacks and not white lead proper; for the product of these recipes was regularly subjected to a special after-treatment not specified for white leads made by other methods. It was roasted gently in the open air. It is possible that this roasting might, under some conditions, be made to produce a carbonate of lead from the acetate. If this is the explanation (and we cannot be sure that it is until it has been confirmed successfully by experiment), we must bear in mind that there were two types of white lead in use in the Middle Ages: one much the same as our modern "Dutch" or stack process white lead, and another somewhat different. We may perhaps suppose that the differences would not be very noticeable. Both types, if there were indeed two, probably shared the fundamental characteristics of white lead pigments: density, opacity, and brilliant whiteness.

Qualities of White Lead

The density of white lead and its opacity are very important to painters. If white lead were not dense and opaque it would be necessary to put it on thickly where, since it is both dense and opaque, a thin coat of it will serve. If medieval painters had not had this heavy, powerful white, they would have had to use two brush strokes, or three, where, having it, one served. The power that it gives of making strokes of light as incisive as strokes of dark is fundamental to the techniques of medieval book and panel painting.

It has only two faults: one, that it is poisonous, and therefore a potential danger to the workman; the other, that as a water-colour pigment it may be blackened by sulphur gases in the air. Quite often one sees on old drawings lights which have been applied with white lead and which have turned brown or black. This darkening can easily be cured, and once cured, it will not recur. In manuscripts, for some reason, it is quite uncommon; and in medieval panel paintings the phenomenon is almost unknown. From the medieval painter's point of view it was a further fault of white lead that it was incompatible with verdigris and orpiment in mixtures. We consider these colours, and not the white lead, at fault in their disagreements; for we have long since banished them from our palette as bad characters. But we are more free to do so than the twelfth-century painter; for we have other greens and yellows to take their places which were not known in his day.

Bone White

The earliest efforts to reconcile verdigris and orpiment to the admixture of white involved the substitution of inert

white pigments for white lead, especially a white made by calcining bones. Almost any sort of bone would do for this purpose. Cennino recommends particularly the legs and wings of fowls or capons, the older the better. "Just as you find them under the dining-table," he says, "put them into the fire. And when you see that they have turned whiter than ashes, draw them out and grind them well."

This sort of white was used in mixtures with verdigris and orpiment, but it lacked the density and opacity of white lead, and was not agreeable to paint with. "Too pasty," a fourteenth-century Italian illuminator calls it. It was nevertheless used to a limited extent as a pigment throughout the Middle Ages, wherever its inertness made it valuable; and it was found particularly valuable for giving a little tooth to drawing paper or parchment tinted with colours. For drawing in silver point, that is, with a drawing instrument made of metallic silver, or tipped with silver, it was desirable to have a drawing surface smooth enough to show the finest lines, yet possessed of some abrasive quality, some tooth, to cause the silver to mark it readily. "Though silver be white," says Bartholomew Anglicus, "yet it maketh black lines and strakes in the body that is scored therewith." But a silver point will make no "black lines and strakes" on plain parchment. It was found that a small amount of bone white added to the mixture of other colours and size with which parchment and papers were tinted for drawing would provide an ideal surface for receiving the marks of a metal style.

Other Inert Whites

For mixtures with verdigris and orpiment a white was

sometimes made from egg shells, calcined in the same way as bones. For mixtures with orpiment, but not for verdigris, chalk could be used as a white pigment in water media. The acid character of verdigris and its temperas made chalk unsuitable for mixtures with that green; but it could be, and sometimes was, used for lightening greens made by mixing orpiment with blue, as well as for making the pale yellow of orpiment paler still. A white made from powdered calcined oyster shells was sometimes used in medieval England, chiefly in connection with orpiment.

Lime Whites

For painting on walls in lime media, white lead was not suitable. For wall painting in egg tempera, it would serve; but without the protection of some organic binder it tended to blacken when exposed to the air. We suppose (though it is only surmise) that the blackening of the lights in the Cimabue "Crucifixion" in the North transept of the Upper Church of San Francesco at Assisi, and in the smaller wall paintings of San Saba in Rome, and so on, is caused by the use of white lead. For wall paintings in size, chalk was sometimes used as a white pigment. Chalk seems also to have been used occasionally in fresco painting; but probably experimentally, and without giving much satisfaction. For wall paintings in lime, two sorts of white were used, one for each of the two types of lime painting.

In the older process of lime painting, that executed with colours mixed with lime on walls uniformly plastered, the normal white was lime putty. When lime is kept damp in a pit or sump for a long time, it becomes thick and stiff and concentrated, and differs markedly in consistency from

freshly slaked lime. Old lime putty is almost as dense as white lead, and enables the wall painter to work with as much *impasto* as he likes. The layers of paint in some medieval wall paintings have an appreciable thickness, due in large measure to the liberal use of lime putty in the colour mixtures.

In true fresco painting, where the colours are bound by lime dissolved out of fresh plaster, heavy *impasto* is comparatively rare. The use of lime putty as a white undoubtedly persisted in the practice of lime painting in fresco, but in the highly developed Florentine fresco technique another white took its place. This white was called in Florence *bianco Sangiovanni*, St. John's white, after the patron saint of Florence. It was made by exposing little cakes of lime putty to the air for a long time, occasionally regrinding them with water, making them into cakes again, and placing them again in the open air. In this process the lime crystallizes and becomes converted gradually by the carbon dioxide present in the air, into calcium carbonate of great density and brilliance. It lends itself admirably to the purposes of true fresco, for which it was exclusively employed.

RED COLOURS

Reds are abundant in nature. Red clays, red stone, of many hues, remind us of the great variety of red colours with which the oxides of iron decorate the face of Mother Earth. But by no means every red clay or stone makes a good pigment, or even a usable pigment. Many earths seem in nature to be strongly coloured which, if they are dried,

have no useful colour left in them. A small amount of colouring material will tinge a clay strongly while it is damp, but will hardly show itself when the clay is dry. Many stones seem richly coloured which, if they were ground to powder, would prove colourless. If one were so extravagant as to powder up a ruby, even a ruby of the deepest dye, the result would be a pure white dust. (This fact can be demonstrated at less expense with a bit of coloured glass.) Ochres to be good must consist very largely of the coloured salts of iron and not, as most earths do, contain much feebly coloured clay. The best ochres for the painter are deposits formed by the weathering of iron ores; and they can be converted by washing, by levigation, into almost pure iron oxides. Deposits of pure iron oxide in the form of hematite were regarded as an important source of red colour in the Middle Ages.

Sinopia

In classical antiquity the great source of red ochres was Pontus Euxinus, and the choicest red earth came from the Pontine city of Sinope. This red was a valuable monopoly, and ancient Greece and Rome looked to Sinope to maintain the quality of its product. To guard against substitutions the colour was sold under a seal (stamped into the cakes of colour, we may suppose), and was known as ''sealed Sinope.'' In the Middle Ages the name of Sinope came to be applied to other earths of less distinction, and the Latin and Italian word *sinopia* came to mean simply a red ochre. We have even an English word from the same source, ''sinoper,'' which means the same, an earth red.

The Range of Ochres

Red ochres vary enormously in colour. Some are quite light and warm, like that which we now call Venetian red, and others are very dark and cold and purple, like our Indian red or Caput mortuum. Some are clear and strong, others more or less tinged by admixture of other minerals than iron oxides. There is a red, a *terra rosa*, from Pozzuoli, near Naples, which has a delightful salmon pink quality which we may think we recognize in some medieval Italian wall paintings. There is the deep maroon of ground hematite, which we may be quite sure we see on walls in Florence.

Appetites for Colour

All these red iron colours are useful in wall painting, and some of the brightest are good for panels, too. Even at their strongest, however, they are seldom powerful enough to be attractive to painters of such small and brilliant, jewel-like works as we see in late medieval books, though they were used to a considerable extent in medieval illuminations up to the fourteenth century.

It is hard for us to realize how brilliant the colours in medieval painting must have been. And we often resist evidence to prove it. A wise and learned student of the Middle Ages ten years ago translated a tag from Terence which the student of medieval paintings may do well to remember:

> We see their age in gloomy guise
> Because we see it through our gloomy eyes.

If the study of medieval materials served no other purpose than to lay before us evidence which would persuade us that

medieval painting generally was as little "gloomy" as medieval illumination, it would be justified. We must not be deceived by surfaces covered with dirt and darkened varnish, or saturated with oil or wax, into supposing that the people who painted books like colours bright, and the people who painted panels and walls liked them sombre.

Our palates are jaded. We can no more enjoy a feast of colour such as the Middle Ages throve on than we can take pleasure in the gargantuan delights of what used to be considered a well-set board. Our taste in colour is like our taste in food and drink, moderate, refined, civilized, and, if the truth were told, perhaps a little liverish. We have no appetite for robust, rich excess. The spirit of pageantry leaves us when we look at pictures. We fear the sun, we choose the gentle shade, we like our gilding rubbed and dulled and worn, and our silver oxidized; and cowering under the topis of our sensitive aesthetic consciousness, we prefer not to believe in the stark brilliance, the garish, gaudy sunshine that the Middle Ages revelled in. We care more for subtle harmony than for triumphant, gorgeous brightness; but we forget that there are harmonies of midday as well as harmonies of dawn and dusk. We shall understand medieval painting better if we can contrive to throw off the dark glasses of prejudice, and the other dark glasses of surface effects—dirt and accident—and see the thing as it was meant to be, and not as time and our own delicate digestions have made it appear.

Minium—Orange Lead

Two bright red colours were known in classic times. One of these was the pigment known in the Middle Ages as

minium, orange lead. We have a red lead nowadays, the pigment which is used on ironwork, on gates and bridges and so on, before their final painting; but the medieval minium was made in a different way from our red lead, and was paler and more orange. In making one of the medieval types of white lead it was necessary, as we have seen, to roast the first product gently in the air. If this roasting was continued, the white lead was gradually changed first into a yellow colour and then into the orange tetroxide of lead called minium. Its colour varied somewhat, according to the strength and duration of the roasting to which it was subjected.

This pigment was very common all through the Middle Ages in manuscript embellishments and painting. It was not used on walls, and not very much on panels; but in manuscripts it served both by itself and in conjunction with the costlier cinnabar and vermilion as one of the chief elements of coloured decoration. It was cheap and easy to make, and its manufacture did not depend upon access to a supply of any rare mineral. It was very bright and gay in colour, and as long as cinnabar was hard to get, and before vermilion became common, this orange minium was the nearest approach to a bright red colour that a painter could manage for his everyday work.

Minium is a beautiful colour in itself. Pliny calls it "flame colour," *colour flammeus*. Actually it was called by many names at one time or another. *Stupium* was really the proper classic Latin name for it, and *minium* was sometimes applied to cinnabar. The confusion of medieval terminology in regard to red colours is immense. *Minium* and *miltos* and *cinabrum* and *sinopis* and *sandaracca* are a complicated tangle.

Minium means either this orange lead or the red sulphide of mercury. Cinnabar means the red sulphide of mercury or the red resin, dragonsblood. Sandarac means orange lead or a red sulphide of arsenic—and so on.

Minium—Cinnabar

We need not deal here with these complications; but it is perhaps worth while to note that *miniare* meant to work with *minium* (that is, either orange lead or red sulphide of mercury), and that a person who worked with minium was called a *miniator*, and the things that he was to miniate were called *miniatura*. So miniatures were originally the paragraph signs and versals and capitals and headings, and so on, which were to be put in in red in manuscripts. The men who put these in sometimes did illustrative and decorative drawings and paintings besides, and these came to be called miniatures too. And, finally, because they were only incidental, and therefore usually rather small, the word miniature came to mean "diminutive."

Natural Cinnabar

Minium in the classic sense is cinnabar, the native red sulphide of mercury. We do not know whether cinnabar was called minium because pebbles of it were found in the sands of the River Minium in Spain, the modern Menjo, or whether the river was called Minium because pebbles of cinnabar were found in its sands. In any case, the chief source of cinnabar in classic times was Spain. Pliny tells us that in his day Spain was practically the only source. The best mines, he reports, were the property of the State:

Nothing is more carefully guarded. It is forbidden to break up or refine the cinnabar on the spot. They send it to Rome in its natural condition, under seal, to the extent of some ten thousand pounds a year. The sales price is fixed by law to keep it from becoming impossibly expensive, and the price fixed is seventy sesterces a pound.

We may suppose that this colossal price was paid only for cinnabar of high quality. In its natural state, cinnabar is usually rather liver-coloured, though occasionally scarlet red. Good samples of it, when ground, yield a bright red, the only bright *red* red pigment known to the ancients.

The Invention of Vermilion

The best cinnabar came from Spain, but there were some deposits of it in Italy, at Monte Amiata, not far from Siena, and elsewhere in Europe. There are deposits of cinnabar which would not make good pigment, but which can be used as a source of mercury. We do not know when scientists first discovered how to make mercury from cinnabar by depriving it of its sulphur content; but we do know that this was understood in the third century A.D.; for it is described in the writings of the alchemist Zosimus. Mercury was a source of the greatest interest to medieval alchemists, and its appearance and chemical behaviour were the basis of a very large part of alchemical theory and practice. According to one influential system of alchemical thought, mercury and sulphur were regarded as the parents of all metals, and the marrying of mercury to sulphur, the manufacture of vermilion, the marvellous re-synthesis of these elements into the likeness of the cinnabar from which the mercury was extracted, was a consummation greatly admired and devoutly practised.

103

This synthesis is not complicated. It is only necessary to mix mercury with sulphur and heat them together. If they are simply mixed and ground together, a black sulphide of mercury is formed, *Aethiops mineralis*; but at the proper temperature this vaporizes and recondenses in the top of the flask in which it is heated. The flask is then broken, and the vermilion is taken out and ground. When it is first formed it may be almost black; but as soon as it is ground the red colour begins to develop, and the longer it is ground the finer the colour becomes. "Know," says Cennino, "that if you ground it every day for twenty years, the colour would still become finer and more handsome."

We do not know when it was discovered that this synthesis could be performed. There is an uncertain indication in the works of Zosimus that he knew about it; but the first definite evidence that we have is a late eighth-century manuscript in Lucca called (by its first editor, L. A. Muratori, two hundred years ago) *Compositiones ad tingenda musiva pelles et alia.* This text is not lacking in the suggestion of certain Spanish relationships; but its background is not Moorish but Greek, so Greek, indeed, that some passages in it are actually in the Greek language, though the Latin scribe, who presumably took it down at dictation, did not realize that, and wrote them as if they were in some curious, incomprehensible kind of Latin. We cannot be sure whether the invention of vermilion was known in Hellenistic times, or whether it was a product of Syrian or Arabic alchemy, or Byzantine or European; but we may fairly safely assume that the knowledge of it was popularized in Europe under the influence of Moorish science after the twelfth century.

Early Experimental Chemistry

The impetus given to chemistry by the dissemination of Moorish learning was far reaching and beneficial. It had above all the effect of emphasizing the practical, experimental aspects of the science. And out of the tide of experimental chemistry which swept over Europe in the twelfth, thirteenth, and fourteenth centuries a number of new colours were cast up on the artist's palette. Besides this, the manufacture of some colours already known seems to have been extended. Almost every art derived some benefit from the new activity in experimental science: the arts of metal-working, glass-making, and pottery glazing particularly were enriched. It is a constant feature of the history of craftsmanship that the craftsman seizes almost instantaneously upon any scientific invention for which he can find any sort of artistic application. This is so true that not infrequently in the history of science the craftsman's appetite for new methods and materials has provided the impulse behind scientific discovery. In the late Middle Ages, science and technology advanced rapidly, hand in hand.

Supply and Demand

Although the late eighth-century *Compositiones* recipes prove that the making of vermilion was understood before the year 800, and though we have other accounts of the process written in succeeding centuries to show that it was not an isolated knowledge that our earliest text reports, still there is good reason to believe that the manufacture of vermilion was something rather rare and mysterious to Europe at large until some time in the eleven-hundreds,

and not really common knowledge until still later. By the fifteenth century, almost everyone who had any interest in making vermilion knew how to do it. Cennino, about 1400, says:

> If you want to take the trouble, you will find plenty of receipts for it, and especially by asking of the friars. But I advise you rather to get some of that which you find at the druggists' for your money, so as not to lose time in the many variations of procedure.

And a manuscript in Naples, written at about the same time, leaves out the account of how to make it, saying that you can "get plenty of it anywhere." This is a far call from the price of seventy sesterces a pound paid in Pliny's time for cinnabar brought under guard from Spain.

It is interesting to compare the careful, even niggardly, use of vermilion in some early medieval manuscripts, when it was still rare and precious, with the careless, wasteful, irreverent applications of it which may be observed in some fifteenth-century books. It is a little hard for us to realize that vermilion embellishments in the tenth century, eleventh, and perhaps even in the twelfth century were as costly and as choice as gilding.

Influence of Vermilion

No other scientific invention has had so great and lasting an effect upon painting practice as the invention of this colour. Vermilion is normally a brilliant, sealing-wax, pillar-box kind of red. Sometimes it inclines to scarlet, sometimes to a colder, more violet cast. It is a powerful colour, of high intensity and excellent pigment quality. Given abundant vermilion, the standard of intensity in the painter's palette automatically rises. Equally brilliant blues and greens

and yellows were required to go with it. The classic earth colours would no longer serve alone. Beautiful, precious, and esteemed in itself, vermilion required a proper setting of other pigments. If the Middle Ages had not had this brilliant red, they could hardly have developed the standards of colouring which they upheld; and there would have been less use for the inventions of other brilliant colours which come on the scene in and after the twelfth century.

A Defect of Vermilion·

Vermilion has one serious fault as a pigment for certain purposes: it sometimes, quite captiously and unpredictably, turns black. This alteration involves no chemical change. It is produced simply by a rearrangement of the internal structure of the red sulphide of mercury into the structure of the black sulphide of mercury. The causes of this change are not clearly understood. Direct sunlight will sometimes induce it, and sometimes not. It seldom if ever takes place in tempera or oil paintings under reasonable conditions; but it is likely enough to take place in lime painting on walls to make it inadvisable to use vermilion for wall painting. Occasionally a little blackening may be observed in areas of vermilion in medieval manuscripts; but one is not always quite sure whether this is due to a change in the vermilion or in something which may have been mixed with it, such as white or orange lead. Fortunately, this defect, though it undoubtedly exists as a danger, seldom makes itself felt. Most of the vermilions in medieval paintings are still bright and sound. Many modern vermilions are made by a different sort of process from that in vogue in the Middle Ages, and there is some evidence to show that

they are more susceptible to this structural disturbance than vermilions made in the medieval way.

Tempering

We have already noted the precautions which were taken to give vermilion an agreeable lustre in manuscript decoration, the use of egg yolk along with the glair with which the colour was normally tempered in books. In tempera painting on panel, vermilion was tempered with egg yolk alone, or with yolk and white together. In the fourteenth and fifteenth centuries there seems to have been a feeling, especially in Northern Europe, that the colour of vermilion could be improved by a little added warmth, and it was not unusual in England, France, and Germany, to mix with it a little saffron for this purpose. In England, in the fourteenth century, a decoction of walnut bark was sometimes used to enrich the colour of vermilion. In Italy and France, and no doubt elsewhere, we read that illuminators used to blend vermilion with minium, orange lead, to make the colour brighter and warmer. This modification was practised particularly with vermilion which had been tempered and washed repeatedly, and become somewhat dingy in the process.

The Red Lakes

Useful, beautiful, and admired as vermilion was, it was still not adequate to produce deep, rich, saturated, transparent reds, or even a full range of violet and rosy colours. The warm cast normally characteristic of vermilions, their inclination to orange, tends somewhat to dull and grey mixtures of vermilion with blue. And it is one of the most opaque pigments; so that it yields even relatively transparent

effects only in the high-value ranges. To obtain transparent reds in dark passages, and indeed to obtain rich dark reds of any sort, on a small scale, painters were obliged to look to other pigments, chiefly to the red lakes of organic origin. The chief dyestuffs used for making red lakes in the Middle Ages were lac, grain, and brazil. Several other reds were known and used for making lakes; but these three were by far the most important. None of them is used in significant quantity for modern artists' colours.

Lac Lake

The word "lake" as applied to pigments derives from a material known as *lacca* from which lake pigments were prepared. Curiously enough, we have very little information about what was originally meant by *lacca*. We suppose that was the material that we now call lac, the gum lac of India, a dark-red incrustation of resin which is produced on certain kinds of trees by the sting of certain insects. This gum, or rather resin, is the source of our shellac. If the crude material is boiled with water containing a little alkali, the colouring-matter dissolves in the water; and it is dried and sold (to a very small extent nowadays) as "lac dye." This can be used for painting, or a lake can be coloured with it. A pigment is still made from it, and sold under the name of Indian lake. The colours which lac dye can be made to produce are generally quite violet, and they are apt not to be very brilliant. Perhaps for this reason the author of the treatise *De arte illuminandi* says: "I am not going into the subject of lac—I leave that to the painters." Cennino, who was a painter, thought highly of it. He advises beginners, "for their great pleasure, always to start by doing draperies

with lac.'' We cannot be sure that he meant this Indian lake; but his circumstantial description agrees well with what we know of it:

> A colour known as lac is red. And I have various receipts for it; but I advise you, for the sake of your works, to get the colour ready-made for your money. But take care to recognize the good kind, because there are several types of it. . . . Get the lac which is made from gum. And it is dry, lean, granular, and looks almost black, and it has a sanguine colour. This kind cannot be other than good and perfect. . . . It is good on panel; and it is also used on the wall with a tempera; but the air is its undoing.

This lac lake was primarily a panel-painting colour: too dark and dull for books, and not stable enough for walls. Lakes in general were thought neither good nor necessary for most wall paintings; for the dark, purplish earth reds took their place quite adequately, as far as colour went, and much more securely.

Hedera *and* Lacca

There is very little written evidence about this Indian gum lac which seems at all specific. References to *lacca* are common all through the Middle Ages; but they are ambiguous. *Lacca* means not only ''lac'' in particular, but also ''lake'' in general, that is, any lac-like, or lac-lake-like pigment. The situation is still further complicated by the fact that very early the name *lacca* was given to another gum, a gum supposed to have been extracted from ivy by piercing the stem of the ivy vine in the springtime, when the sap is rising. This gum, so writers in the Middle Ages from the twelfth century or earlier constantly tell us, becomes blood red. I have lacerated the stems of ivies in vain: I have never succeeded in getting gum of any colour to exude from them.

Mrs. Mary Philadelphia Merrifield, in commenting on one of these recipes, says: "It appears that the resinous juice exudes from the ivy in warm countries only." I very nearly destroyed an ivy in the garden of a house which I occupied in Rome one spring in an effort to confirm this view; but to no avail. In spite of failures, I still believe that a red colour was made in this sort of way.

One's first suspicion, when a rule of this sort seems not to work, is always that the plant name is at fault. Botanical identifications in the Middle Ages sometimes rested upon very superficial similarities. Countries where certain plants did not flourish would apply the names of those plants to others which did flourish there. This method is not without modern parallels. In America, where bay and myrtle are seldom seen, we sometimes call periwinkle "myrtle," and I think the plant that we call "bay" is almost unknown in England. Laurel is not hardy in New England, so we call *Kalmia* "laurel" because it looks a little like it. But ivy was known all over Europe, and was called *Hedera* in the Middle Ages as it is to-day. It is one of the few plants which were not, as far as we know, subject to confusions of nomenclature. Though it is glossed as *lierre* in a fifteenth-century French text, it is just possible that this so-called lac from *Hedera* came actually from a *Rhus* or from some other sort of plant. And some day, when I have a garden, I hope to continue sticking augurs in the spring time into the stems of everything that might have been this *Hedera*.

Grain

The next red dyestuff for us to consider is grain. This was probably more important in medieval painting than

either of the lacs, the Indian or the ivy. The English word "grain" in this connection comes from the Latin word *grana*, which in turn translates the Greek word κόκκος, which means a berry. If the insect called *Coccus ilicis* stings the oak called *Quercus coccifera*, it dies upon the branch. Twigs of this prickly oak became covered with clusters of dead insects, and looked like fruits or berries to the Greeks, who called the product κόκκος. The Romans preserved the Greek conception of the nature of this material in their words *coccum*, *granum*, and *coccigranum*. Middle English took over the medieval Latin *grana* in the form of "greyn," and we have a good right to the word "grain" to designate this dyestuff. We use it with no conscious thought of its original significance in the phrase "dyed in grain." To Chaucer that meant dyed crimson; to us it often means no more than deeply dyed.

Confusion of Nomenclature

At some time early in the Christian era an observant, Latin-speaking individual noticed that this so-called *grana* was not a grain at all, not a berry, but a collection of dead insects; and he rejected the old name for it as insufficiently descriptive. He called it *vermiculum*, the "little worm" material; and in the Vulgate, which Jerome translated from the Greek in the fourth century, the Greek word κόκκος, which occurs in Exodus xxxv. 25, is translated not as Latin *coccum* nor as *grana*, but as *vermiculum*. (We must remember that the colour which by the twelfth century was called *vermiculum*, our vermilion, was not then invented, and the native mineral equivalent was called *cinabrum* or *minium*.) We need not go on here with this account of the

confusion of names. It would take us far afield; and we might in the end have to explain how a bright green pigment happens to be called cinnabar in modern Germany, and why the French verb *vermeillonner* and the English verb "vermeil" mean to lacquer metals yellow. Nevertheless, a little notice of these complications must be taken, for when a material has a great history of words, we may be quite sure that it was important in its day. And we are not nearly through with the words which originated on the twigs of the prickly oak. We have still to consider the most important and the most descriptive.

Confusion of Materials—Kermes

The Arabs called a red insect dyestuff "kermes." The Arabic name was taken over into medieval Latin in the form of the adjective *kermesinum*, which led to the Italian *cremesino*, the French *cramoisie*, and the English "crimson."

Grain and kermes were not identical. Both were largely displaced by a third insect dye, cochineal, which was introduced into Europe at the beginning of the sixteenth century; and in the course of time the distinction between the two came to be disregarded. Through the nineteenth century, grain and kermes were generally thought of as the same thing. Thirty or forty years ago the distinguished historian of the Florentine wool-trade, Alfred Doren, found documents which showed that kermes was more valuable than grain in the fifteenth century and, furthermore, that different methods were employed in dyeing with the two materials. The great fifteenth-century Florentine *Practica della Mercatura* recognizes them as different both in

the amount of customs duty that they paid and in the values of cloths dyed with them.

Students of medieval pigments have not yet fully adjusted themselves to abandoning the old notion that kermes and grain were identical, and we find it hard to say what the one is if the other is what we used to think both were. It seems reasonable to suppose that they must have been fairly similar ever to get themselves confused, and we are surely justified in believing that both were actually insect dyes. It is not inconceivable that as the Arabic name, kermes, came to be associated with the material which had up to then been called grain, the name grain may have been transferred to the gum lac which had up to then been called *lacca*. This explanation is by no means certain; but it seems possible. Another suggestion has been advanced by Wilhelm Heyd. Heyd found that still another red insect dye was imported to some extent into Western Europe during the Middle Ages, the so called "Polish cochineal." This is an insect properly described as *Margarodes polonicus*, not a *Coccus*, like the *C. lacca* of the Indian gum, *C. ilicis* of the supposed grain, or *C. cacti* of the Mexican cochineal, but apparently possessed of somewhat similar properties. It is conceivable that the late medieval grain was "Polish cochineal," or that it was Indian lac, or that it was some inferior form of *ilicis*; but it is also conceivable that it was some other material altogether.

In a fourteenth-century manuscript in Montpellier there is a statement that "Gorma is a certain colour with a purplish cast, and it comes from a certain region which is called Rosia." Heyd thought that this "Rosia" might be Russia, and if so, equally well Poland. There are, however,

several other versions of this statement in other manuscripts which read: "Gorma comes from a certain region, and this is called *rosa* (rose)." In Alexander Neckam's *De utensilibus*, there is a gloss which seems to identify *grana* with *brazil*; but this perhaps represents only a local usage.

Grain Lakes

We cannot at present distinguish with any security between grain and kermes. We are so much in the dark about them that we can do no more than recognize that more than one sort of insect dyestuff was in use in the Middle Ages, and remember that when we speak of grain we are not sure what it means. We may comfort ourselves with the reflection that medieval painters were probably almost as badly informed.

The insect dyes were usually made into pigments by a very roundabout process. They were usually used primarily to dye silk or woollen cloth, and then clippings or shearings of these cloths were used to make lake pigments. Scraps of cloth wasted in tailoring were saved, and the shearings of woollen cloths dyed "in grain" were collected; and the dye was extracted from them by boiling in lye. Alum was added to this lye extract, and the dyestuff was thrown down with the aluminium hydroxide in the form of a crimson lake. These lakes were often called "shearing lakes," or "grain shearing lakes" after their principal source, and they were generally greatly admired. Cennino disapproved of them. "Some lake," he says, "is made from the shearings of cloth, and it is very attractive to the eye. Beware of this type. . . . It does not last at all, either with temperas or without temperas, and quickly loses its colour."

I have no first-hand knowledge of these lakes. Kermes used to be procurable: William Morris used it as a dye in his tapestries; but it is hard, if not impossible, to obtain it now. Perhaps it still exists in Portugal, where the prickly oak and the *Coccus ilicis* are found together; but both kermes and grain, whatever they may have been, were completely, or almost completely, ousted from trade by the discovery of cochineal in Mexico. Professor Laurie, who has worked with both kermes and cochineal, tells me that they are, as one might expect, very similar in colour and behaviour. Cochineal is still used for pink icings on cakes, and for making some rather fugitive pigments, crimson lake and carmine. We may suppose that the kermes or grain lakes were crimson in colour, and not particularly durable. No doubt some of the lakes in medieval painting which have faded to brownish, yellowish pinks were originally *kermesine*, or crimson.

Brazil Wood

Just as lakes are not necessarily made from lac, so grain and the shearings of grain do not always stand in medieval recipes for the insect dyes. Sometimes so-called grain lakes were made from cloth dyed with other materials, sometimes they were not even made from cloth at all, and were only called grain lakes because they looked like them. The greatest source of red lakes, and of red colours for dyeing, too, was a kind of wood called brazil. Many people wonder how a wood can have been called brazil centuries before Brazil was discovered. If there is any connection between the name of the dyewood and the name of the country, it is that the country was named after the wood; for many

dyewoods, including brazil, are found in Brazil. The word comes from the same root as the word "brazier," and refers to the glowing red colour of the dye, and not to the geographical source of the dyewood. In the Middle Ages Ceylon was a great centre of supply for brazil wood. It seems to have been sent from Ceylon to Alexandria, and imported from Alexandria into Europe in great quantities.

Botanically, brazil wood is a *Caesalpinia*. It may be any of several kinds of *Caesalpinia*, and we have no way of knowing at present what kinds were available in the medieval European market. Probably it does not make very much difference in the history of the colours, for the essential dyestuff, brazilin, seems to be common to the whole family. Almost the only clue we have to an identification is the statement, which occurs in several medieval texts, that the best kind of brazil wood has whitish veins in it and tastes sweet. This does not so much identify any particular kind of wood as demonstrate that several kinds were available in the Middle Ages. In its natural state brazil wood is a light, brownish red, not unlike natural mahogany in appearance. It is sold nowadays in blocks or chips, and sometimes also in scrapings or shavings. In the Middle Ages it was always sold in blocks, and the craftsman was obliged to reduce the solid wood to powder by scraping (usually with a piece of glass), or filing, or pounding; for the finer it is powdered the more easily and completely the colour can be extracted from it.

Brazil Lakes—Transparent

When the brownish powder of brazil wood is wet it turns reddish. If it is steeped in water the dyestuff comes out of

it and turns the water brown. If it is steeped in a solution of lye it colours the liquid deep, purplish red, and hot solutions of alum extract the colour from the wood in the form of an orange-red liquor. Most medieval lakes were made either from the extract made with lye (that is, a weak solution of potassium carbonate), or from the extract made with alum solution; because these solutions get the colour out of the wood more thoroughly than plain water. By adding lye to the extract made with alum, or alum to the extract made with lye, a precipitate of alumina is thrown down which brings the colour with it. Just what shade of colour the resulting lake will be depends upon how acid or how alkaline the mixture of solutions is made, and also upon how much of the brazil colouring-matter there is in the solution precipitated. The more alum there is in the mixture the warmer the colour will be; the more lye there is the colder the red of the lake pigment will come out. The precipitate is collected by allowing it to settle and pouring off the liquid; and the pasty mass of lake is then smeared on some absorbent surface, such as a new brick or tile, to dry. When it is dry, it can be ground and used as a pigment and it will possess about the same degree of transparency as the alumina of which it is chiefly composed. Hundreds, almost thousands, of variations on this basic method were devised and practised in the Middle Ages for making transparent red pigments of various shades and qualities.

Brazil Lakes—Opaque

Sometimes the decoction of brazil wood with alum was precipitated with chalk, and a more opaque, pink, rose-

colour was produced by the resulting admixture of calcium sulphate to the alumina lake. Sometimes, in England, instead of adding chalk to the solution, a chalk stone was hollowed out, and little holes were made in the bottom of the hollow, and the hot alum solution coloured with brazil was poured into the hollow of the chalk. The reaction between the alum and the chalk took place at the surface of the chalk stone, in that case, and a crust of semi-opaque brazil lake was formed in the hollow and in the little holes.

When lakes were made by precipitating the alum solution with chalk, the calcium sulphate was formed automatically along with the lake, in intimate combination with it. Sometimes brazil lakes were given some opacity by adding opaque substances to them at the moment of precipitation, and even after. When white lead was used, as it sometimes was, it had no other effect than to give a little substance to the lake, to make it a little less transparent, and to develop the rosy colour. When marble dust and powdered egg-shells were added to the newly formed lakes, or introduced along with the precipitating agent, they probably had the further effect of controlling the colour produced by reacting chemically with any excess of alum which might give a brown cast instead of the desired rose. In all these cases the brazil colour was *mordanted* upon the white material, whether calcium sulphate, or an excess of chalk, or white lead, or marble dust, or powdered egg-shells. The white substances were, so to speak, dyed with the brazil; and the pigment so formed was different from a mixture of a finished lake with a white pigment.

Brazil Extracts

Sometimes the brazil lake was made from cloth dyed with brazil, just as the grain lakes were made; and it often passed for grain. Sometimes brazil was not made into a lake at all, but used as a sort of red ink. The brazil wood was soaked in glair, and a little alum added to develop the colour and to fix it. This extract of brazil in glair could be used fresh, or it could be dried and tempered for use at any later time with a little water and a trace of honey. Extracts of brazil wood mixed with alum were used as red inks in Europe quite generally until a generation or two ago, but they were made with a little gum arabic in place of the glair. In medieval books, this sort of perfectly transparent red colour was sometimes used as an ink, and sometimes also in painting, as a glaze, where the effect of a ruby stain, without any body, was wanted. On panels no such perfect, absolute transparency was needed, and the ordinary alumina lakes were quite transparent enough.

The Importance of Brazil Colours

The amount of brazil wood colour used in the Middle Ages both for painting and for dyeing was colossal. Important as the insect dyes were, brazil was vastly more common, no doubt because it was both cheaper to buy and easier to use. In the fifteenth century red inks made from brazil wood became very popular. The purplish-pink inks of the Italian humanists were made from brazil. It was the source of the vast majority of rose colours in manuscript and panel painting, and probably also of a large proportion of the dark, transparent reds. Like grain and kermes, brazil was to some extent replaced after the Middle Ages by the

more brilliant and powerful cochineal, and ultimately by the more permanent reds from madder. It is used very little nowadays, practically only for cheap wallpapers and marbled papers, though it was used for red ink quite commonly until about fifty years ago. Brazil lakes are not very permanent, and to our eyes not in themselves particularly beautiful; but they were used in enormous quantities in medieval painting, and were highly esteemed by medieval painters.

Madder

As far as we can discover it was chiefly in conjunction with brazil that another red colouring substance, madder, came into use as an artist's pigment in the Middle Ages. There are a few bits of evidence which suggest that it may have come in quite early as an independent agent, and then gone out again. It was certainly used as a dye from very early times; but as a pigment, or component of pigments, it does not seem to have much importance before the fourteenth century. We must, however, bear in mind the possibility that any red colour used as a dye may have been used inadvertently as a pigment; for the people who dyed cloth were not the same who made pigments, and under the name of "shearings of grain" almost any kind of red dye-stuff may have found its way into painters' colours.

"*Warantia*," a Parisian author of the beginning of the fifteenth century tells us, "is a colour, or the raw material of a colour; because if it is cooked in water with lac or ivy gum it makes a red colour which is called cynople; and there is also a red colour made from that *warantia* for dyeing skins." Now *warantia* is *garance* in modern French, and

garance is madder. Madder, botanically the *Rubea tinctorum*, is a field plant which grows wild in Italy and has been cultivated in France as a dyestuff at least since the latter part of the thirteenth century, and perhaps long before. The colour comes from the root, which is allowed to grow for two years in the ground. This root is not in itself red, like a beet. On the contrary, in its natural state there is very little to suggest that it is a dyestuff at all. But it contains a substance which chemists now call alizarine, which can be made to produce red lakes of several shades.

To make as good a lake from madder as any beginner can make from brazil wood calls for a good deal of expert chemical knowledge and careful manipulation; and there is no evidence to suggest that medieval colour-makers possessed the knowledge necessary to making good madder lakes. We know that madder lakes were produced in Italy in the seventeenth century, and that in the eighteenth century they became the most highly esteemed red lake colours, and have remained so until the present day. Artificial madders, made from synthetic alizarine, have supplanted them to a large extent in recent years; but they are generally rather too strong and harsh in colour, and though they are quite as permanent as the natural madders, both natural and artificial madders fade in time, and the natural product seems to grow old more gracefully than the artificial.

Our own dependence on madders, and the experience of modern investigators that they are the only red lakes which are able to stand up under vigorous tests for permanence, have led people rather incautiously to suppose that painters in the Middle Ages must have had them,

first, because they could not have done without them, and second, because if they had used anything else, their colours would have faded. Now we know, as well as we know anything, that brazil lakes were made all over Europe from the twelfth century on, at least, in great variety; and we can be quite sure that no one in the Middle Ages knew how to make a madder that would compete with a brazil or with a grain lake. Painters could certainly have done without them. They had other pigments which were at least as good-looking to begin with. But we say that brazil lakes are not permanent, and lake colours in medieval paintings have not faded out. When we say that a colour is not permanent, we mean that, if we paint out a thin water colour wash on white paper, cover half of it with tin-foil, and put it in the sun, the uncovered part will bleach out in a few days or weeks. Under these conditions brazil lakes appear far from permanent; but medieval paintings are not all thin water-colour washes, and happily they are not often half covered with tinfoil and placed in the blazing sun. These ageing tests are deceptive. The study of medieval painting materials has been much obscured by the illogical argument that since medieval paintings have lasted, they must have been done with colours which under modern testing reveal themselves as rigorously permanent. In the first place, many, many medieval colours have faded, and in the second place, most medieval paintings have never undergone in all their long lives half such severe punishment as the modern tester of pigments inflicts upon his subjects.

Unless we find some real evidence to the contrary, we must suppose that the pure madder lakes as we know them

came into use in the seventeenth or eighteenth century, and that they are not important in the Middle Ages. Madder as a dye for skins, for silks, and especially for wools, probably has a very long history. It was the source of the "Turkey red" of our grandparents, a most important dyestuff in the history of British costume, civil, sporting, and military. The chief use of madder in medieval painting, however, was the manufacture of a compound red containing "mader and greyne . . . and brasil and lak," known as *sinopis*, or in English as "cynopre" or "cynople." This elaborate red compound pigment was much favoured in the fourteenth and fifteenth centuries, especially in England and France.

Dragonsblood

One other important vegetable source of red remains to be mentioned, an East Indian shrub known as *Pterocarpus draco*, or *Dracoena draco*. The sap of this shrub dries into a deep brownish-red gum resin which is known now as it was in the Middle Ages as "dragonsblood." In classical times it was called Indian cinnabar by Greek writers; but Pliny, whose word was law in the Middle Ages, and Avicenna, scarcely less authoritative, established the principle that this material was a product of a titanic battle between the dragon and the elephant which ended in the mingling of the blood of the two combatants. The classic explanation was not merely perpetuated by medieval authors: it was elaborated. Bartholomew Anglicus' account of the battle is epic:*

* Quoted from Robert Steele, *Medieval Lore from Bartholomew Anglicus* (London, 1905), pp. 149, 150.

Between elephants and dragons is everlasting fighting; for the dragon with his tail bindeth and spanneth the elephant, and the elephant with his foot and with his nose throweth down the dragon, and the dragon bindeth and spanneth the elephant's legs, and maketh him fall, but the dragon buyeth it full sore; for while he slayeth the elephant, the elephant falleth upon him and slayeth him. . . . And the dragon leapeth upon the elephant, and busieth him to bite him between the nostrils, and assaileth the elephant's eyen, and maketh him blind sometime, and leapeth upon him sometime behind, and sucketh his blood. And at the last after long fighting the elephant waxeth feeble for great blindness, in so much that he falleth upon the dragon, and slayeth in his dying the dragon that him slayeth.

"According to Avicenna," says Jean Corbichon, a century later, translating Bartholomew into French, "the dragon wraps his tail around the legs of the elephant, and the elephant lets himself sink upon the dragon, and the blood of the dragon turns the ground red; and all the ground that the blood touches becomes cinnabar, and Avicenna calls this dragonsblood." I am sometimes not at all sure that we do not pay too dear for our scientific knowledge.

The great use of this red resin has always been to colour metals. It was used in the Middle Ages for improving the colour of gold, and for glazing other metals in imitation of gold. (This is only one of many indications that medieval eyes admired a ruddy gold.) It is still used to some extent as an ingredient in lacquers for brass and white metals, nowadays usually in conjunction with gamboge. Dragonsblood was used as a pigment in medieval times chiefly by book painters. "Leave it alone," says Cennino, "for it is not of a condition to do you much honour."

Though it was not a lake pigment, it resembled the lakes somewhat in being quite transparent, and its rich, orange-

brownish-red colour formed a tempting adjunct to the cold and purplish tones characteristic of the usual medieval red lakes. Dragonsblood seems to have been most used in the early Middle Ages, and to have passed somewhat out of favour in the fourteenth and fifteenth centuries, though its use was never wholly abandoned. Commerce in dragonsblood may have been interrupted, for one occasionally finds recipes in fourteenth- and fifteenth-century texts for making it artificially, with brazil wood as the chief colouring constituent. But it is perhaps more likely that its special value as a transparent warm red became less urgent as the manufacture of transparent yellow lakes developed, in and after the fourteenth century.

Folium

For the sake of completeness, one other red vegetable colouring-matter may be mentioned, which found occasional employment: a material known as *folium*. This was a substance which, like litmus, changed colour according to the acidity or alkalinity of its environment, an "indicator colour." Three modifications of it were known, red, violet, and blue; and of these the red was the least important. In a neutral solution it was violet, in an acid solution, red, and in an alkaline solution, blue. Its nature is discussed at some length below, under the heading of Turnsole. There is very little evidence, either in literary documents or in illuminations (for which alone this colour was used), that the red modification of folium ever had any real importance. The great red pigments of the Middle Ages were the red ochres, orange lead, vermilion (replacing natural cinnabar), kermes and grain (chiefly in the form of

lakes made from shearings of cloths dyed with them), lac, brazil, madder (chiefly in combination with lac and grain and brazil in the compound called cynople), and dragonsblood.

BLUE COLOURS

Symbolically and aesthetically, the colour blue possessed immense significance in the Middle Ages. Technically, it was important to painters to have a fine blue to complement the brilliant, warm red of vermilion; but the medieval attitude toward the colour goes deeper than that. It is hard to say whether the rarity and costliness of fine blues in cloth and pigments had a share in the origin of the esteem and honour in which the colour blue was held; whether blue was chosen for the Virgin's robes because blue garments were rare and precious in medieval Europe, and blue pigments were also choice. These considerations no doubt played their part; but it is unlikely that they were alone responsible for the dignity and symbolic significance of azure. Probably the example of the Vault of Heaven had a share in these. Probably the blue of the sky did suggest a certain abstract, remote majesty, as purple, through association, suggested immediate, concrete, temporal dominion.

Still, we must not forget that just as the use of the imperial purple was controlled by law in ancient times, so that no one should wear it who was not born to it, so in the Middle Ages in France, to some extent in Italy, and perhaps elsewhere, the dyeing of blue cloth was subject to licence, Crown or State, and the wearing of it implied some dignity and some wealth. In France the output was controlled and limited; and in Italy it was in the hands of a

special group of craftsmen, the *tintori di guado*, set apart from the ordinary textile trades.

For whatever reason, blue did somehow contrive to establish itself as the medieval Christian counterpart of the ancient pagan purple as well as the emblem of maidenhood. The Middle Ages admired particularly those blues which had a purplish cast; so much so, indeed, that when it was naturally lacking, a tinge of purple was often artificially supplied. Greenish blues were less valued. It is a fairly safe principle, in looking at medieval paintings, to attribute any greenish quality in the blues to change. There is no other quarter of the palette so susceptible to distortion by the effects of age as the blues and violets. It is the universal fate of paintings (outside of books) to acquire, as they grow old, a warmer tonality than they had in the beginning. This change is inseparable from oil and varnish, and affects not only paintings done in those media but also paintings which have been oiled or varnished at any time in their history. A little yellowing hardly alters yellows; reds become simply a little more rich and warm; greens stand a little extra yellow gracefully enough; but blues, violets, and cool greys are twisted out of character by even a little brown or yellow over them. Particularly does a little misplaced warmth destroy the violet cast of a fine medieval blue.

Effects of Age

It is a good plan for the student of old paintings, medieval or other, to school himself to discount the effects of age upon the colours; for otherwise he may fall into the disastrous error of supposing that people used to paint antiques. "The Ancients never knew that they were

ancient." Medieval painters never knew that they were being medieval. (Euston Station represents a different point of view.) One small justice which should be paid to old paintings by people who want to see them truly is to remember that circumstances which produce only a small change of emphasis or inflection in the warm colours take the heart out of cool colours. The average medieval painting was predominantly cool: taste and technique combined to make it so. And changes which perhaps improve, and certainly do not greatly injure, the sixteenth-century Venetians and the seventeenth-century Dutchmen and Spaniards, because they simply exaggerate a warmth which is already present, falsify seriously a medieval painting which was intended to exhibit a cool tonality. (Or, for that matter, an impressionist painting. Nothing has suffered more from the yellowing of age than some of the cool Monets, like the mornings at Argenteuil.)

Neutrals

Before we list the blue pigments which we must remember to imagine as blues in the place of the buffs and greens and blacks and muddy greys so often seen in medieval pictures, we should perhaps dwell for a moment upon the neutral greys, used in the capacity of blues. A grey made by mixing black and white is often only approximately neutral, and sometimes positively cool; but even a neutral grey may often be used as a blue in a setting of warmer colours. Blue eyes in eighteenth-century English portraits were often painted with black and white, and not with blue pigments, because if blue colour had been used it would have looked too blue. A small area of neutral grey sur-

rounded by warm colours tells as a blue. In medieval paintings, the effects of contrast upon neutral colours were well realized; and enormous use was made of silvery greys, both as neutrals and as warm or cool, according to their setting. Owing to the effects of age upon varnish these silvery tones are now often buff or brown. Like the more positive blues and violets, they are affected disproportionately to the warm colours by the yellowing of varnish with age.

Azurite

Two of the actual blue pigments in the medieval palette go back to classical antiquity, a mineral, azurite, and a vegetable product, indigo. Azurite is a copper ore, which was called "Armenian stone" in Pliny's time, when Armenia and Spain were the chief sources of supply. In the Middle Ages, Latin borrowed a Persian word for blue, *lajoard*, in the form of *lazurium*, which became *azurium*, and gave us our word "azure." This word probably belonged originally to the Persian blue mineral, lapis lazuli; but it came to apply to the colour blue in general. The regular medieval name for azurite was azure, sometimes called citramarine azure, to distinguish it from the ultramarine azure, the real imported lapis lazuli, which is not found in Europe. Sometimes it was called German azure, *azurrum almaneum*, and in English, "azure of Almayne." We do not know quite why it should so often have been called "German." There are some important deposits of azurite in Eastern France, at Chessy, near Lyons, and some in Hungary; and there may be others not reported to which the Germans had access, and which they capitalized for export. In

Germany itself, this blue was usually called *Bergblau*, "Mountain blue."

But it was not always called "German." It was sometimes found in England, according to some medieval records, and in Spain, in Italy, near Volterra and near Naples, and in Calabria. Sometimes it was called "Spanish blue," sometimes "Hungarian" and "Ragusa blue," sometimes "Lombard blue," and sometimes even just "our blue," presumably when the author who referred to it lived in the neighbourhood of Volterra or Massa or Grosseto or Naples or Ragusa, or in Germany or England or Hungary or Spain or Lombardy, or somewhere where this blue was found. We can generally tell what is meant, because it is usually described as being found in silver mines (as azurite may be) or as having bits of green in it, which are almost surely bits of malachite, a first cousin of azurite, which is almost always found mixed to some extent with any large deposits of the blue mineral.

Preparation of Azurite

The stone of azurite is a beautiful dark blue, and it is sometimes found quite pure and free from other minerals. It sometimes looks a little like lapis lazuli, and the two were very much confused in the Middle Ages. To tell them apart with certainty the stones were heated red-hot. Azurite turns black when this is done, and the true lapis is not injured. To prepare a colour from azurite it was only necessary to break it up and reduce it to a powder. The coarser the powder the darker and handsomer the blue. If it is ground too fine, it turns quite pale. But if it is not ground fine enough, it is too sandy and gritty to be used as a

pigment. The medieval system was to grind it, and then to wash it with water to remove any mud that might be mixed with it, and then to separate the coarse and the medium and the fine grains of blue into separate grades by some process of levigation. If plain water is used this is a very slow and laborious process; so the medieval colour-maker worked out some most ingenious methods for separating the different qualities of blue by using solutions of soap and gum and lye, which did the job better and more quickly, and also various devices for separating the blue particles from any other minerals with which they might be mixed, especially sand.

If the blue was ground with soap and boiled it would float, while the sand would go to the bottom. Fine particles of azurite settle very slowly out of pure water; but if the mineral was ground with gum arabic solution and washed with weak lye, the particles settled more quickly, and the colour could be purified and graded much more readily. After the purification, however, the blue was sometimes deliberately adulterated in trade. A fourteenth-century text tells us that "there are some confounded tricksters who put sand into blue deliberately, to increase the weight, and it is the ruin and destruction of the colour." Some merchants also had a treacherous habit of putting all the best blue at the top of the bag and the poor quality at the bottom.

Characteristics of Azurite Blues

When azurite is washed the very fine particles are rather pale, and this pale, greenish, sky-blue was not much admired for painting. Owing to its fineness, it could be

used in a pen, and it was chiefly reserved for this purpose, for putting pen flourishes of blue around large letters (usually in red) in books. But there was another blue still better for this purpose, turnsole, often used in conjunction with fine azurite, and the palest qualities of azurite seem not to have been in any great demand. To some small extent they were used for modelling up the darker qualities in painting, so as to produce an effect in several values of blue without having to dilute the dark blues with white. Dark azurite blues in tempera oh walls could be modelled up simply by roughening the surface with a stick of wood. Scratches on the dark blue looked light. But this effect was not very lasting, and we can hardly expect to see it for ourselves.

The best grades of azurite for plainting were coarse as pigments go: not actually sandy, but so coarse that it was quite laborious to lay them on, especially in egg tempera. For this reason size was often used as a binder to hold them firmly in place. (Size is more easily affected by protracted dampness or by washing than egg tempera, and blues in wall paintings have therefore sometimes perished through the destruction of their binder where colours in tempera have stood.) It was necessary to apply several coats of azurite to produce a solid blue, and some skill was required to handle the colour successfully. The result was extremely beautiful. The actual thickness of the crust of blue added to the richness of the effect, and each tiny grain of the powdered crystalline mineral sparkled like a minute sapphire, especially before it was varnished.

The open texture of a coat of azurite blue has often been its undoing on panels; for the varnish sinks into it and surrounds the particles of blue. As the varnish yellows and

darkens, the power of the azurite to reflect blue light is destroyed: it is, as it were, strangled by the varnish, not merely smothered. Often a skilful restorer can remove surface varnishes perfectly, and bring paintings back to their original freshness; but no means has yet been devised of washing out old varnish which has penetrated into the body of a film of azurite. A very large number of blacks in medieval paintings were originally blues, and often the colour is still blue at heart, only obscured by the discolouration of the varnish. But sometimes on panels, quite often on walls, and very often in books, we see a crusty surface of bright, pure blue, sparkling and scintillating as the light catches it, and from this (which we may be quite sure is the much-prized azurite) we can train ourselves to imagine what the original appearance of some ruined blues must have been.

Azurite was generally specified in medieval contracts for important paintings, unless the still more precious ultramarine blue was to be used. It was not by any means so choice or so expensive as ultramarine; but it was the best blue of the panel and wall painter for all ordinary purpose, and widely used in manuscripts as well. Its colour is good: at the best, pure blue, at the worst, very slightly greenish. And its texture and surface quality were so exceptional and so beautiful that it was esteemed throughout the Middle Ages. In oil painting this surface quality is lost, and the pigment went out of use as the oil media came in, not suddenly, but quite completely. It has an undeservedly bad reputation nowadays as liable to turn black. It is, in fact, extraordinarily permanent. It does not blacken from the effects of sulphur gases, as some chemists have supposed, but only from the action of the strong alkalis sometimes

improperly used in picture-cleaning, and from the purely optical effect of darkened varnish surrounding its particles.

Indigo

The other great blue that the Middle Ages inherited from antiquity was indigo, a colouring-matter known to the ancient Egyptians and imported by them, and later by the Greeks and Romans, from India (whence its name). It was extracted from certain plants native to India known to modern botany as *Indigoferae,* the bearers of indigo. It was used primarily as a dye, but as a by-product of dyeing with it a blue pigment was formed, the *color indicus* or *indicum*, which became in Italian *endeco* or *endego*, and in English "indigo." The importation of indigo from the Orient continued through the Middle Ages, and the best qualities in the European market were known as Bagdad indigo or Gulf indigo.

Woad

Even in classic times, however, a substitute for the imported Indian indigo was known in the native European weed called in Latin *glastum* or *isatis*, and in English, woad. The dark blue appearance of the British warriors whom the Romans met on these shores was probably not strictly a pigment effect, but merely a staining produced by the fresh juice of the woad plant. Woad is a shrubby herb with broad green leaves which contain the raw material of a blue dyestuff. To develop the blue colour special treatment is necessary; but simply gathering the leaves is enough to produce a deep and lasting blue-black stain upon the hands, and we may suppose that the early Britons simply carried this staining farther.

Woad Indigo

Chemically, there is very little difference between the blue which was made from woad and the blue from true indigo. How much difference there may have been in the appearance of these two products as they existed in the Middle Ages it is difficult for us to judge. We must suppose that it was fairly slight, and not enough in any ordinary case to compensate for the extra cost and difficulty of securing the imported material; for certainly Oriental indigo was very largely replaced in the Middle Ages by domestic indigo from woad. This we know from documentary evidence of several kinds, but not from examination of "indigo" blues in medieval paintings; for no method has as yet been devised for distinguishing the botanical source of an indigo in such minute samples as the chemist-historian is obliged to work with.

Woad Cultivation

The woad plant, *Isatis tinctoria*, grows native in many parts of Europe, and may easily be cultivated in any reasonably temperate climate. It was grown commercially in England until three or four years ago, not actually as a source of blue, but as an adjunct (until about 1930, regarded as almost indispensable) to dyeing with true indigo. The *Isatis* is what gardeners call a "gross feeder," and it exhausts the land that it grows on unless the salts that it extracts for its growth are constantly replaced. This property of the woad plant, indeed, was capitalized by medieval industry; for no source of potash was more esteemed in England than the ashes of woad. The stems and roots and waste from the woad plants were burned, and from the

ashes the mineral salts (largely potassium carbonate) were recovered in the form of a lye, a lixivium, by washing them with water. Lye was regularly made from ashes in the Middle Ages (hence the name of pot-ash), and the ashes of all sorts of plants were pressed into service. The two richest sources, however, were the ashes of woad and the so-called "clavillated ashes," *cendres gravelées*, made by burning the tartar deposited by wine in casks and barrels. In England, woad ashes and oak ashes were the usual sources of lixivia; while in France, the burnt wine lees and the ashes of vine branches and prunings were readily available.

The solutions of potash, used for colour-making, dyeing, making soap, and many other purposes, were made immediately from these ashes, but ultimately from the soil in which the plants were grown. The medieval farmer did not know very much about fertilizing his lands to restore the heavy losses which such a plant as woad induced, and the result was that the woad plantations had to move about, shifting their location every few years to fresh soil as the old soil became exhausted. Woad growing left a trail of agricultural desolation behind it, and the large profits that it yielded for a time in each new site tempted many landowners to their ruin; for these returns were actually not income but capital, not honest earnings but the conversion of the agricultural value of the land into ready cash, leaving no permanent capital value behind. Mankind has never been loath to mortgage the future for present prosperity; and woad farmers, with their sheds and mills, moved about over the face of Europe planting their hungry crop on leased lands, robbing them of their substance, and moving on to

new territory. Eventually the pernicious economic effects of woad farming were recognized, and strenuous laws were passed to govern its practice; but like some other efforts of Governments to control agricultural activities, these medieval legislations failed to solve entirely the grave problems that they were designed to meet. The Middle Ages were willing to pay heavily for the privilege of wearing blue cloth.

Manufacture

When the woad was grown the leaves were gathered, stripped from the plants, crushed, and made up into balls; and these woad balls formed the common raw material of commerce in domestic indigo. For use in dying the dry balls of woad leaves were powdered, spread out, damped, and allowed to ferment. They were then made up into a dye-bath with water and bran, and occasionally some other materials, and subjected to some further fermentation. We have no wholly satisfactory records of how the medieval woad vat was set up; but we know, from the behaviour of indigo, that it required great professional skill to manage it successfully. In the course of dyeing a scum collects on the surface of the vat, and this was called in Latin the *spuma* or *flos indici*, and in English, "florey," or the flower of woad. This foam or flower was skimmed off and dried and used, either alone or in more or less elaborate compounds, under the name of indigo in the Middle Ages.

Social and Economic Consequences

Every step of the process of woad manufacture, from plant to florey, was difficult, expensive, and uncertain. The

plant ruined the land; the harvesting and storing of the crop required judgment and skill and enormous labour; the fermenting of the woad leaves produced ammonia and other complicated smells in such quantity that the establishments for woad dyeing had to be isolated by law from residential and business quarters even in an age not unduly sensitive to foul odours; the waste from the dyeworks contaminated water supplies; the conduct of the dye vat required endless patience and skill. Yet somehow the process went on, went on and flourished, and stuffs were dyed with woad and worn with no benevolent thoughts of the wrack and ruin that their manufacture had left behind them—farms ravished, countrysides laid waste, city wards made intolerable by the reek of the woad works, waters poisoned, to produce the blue cloths, and incidentally a blue pigment, that the Middle Ages loved and admired.

Compound Indigo Pigments

By itself indigo (whether true indigo or woad indigo) is a very dark, purplish, even blackish, colour, and less attractive than when it is mixed in some way with some material to lighten it. Even the ancients used to stain white substances with indigo; and in the Middle Ages certain compounds of indigo with whites assumed the character of independent pigments. In a twelfth-century manuscript in Cambridge we find a typical recipe for one of these:

Take white marble and put it into hot dung for a day and a night, and then take it out and grind it on another marble strongly, and make a very fine powder. And then take the foam which is found in the cauldron in which clothes are dyed the colour of indigo, and put it on this powder, and work it up for a long time. And when it is dry, add more of the foam, until it acquires a good azure colour. Then after it is thoroughly dry,

powder it finely and wash it with water in a basin; and then let it settle and pour off the water, and after pouring off the water let it dry. When it is dry, powder it very finely on the marble, and put it away in a little bag. And know that the foam is better before the cloths are dyed. Know, too, that you can do all this with white lead as well as with the powder of marble.

In this rule, as in many medieval discussions of indigo, we cannot be sure that the source of the colour in the dye vat was woad and not Oriental indigo; but quite often, as time goes on, the dye is referred to as *glastum* (the old Roman name for woad), or *guatum* or *guato* or *blodum* or *guède* or *waid* or *wode*, or in French as *pastel*, all of which are names for the European woad. So in a fifteenth-century manuscript in Cambridge we find a rule "For making azure" out of powdered calcined marble by making it into a paste with either the "water or the foam of woad." The same rule tells us that this colour was sometimes made with a lime made from egg-shells, as we learn also from many other documents. Quite a number of medieval recipes of this sort claim to produce a blue "better than that which is extracted from the mineral." We must recognize a whole family of these indigo or woad pigments consisting of mixtures of indigo with powdered marble, natural and calcined, calcined gypsum, calcined eggshells, and white lead; and we must bear in mind that these mixtures were regarded as pigments in themselves, independent of the indigo from which they were made.

Other Vegetable Blues

The name indigo was attached to all sorts of blue vegetable colouring-matters in the Middle Ages except one, turnsole, which possessed a rival identity of its own, and

like indigo lent its name to many minor substitutes. Indigo and turnsole were the great medieval organic blues, and while in general they stood for the blues from woad, *Isatis*, and from turnsole, *Crozophora*, their names were applied to blue colours made from elderberries and mulberries and bilberries and centaureas and all manner of other vegetable sources.

Turnsole—Identification

Indigo and woad indigo were used for all purposes, for books, for panels, and even for walls. Turnsole, on the contrary, was almost entirely reserved for painting, writing, and flourishing in books. The English name, turnsole, comes from the Latin *torna-ad-solem*, "turn to the sun." It was sometimes called *solsequium*, the sun-follower, and there used even to be an English derivative of this, "sunsikell." There is no more satisfactory identification in the botany of medieval colour-making than that of the plant from which this turnsole colour was made, but it is rather complicated.

Certain medieval glosses tell us that *torna-ad-solem* and *solsequium* were names given to the same plant, and Sloane MS. 4 tells us that it had still another name, *morella*. There are abundant indications that turnsole was known as *folium*, and in several fourteenth-century tracts we find this statement:

Morella is a kind of plant which grows in the land of St. Giles. Out of this plant three grains are formed in the seed; and cloths are especially stained with these grains so that they yield a splendid colour; and this colour is called *folium*.

That is, folium is the colour which is produced from the

seeds of the plant known as morella. To identify the plant, therefore, we must find one which bears a triple seed capsule, whose seeds possess the power of staining cloth, and which was grown in the fourteenth century in Southern France, the land of St. Giles. Furthermore, since the medieval accounts of folium tell us that it is red when acid, violet when neutral, and blue when alkaline, we must identify the morella as a plant whose seeds contain a colouring agent which exhibits these characteristics.

If we take the three seeds as a starting-point, we may describe our plant as *tri-coccum*, three-seeded. It is a three-seeded turnsole. The word turnsole or *solsequium* is equivalent to the Latin-Greek name *Helio-tropium*; so we may call the plant *Heliotropium tricoccum*. Now there is a plant which used to be called *minus tricoccum*, and is now called *Crozophora tinctoria*. It is native to Southern France, and is called in Provençale *maourèla*, or *maurelle*, which takes us back to the fourteenth-century name, *morella*. Furthermore, the English for *Heliotropium minus* is "small turnsole," and in Lyte's English botany of 1578 we read that "with the seede of the smal Tornesoll . . . they die and stayne old linnen cloutes and ragges into a purple colour." And in Holme's *Armoury* of 1688 we read that "at the leaves come forth three berries . . . which have within them a juice or moisture of a purple colour of which that Turn-sole is made." There are descriptions of the plant turnsole in Sloane MS. 416 and Riccardiana MS. 1246 in Florence which make it quite certain that the medieval turnsole, from which the colours called folium were made, was indeed the plant now called *Crozophora tinctoria*.

Turnsole—Manufacture

The method of making the colour out of the seeds of the
Crozophora is described in many medieval texts. It was
prepared, as the extracts given above suggest, in the form
of "clothlets," bits of cloth saturated with the juice of the
seed of capsules. The capsules were gathered in the summer,
and the juice extracted from them by squeezing gently, so
that the kernels, the seeds proper, were not broken, but
the juice of the capsule was expressed. When a good supply
of this juice was ready, cloths were dipped into it, dried,
and redipped and redried over and over, until they had
soaked up a substantial amount of the colour. If the colour
was to be used as a red, plain linen cloths would do. If it
was to be used as a violet, the cloths were first soaked in
lime water and dried, once or twice, so that they carried
enough lime to neutralize the natural acidity of the juice.
And if it was to be used as blue, the limed cloths were used
to soak up the colour, and when finished as violet they were
exposed to the vapours of ammonia to increase the alkalinity
still further and to bring up the full blue colour. This blue
was not altogether permanent as blue: it tended somewhat
to revert to violet. But this tendency was not regarded as
a fatal fault, and the turnsole blue was used as a blue in great
quantities in the later Middle Ages. Turnsole violet was
highly esteemed in fourteenth-century Italy. The *De Arte
Illumandi* describes it as "a common and universal shading
for all colours."

Clothlets

Just why these turnsole colours should have been called
folium is something of a mystery. Mrs. Merrifield suggested

that the bits of cloth were kept between the leaves of a book, the *folia*, and took their name from those. The generic name, however, for cloths saturated with colours in this was was *petia* in Latin, and *pezza* or *pezzetta* in Italian, and the special name for a folium clothlet was *bisetus folii*, *bisetus* being a corruption of *pezzetta*.

Clothlets were a most convenient form of colours for illuminators. It was only necessary to put a bit of clothlet into a dish, and wet it with a little glair or gum water, and the colour would dissolve out of the cloth into the medium, forming a transparent stain. A good many colours were prepared in this way for late medieval book painting, as transparent colours came to be more and more prized by the painters of miniatures. Almost any coloured vegetable juice could be prepared in this way with at least some temporary success, and everything possible was tried; but the turnsole colours were the most satisfactory and important.

Turnsole proper is, as far as we can tell, a medieval invention, and it seems even to have been a fairly late introduction. It was in use possibly as early as the twelfth century; but it does not become prominent until the fourteenth. Once established, it became extremely popular. It paved the way for the general introduction of clothlet colours, labour-saving methods, and the technical degradation of manuscript painting. Clothlet colours were rich and beautiful, too beautiful: they were dangerously seductive. They were easy to use, always ready; they needed no washing and grinding. Fourteenth-century manuscript painters found that a touch of turnsole in their azurite enriched it, made it bluer and better. They liked to glaze the

shadows on an opaque blue with a dark transparent blue. In the fifteenth century, transparency in the colours was much over-emphasized; and the popularity of clothlets is not unrelated to the stylistic trend. Patrons admired the glowing tones that they gave easily. Manuscript painting was turning into a luxury trade, and richness and elaboration and elegance and succulence of colour were becoming prime considerations. Style and technique go hand in hand, and patronage often calls the tune. Given the tendency of book painting in the later Middle Ages to cater to a wealthy, secular clientele, the use of transparent colours to the detriment of form and significance was as inevitable as the stylistic accompaniments which we may observe—the smart, "trick" handling, the emphasis on costume, genre, gaiety, and luxurious fantasy of all sorts.

Ultramarine Azure

There is some evidence that a blue was extracted from lapis lazuli in quite early times, and that it was used in Europe long before any of the recipes for extracting it which we find in European texts were written. We know very little about its early history; but the name, ultramarine, suggests what other evidence seems to bear out, that this material may have been imported ready-made from some land "across the seas" long before its preparation was understood in Europe. The lapis lazuli from which it was made is not found in Europe, but almost exclusively in Persia. The stone itself is therefore obviously "ultramarine," but that is hardly sufficient cause to have given the name of ultramarine to the pigment made from it; for many other raw materials of colour-making in the

Middle Ages were imported and their origin forgotten, or designated specifically as "Yemen alum," or "Armenian bole." It seems probable that methods for extracting a concentrated blue colour from lapis lazuli were first developed somewhere outside of Europe, and that the pigment was known, as an imported product, before European craftsmen knew how to make it.

Lapis lazuli, even the best and darkest blue sort, always contains a good deal of material which is not blue, such as calcite, which is white, and iron pyrites, which sparkles like gold. If lapis lazuli is powdered, the result is disappointing as a pigment; for unless the stone is unusually deep and rich in colour, the resulting powder is hardly blue at all, but simply grey. Under the microscope this powder may be seen to consist of a few particles of blue among a great many colourless particles, and to make it into a useful pigment, this relation must somehow be reversed. The blue cannot be separated from the impurities satisfactorily by washing with water. More complicated measures had to be invented before the Middle Ages could extract good ultramarine from lapis lazuli; and there is no documentary evidence to suggest that the necessary inventions were known, at least in Europe, before the thirteenth century.

Manufacture

There are, indeed, only three known recipes for making ultramarine as early as the thirteenth century. One is a not very promising rule in a Latin work attributed to the Arabian alchemist Geber. It depends on mixing the powdered lapis lazuli with a powdered resin, and then washing the mixture with water. The others are found in

two manuscripts in England, one in Sloane MS. 342, and the other in Cambridge, Caius College MS. 181, in a work attributed to Michael Scot, the Scottish alchemist who resided at the Court of the Emperor Frederick in Sicily and did much to familiarize the scientists of Europe with the science of the Arabs. The invention of the method which these texts report may well be a product of Moorish ingenuity, and it may even have been from some Arabian source that Europe before the thirteenth century obtained its ultramarine azure. The principle of which the successful separation of the blue particles of ultramarine was based has only begun to be understood in quite modern times; but the practice was well known in Italy in the fourteenth century. It consisted in mixing the powdered lapis with a paste of wax and oil and resin, and kneading the mixture under water or lye until the blue came out in the water, largely free from the uncoloured parts of the mineral. There are many accounts of the process in fourteenth- and fifteenth-century works, differing so slightly in the main issues as to suggest that they may all have sprung from some common source at no very remote date. The fullest and most circumstantial account is Cennino's, written at the close of the fourteenth century.

To begin with, get some lapis lazuli. . . . Pound it in a bronze mortar, covered up so that it may not go off in dust; then put it on your porphyry slab and work it up without water. Then take a covered sieve such as the druggists use for sifting drugs, and sift it, and pound it over again as you find necessary. And bear in mind that the more finely you work it up, the finer the blue will come out, but not so beautifully violet in colour. . . . When you have got this powder all ready, get six ounces of pine turpentine from the druggists, three ounces of mastic, and three ounces of new wax, for each pound (i.e. *12 ounces*) of lapis lazuli. Put all these

147

things into a new pipkin, and melt them up together. Then take a white linen cloth, and strain these things into a glazed basin. Then take a pound of this lapis lazuli powder, and mix it all up thoroughly and make a plastic of it, all incorporated together. And have some linseed oil and always keep your hands well greased with this oil, so as to be able to handle the plastic. . . . When you want to extract the blue from it, adopt this method. Make two sticks . . . and then have your plastic in the glazed basin in which you have been keeping it, and put into it about a porringerful of lye, fairly warm; and with these two sticks, one in each hand, turn over and squeeze and knead this plastic, this way and that. . . . When you have done this until you see that the lye is saturated with blue, draw it off into a glazed porringer. Then take as much lye again, and put it on the plastic. . . . And go on doing this for several days in the same way, until the plastic will no longer colour the lye, and then throw it away, for it is no longer any good. . . . If you have eighteen porringers full of the yields, and you wish to make three grades of blue, you take six of the porringers and mix them together and reduce it to one porringer; and that will be one grade, and in the same way with the others. But bear in mind that if you have good lapis lazuli, the blue from the first two yields will be worth eight ducats an ounce. The last two yields are worse than ashes; therefore be prudent in your observation, not to spoil the fine blues for the poor ones. . . . And keep this to yourself; for it is an unusual ability to know how to make it properly. Know, too, that making it is an occupation for pretty girls rather than for men; for they are always at home, and reliable, and they have more dainty hands. Just beware of old women.

Intrinsic Value

Ultramarine was essentially an expensive material, an instrument of luxury. To follow Cennino's advice and exhibit this beautiful and costly colour in conjunction with metallic gold was to reach the peak of highest elegance in appearance, in associations, and in intrinsic worth. The idea of intrinsic worth has gone out of painting nowadays entirely. We have no work for painters that seems to us to call for it; but the Middle Ages had, quite definitely. They lavished

costly materials as well as unlimited service upon their churches; and as the Renaissance approached, as the society of Europe came to look kindly upon the exaltation of wealthy individuals, it became an increasingly important function of art to provide the marks of individual distinction. Timidly at first (for public opinion was against it, on grounds both of religious austerity and social policy), the ruling classes began to use the artist to point the distinction that their wealth and power made between them and their fellows. And it seems to have been a positive satisfaction to late medieval patrons to foot heavy bills for blues and gold.

Very few people can detect flaws in gems which cut their cost in half; very few, for that matter, know real gems from false. But perfection, rarity, intrinsic superiority, give the flawless genuine stone a value based on a human quality which has survived all logical arguments against it. We rationalize; we persuade ourselves, if we think of using genuine ultramarine, that it is subtly more beautiful than other blues. The Middle Ages were more frank: the costliness, the permanent intrinsic value of the blue from lapis put it in a class with gems, to be worn proudly or offered humbly as a worthy gift.

Ultramarine is imitated nowadays by a process which was invented in France in the eighteenth century as a result of a prize offered by the French Government. The raw materials of ultramarine manufacture are soda and china clay and coal and sulphur, all cheap and common. The process requires some skill, but it is inexpensive, and the product is many thousand times less costly than genuine ultramarine prepared from lapis lazuli. Chemically, as far as we know,

the artificial ultramarines are not distinguishable from the blue particles of genuine lapis. The only way to tell the false from the true is by the company they keep: true ultramarine always contains a large percentage of colourless, optically active crystals, from the minerals with which it is associated in nature, while artificial ultramarine is pure blue and free from these diluting elements. If artificial ultramarine is mixed with a poor grade of genuine ultramarine, a quality which contains little of the natural blue and much of the natural impurities, the result is a colour which neither the trained eye nor the scientific method can at the present time distinguish with certainty from finely ground genuine ultramarine of good quality. The importance of the intrinsic value of this pigment in medieval painting has little to do with its appearance; but it has a great deal to do with an understanding of the Middle Ages and their osmosis into what we call the Renaissance.

Distribution

Ultramarine is in some ways less important to medieval painting than azurite. It did not become at all common, as far as we can tell, before the fourteenth century, and perhaps not before the fifteenth. It was probably less generally used in the Middle Ages proper than has often been supposed. The pigment was current in Europe, as we have seen, earlier than the recipes for preparing it. It was probably attracted, first as an imported, and later as a domestic, product, to the centres of wealth and luxury. Fifteenth-century German texts seldom know it except by name, and give very inadequate substitutes for the "fine azure as they make it across the sea." Even in the sixteenth

century, in 1549, Valentin Boltz remarks that "Ultramarine is prized as the choicest of all, but in German lands is seen seldom, and in small quantity." In the fifteenth century, in Italy, and somewhat less in France, it was the standard of quality. (Almost all the French recipes for making it are of Italian descent.) The popularity of this blue in early Renaissance Italy and its comparative rarity elsewhere are probably due to the higher development of that personal luxury of which it was in Italy so often the obvious material expression in painting. Rich wares go to rich markets.

Artificial Copper Blues

What about the poor markets? Azurite was by no means cheap, indigo and woad were hardly bright enough for all purposes, and ultramarine was far too dear for any but the smallest or the choicest works. What pigment could be used for woodwork, or a sky-blue ceiling, that would not cost more than the building? What blue could a poor man afford?

The medieval answer was the artificial copper blues. We are only just beginning to realize that as far as quantitative importance is concerned, the artificial blues from copper are probably more significant in medieval painting than all the rest put together. There are two reasons why we have been so long in waking up to this: one, that we have depended too much in our thought about medieval painting methods upon one document, Cennino's account of his own practice, and he makes no mention of these manufactured blues; the other, that we know these copper colours to be quite impermanent by our strict modern

standards, and we tend to attribute to the Middle Ages a standard of judgment about permanence which did not actually develop until much later. There can be no doubt that for every ounce of ultramarine used in the Middle Ages, many, many pounds of copper blues were used.

Blue Bice

There are endless medieval recipes for making these blues, and very few of them have been investigated experimentally in modern times. Some of them have been tried unsuccessfully; others have yielded beautiful and instructive results. It is not altogether easy to make satisfactory copper blues. Even in the eighteenth century, even indeed in the nineteenth, the manufacture of blue bice, blue ashes, as it was then called, *cendres bleues*, was understood in full perfection only in England, and French colour-makers tried in vain to equal the English product. The making of this once-famous colour is now almost extinct in England. Demand for it is small; and it is now almost as little known as the medieval blues from which it descended. At its best blue bice is a bright, pure blue of middle register, neither very dark nor very pale, fine grained, of pleasant working quality, especially in water media, but not reliably permanent, and not nearly so stable as natural azurite.

By the eighteenth century the name "bice" had come to mean a colour made from copper, sometimes green, though generally blue. In the fourteenth century bice was an adjective, and meant dark. "Azure bys" was "dark blue." In the fifteenth century it had become a noun, and meant blue; thus we find, in fifteenth-century texts, directions to "grynde the byse," the "azour or elles bys," and

so on. In the eighteenth century the copper seems to have been generally in the form of a carbonate; while in the Middle Ages many sorts of copper salts must have figured as "blue bice."

Copper-Ammonia-Lime Compounds

There is quite good reason to believe that most of these copper blues, if not indeed all of them, were really copper-ammonia blues, that is, that they depended for their colour on the property of copper and ammonia to combine in certain deep blue compounds. A solution of copper sulphate, weak enough to look pale greenish-blue, turns to a very dark blue if one adds some spirits of ammonia to it; for the "cuprammonium" salt is formed which is characteristically dark blue. This particular compound is not durable: if the solution is evaporated, the ammonia all goes away, and nothing is left but the original copper sulphate. In conjunction with lime, however, it is possible to fix the copper and ammonia in a stable form, as a dark blue cuprammonium-lime compound; and there are countless medieval recipes for achieving this end. Some of them are clear and easy and sure to work, others we do not as yet understand (and they may be the most significant of all).

Sometimes the lime is supplied as lime, and sometimes as egg-shells. Copper in the form of the acetate, the green colour, verdigris, is mixed and ground with lime and sal ammoniac, in a conventional recipe for one of these blues. The lime acts on the sal ammoniac and produces ammonia, and this turns the green copper acetate dark blue. Any excess of lime tends to make the blue somewhat lighter. To make the blue compound stable it was subjected to varying

153

treatments, usually subjected to long, steady heat. Sometimes other ingredients were added, especially "oil of tartar"; but until we know more about the chemistry of these operations there is very little more to be made of the recipes than the basic fact that they were designed in enormous numbers to produce cheap blues from common materials for everyday purposes.

The weakness of these blues is their tendency to revert to green through the loss of their ammonia content. This defect in them may well be the explanation of the patches of bright green which sometimes make their appearance in blues in medieval wall paintings. A conspicuous example of this change from blue to green is to be seen in the vaults of the Upper Church of San Francesco at Assisi. The phenomenon has been explained as a change of azurite into malachite; but it is perhaps more likely that it results from the employment of a cuprammonium-lime blue.

The Silver-Blue Mystery

One of the types of rule that we do not at all understand, and which may possibly be just superstition, is concerned with making blue from silver. Generally the silver is to be exposed to vapours of vinegar or ammonia, sometimes one and sometimes the other; and it was supposed, by people who wrote about these things before ultramarine-making was understood, to yield the best of all blues. Sometimes the silver was anointed with plant juices. This type of recipe is not infrequently described as of "Saracenic" origin. We should be perfectly justified in supposing that the colour must have been due (if it was formed at all) to the presence of some copper in the silver, if it were not that absolute

purity of the silver, and freedom from copper, is regularly imposed as a specific condition of manufacture, and refining silver was very well understood in the Middle Ages. If any copper is present, the recipes warn, the colour produced will be green and not blue. We cannot, however, explain this puzzle at all, except by the unsatisfactory conclusion that it may have been in some way a roundabout method of making a copper blue.

The Azure-Vermilion Tangle

In connection with the manufacture of blues we must observe that medieval books of recipes often contain, in and after the fourteenth century, rules for making azure (sometimes even called ultramarine azure) which, if they are carried out, will result in vermilion, and not blue at all. The reason for this puzzling circumstance seems to be a confusion of the Arabic words *açifur* and *azenzar*, which mean "vermilion," with the Latin *azurium*, which means "blue." This explanation, again, is not quite satisfying; but we have no other way to account for the perfectly good rules for making vermilion which are presented as rules for making blue. This error, whatever its origin may be, carries on in the technical literature well into the seventeenth century, and even later.

PURPLE COLOURS

We have spoken of reds and blues, and we must pause to examine briefly the intermediate qualities of colour which pass for purple. Purple is a most troublesome word. To some people it means one thing, to others another. All agree that

it has something to do with red and blue, but some seem to think of it as a colour predominantly red and others as predominantly blue. In classic writings it is applied to the colour of cheeks and to the colour of the sea. Historically, purple is the colour produced by shellfish; and in fact the colour of the classic purple from this source almost certainly covered a wide range of tones. The Latin word *purpureus* is simply a derivative of the Greek πορφύρεος, and πορφύρα, "porphyry," is the collective name of a group of shellfish families corresponding closely with the English word "whelk."

The Whelk Reds

The most familiar of the names of these shellfish is *murex*, and we often speak loosely of the "murex purple," meaning the purples of antiquity. Actually, a good many other molluscs besides the murex yielded the porphyry dye. There are seashores piled high to this day with the carcases of whelks which died to provide stripes on Roman togas, the family name of *Porphyrygenetos* (born to the purple), and the luxury writing materials of the Emperors. Millions and millions of Mediterranean whelks gave each a little drop of liquid which produced the purple of the ancient Courts, the purple of Byzantium, the purple of great codices written in gold, the purple ink in which the Patriarch of Constantinople used to sign his name in letters to the Pope of Rome. Very large numbers of British whelks gave their lives for similar purposes in the early Middle Ages. Parchment was dyed with shellfish purple in France as late, perhaps, as the tenth century. Early Irish and English manuscripts seem quite certainly to have been decorated with this colour, no

doubt a product of local manufacture. The Venerable Bede, at the very beginning of his history of England, mentions that in the waters which surround this island there are found an abundance of whelks, from whose blood a crimson colour is made which time and sun cannot destroy, but which becomes more beautiful with age. The preparation of purple from British whelks is being investigated at the present time by Miss Louisa Hodgson of Armstrong College, Durham University, as a part of her extensive programme of research into the natures of medieval painting materials.

There is very little evidence about the actual use of whelk reds in the Middle Ages, though the name is common in early English writings. The probability seems to be that it went out of general use quite early, perhaps about the eighth century, though it may have been revived sporadically, locally, as late as the twelfth century. It was most laborious to produce, and we may wonder whether the disposal of the remains of the whelks must not have created a public nuisance out of proportion to the value of the colour to medieval workmen. It must surely have required the strong arm of ancient empire to enforce the practice of a manufacture which entailed establishing so potent an atmosphere of marine putrefaction. When one considers what one misplaced fish can do to the fresh air of a bathing beach, it is hard to contemplate with equanimity the results of collecting a dye drop by drop from enough molluscs to produce a solid colour in a stout woollen toga for a well set-up Roman emperor. It is at least reasonable to suppose that those who collected the dye were not too particular about the ichthyological identity of the shellfish; and as the dyes

came from several sources, they varied substantially in colour. Several qualities of purple were definitely recognized. We know that the range of the classic colour ran all the way from red to black. In such medieval manuscripts on purple parchment as seem to have been dyed with shellfish purple, a similar range of colour may generally be seen: crimson, plum-colour, and black, often with a bluish bloom, and very little uniformity of tint.

The true purple was, of course, the badge of wealth and distinction and extravagance in classic times. Its only rival was gold. In the Middle Ages there were other materials of comparable worth: first vermilion, while vermilion was rare, and then ultramarine. There were colours of similar appearance and equal beauty, which, though they lacked the intrinsic worth of the shellfish dye, depreciated its value as a perfect artificial gem might depreciate the value of the genuine stone. The true purple was apparently not individual enough, not different enough from colours obtainable by other means, to advertise its rarity and hold its own in competition; and it seems to have passed gradually out of use.

Folium and Archil

Colours obtainable from turnsole corresponded fairly well with the range of the ancient purple. That may conceivably be the reason why turnsole colours were sometimes called *folium*: that they resembled the purple of the manuscript *folia*. And another purple colour enjoyed some importance in medieval painting, a dye made from a lichen. We call it archil in English. We used to call it orchil, and this word was a derivative of *oricella*, from the Latin name,

roccella, which the botanists still apply to the lichen itself, *Roccella tinctoria*. A pigment was sometimes made from it; but its chief importance was as a dye, and perhaps its chief interest for the study of medieval art is that a Florentine family, well known as patrons of art, who are said to have made their fortune in dyeing wool with *oricella*, were known as the *Oricellai*, the dyers with archil, or in more familiar form, the Ruccellai.

Mixed Purples

Except for folium and archil, and to a limited extent the whelk reds, the Middle Ages seem to have depended for their purples largely upon mixtures of red and blue colours. There were, of course, a great number of purplish red lakes (notably the naturally violet lac lake), and the medieval eye favoured blues with a violet cast. Mixed purples were therefore readily made as needed. For walls, hematite and the dark-red ochres served well for purples alone, or mixed with black. Colours which we should ordinarily call purple now are not very common in medieval painting, partly, no doubt, because they have faded or become neutralized through the yellowing of varnish, and probably partly because they were not particularly fashionable. Purplish blues and purplish reds are common enough; but the sort of colour that most people mean when they speak of "Royal purple," though it could easily have been mixed by medieval painters, seems to have been used rather seldom, and more often in any case as shading upon other colours than as an independent tone.

GREEN COLOURS

The palette of the medieval wall painter was rather weak in greens; that of the illuminator was rich. Between these extremes stood the palette of the panel painter; and to estimate that requires some exercise of the imagination, or of the more drastic methods of scientific analysis, because many greens in medieval panel painting have undergone radical changes in the course of time. To appreciate the full resources of the Middle Ages in respect to greens, one must turn to the paintings in medieval books, where the widest range of colours may still be seen, relatively little affected by the adverse influences which have detracted from the original beauty and variety of the greens of panel painting.

Malachite Green

Azurite, the native blue carbonate of copper, has a first cousin, malachite, the beautiful green mineral familiar to modern eyes as the embellishment of some luxurious cigarette-boxes, desk-sets, and furniture. The stone has a grain rather like the grain of wood, and by skilful cutting and veneering elaborate and often beautiful patterns can be wrought in it for inlays and veneers of stone. It is used to a small extent for minor jewellery, and the choicest sorts are called "gem malachite"; but none of it has any great intrinsic value. It occurs in several modifications in nature, some pale and cold in colour, others bright, grassy green; some very hard and stony, and some, better suited to colour-making, rather friable. It is found generally in conjunction with azurite, often merging imperceptibly into the blue

colour. Geologically, azurite is supposed to be the parent, and malachite usually represents a changed form of the original blue deposit. It differs from azurite chemically only in containing a higher proportion of combined water. It may be made into a pigment in the same way as azurite, by grinding and washing, and it was one of the very popular greens of medieval painting, in Asia as well as in Europe. Like azurite, it is not at its best in oil, and has therefore largely gone out of use in the West since the introduction of oil painting. It is still much used in the Orient, particularly in Japan.

Curiously enough, though it was very widely used in the Middle Ages, we find very few recipes for preparing it as a colour, and indeed very few references to its use. Cennino calls it *verde azzurro*, "blue green," and its close association with the blue (which is constantly discussed) probably made it seem unnecessary to treat it separately in the cookbooks, just as rules for handling silver are generally lumped together under the rules for handling gold: the one follows the pattern of the other.

Probably this "blue green" was regarded as a sort of blue, not requiring separate treatment. Nevertheless, it is curious that it should be so little mentioned and so little called by name in view of its commonness in painting. A faint possibility exists that we are wrong in supposing all the bright, pale, crusty, bluish greens in medieval manuscript and panel paintings to be malachite; but malachite matches the colour and character of these greens so closely that we naturally believe in the identification and prefer to explain away the rarity of references to the pigment in the colour-makers' textbooks.

As far as it is called by name at all, it passes as "blue green," "mountain green," rarely as "gold solder," *chrysocolla* (not the geologists' chrysocolla, which is a silicate of copper, and of no use as a pigment, but another gold solder; for malachite was used for soldering gold in antiquity as well as in the Middle Ages), and once, if we interpret the phrase correctly, as "blue turned green," *azurinum conversum in viridem colorem*. (This may, however, denote a copper-ammonia blue which has turned green through the loss of ammonia.) There is frequent mention in medieval documents of a colour known as *viride terrestre*, which we naturally suppose to be the colour known to us as "terre verte"; but there is some reason to believe that *viride terrestre*, "earth green," is not the same as terre verte, "green earth," and that medieval references to it may at least sometimes signify malachite and not terre verte. If so, the rarity of allusions to this pigment would be far less, and we should be entirely comfortable in believing in its identity as we see it in medieval paintings.

The Green Earths

There is no physical resemblance between malachite and the green earths which we call terre verte. Malachite is pale, bright, opaque, and crystalline. Green earth is rather dull, transparent, and soapy in texture, like a clay. The colour of green earths is not constant. It ranges from a light, bluish grey with a greenish cast to a dark, brownish olive. The name terre verte is applied to several different minerals, but the sort which seems to have been most important in medieval painting is the light, cold green of celadonite, found chiefly in small deposits in rock in the neighbour-

hood of Verona in Northern Italy. The chief deposits of glauconite, which yields the yellowish and olive sorts, are found in Czechoslovakia. No effort has so far been made to distinguish the characters and sources of terre vertes in medieval paintings; and if these distinctions could be made successfully, they might have a good deal to tell us.

These green earths were not strong colours; they would not do for painting naturalistic landscape effects. Indeed, they were not much used for landscape except in wall painting, where their relatively dull tones were in order. In manuscripts and on panels, and walls as well, the chief service of the green earths was to underpaint the warm flesh tones. The green colour often seen in the flesh painting of medieval works is more than likely to be one of these green earths. It is perhaps not always so. I have seen manuscripts in which I felt quite sure that it was not, and we must perhaps look farther for an explanation of the very strong, dark-green underpaintings affected by Matteo di Giovanni, or the soft, yellowish underpaintings of some of his Florentine contemporaries. In the fifteenth century generally liberties seem to have been taken with the traditional green preparation for flesh: a little ochre was mixed with it, or a little black, or a stronger green, or a mixture of black and ochre was substituted, and so on. But in general, especially in works before the fifteenth century, it was quite usual to underpaint flesh with green earths mixed with white only.

Verdigris

One manufactured green, verdigris, was known to the ancients and was used to an enormous extent in medieval

times. Verdigris is an acetate of copper, usually made by treating copper in some form with vinegar from one of many sources. There are a good many possible acetates of copper, which differ from one another in colour and in solubility and in their general behaviour; and we know extraordinarily little that is specific about the medieval forms of verdigris.

We know that a great deal of verdigris was made in the Middle Ages by hanging plates of copper over hot vinegar in a sealed pot until a crust of green formed on the copper. We know that some was made by burying copper sheets in fermenting marc; some by grinding copper filings with vinegar; some by grinding copper oxide with vinegar, and so on. We do not know what effect other metals alloyed with the copper may have had. If there was lead in the copper, some white lead may have been produced along with the verdigris. If instead of nominally pure copper bronze or brass was used, as it often was, no doubt the product was somewhat different. If the verdigris was made with marc, it is more than likely that the colour contained not only acetates but also tartrates of copper. If it was made with apple vinegar, as it often was in England, other organic salts, such as malates, may have been present. There is a modern copper salt that we call verdigris; but we are not justified in supposing that medieval verdigris was exactly the same thing.

On the contrary, indeed, we are compelled to recognize that several somewhat different sorts of material passed for verdigris in medieval times. We find in recipes indications that the verdigris was sometimes quite insoluble in water, and that it was sometimes readily soluble. Sometimes in manuscripts it has spread into the parchment and stained

it; sometimes it has corroded the parchment, eaten into it, so that the painted parts actually drop out and leave gaps in the page; and sometimes it has behaved quite quietly, and stayed in place, and kept its transparent blue-green colour without any of these distressing accompaniments.

Effects of Age

Verdigris, as Cennino says, is "very lovely to the eye, but it does not last." That is to say, it does not last except under favourable conditions. It is suceptible to the action of prolonged moisture, it is readily blackened by alkalis (often used in cleaning pictures), it reacts unfavourably with some other pigments, and it may be darkened by gases in the atmosphere. There is a great deal of darkened verdigris in medieval and Renaissance painting, and it mis-leads art historians daily.

Verdigris was a particularly favoured pigment in the early days of oil painting in Italy, and was used lavishly in land-scape in the second half of the fifteenth century. The little river landscapes so characteristic of the school of Domenico Veneziano, of Piero's work, and Baldovinetti's must origin-ally have been predominantly of a vivid green. For one reason or another, the verdigris with which they were painted has turned to a dark mahogany brown, and the original intention is entirely falsified. Oil glazes of verdigris are extremely rich and "lovely to the eye," and all the fifteenth-century Italian oil painters revelled in them. But their beauty was fugitive. The Italians lacked the skill which the Flemings seem to have possessed of locking the pigment safely in some preserving vehicle. The rich brown tone which these landscapes now exhibit is entirely foreign to

their original verdant beauty. In the Piero "Adoratio" in the National Gallery there are greys and blues glazed with what now appears dark brown, attractive enough in their present condition, but inconceivable as a deliberate treatment of landscape in Piero's time. These brown stains were originally green, far lighter than they are now, far cooler, more distant, more ethereal in effect.

In panel paintings in tempera, verdigris seems sometimes to have survived; but there too it has often darkened to the great detriment of the work. A conspicuous and common example is to be seen in the painting of veined marbles, which are so common an adornment of fourteenth- and fifteenth-century Italian panels. In these (in Fra Angelico's, for example), streaks and smears of dark brown often run over pale blues, greys, and pinks. These unpleasant brown stains were originally bright green, and while modern taste would probably not be much gratified if it were possible to restore the original effect, the present state is not agreeable to us, and would have been outrageous to the painter's senses.

The accidents of time affect no other pigment so generally or so disastrously as verdigris, and the sympathetic student of medieval paintings should be ready at any moment to translate in his eye the brownest colour into the most glacial or grassy green. The National Gallery is full of good subjects for practice in this sort of translation. The Pollaiuolo "Apollo and Daphne," for example, would not be too difficult; whereas the little "Hercules" panels in the Uffizi would be a post-graduate problem in translating. The Middle Ages abhorred nondescript browns; they did not portray mournfully the dreariest days of autumn, as some panels

might lead us to suppose; but the very ardour with which they pursued bright colour betrayed them in their greens. This verdigris which they loved for its vivid colour endowed their works, *ex post facto*, with the very colour that they loved the least. When we see browns in medieval paintings we must always wonder whether they may not originally have been greens.

There is reason to believe that the changes in verdigris from green to brown have taken place rather slowly. We sometimes find seventeenth- or eighteenth-century copies of Renaissance paintings in which portions which are now brown in the originals appear as green, showing that the green of the verdigris survived for two or three hundred years.

Verdigris in Books

Verdigris was enormously used by scribes and illuminators of books, and in books it has generally suffered far less than in panel paintings. Whole pages were sometimes stained with it. Initial letters were often written with it, alternating with vermilion letters, or letters of vermilion and azure. All sorts of special temperas were devised for it. The normal method was to dissolve it in wine, and let the solution thicken until the colour was strong enough. Sometimes vinegar was used; but this was not generally approved. In fourteenth-century England there was a passing vogue for tempering verdigris with the juice of rotten apples. Sometimes, especially in the fifteenth century, the milky juice of a *Euphorbia*, a spurge, *latte di totomagho*, was used, probably to make the soluble green a little waterproof. Quite generally in the late Middle Ages coloured vegetable juices

were used to temper the verdigris, especially the juices of the herbs parsley and rue. To make the colour richer, sap green was sometimes mixed with it. In all periods, to make it warmer, less sea-green and more grass-green, saffron was blended with it. The saffron has generally faded out, or been lost in the darkening of the verdigris itself; but the effect can occasionally be seen in an exceptionally well-preserved manuscript.

Salt Green and Rouen Green

Two variations on the theme of verdigris ·were fairly popular in the Middle Ages, one early, called salt green, the other used from the twelfth century on, called Rouen green. (Verdigris is, of course, *Greek* green, *viride de Grecia*, *vert de Grèce*, ver-di-gris. It was sometimes called Spanish green in medieval Latin, as it is in modern German, *Grün-span*, which used to be *Span-grün* or *Spon-grien*.) Salt green was made like verdigris, but the plates of copper were coated with honey and salt, and some copper chloride may have been formed along with the acetates. The use of honey with verdigris was fairly usual, probably to keep it slightly moist after its application; for verdigris loses something of its richness if it becomes too dry. An excess of honey is to be suspected as contributing to the tendency of some verdigris to spread in the parchment of manuscripts. Rouen green, *viride rotomagense*, won quite a reputation in France and England in the fourteenth century, though it was known before and after. It was made by coating the copper with soap before it was exposed to the action of the vinegar; and the result was presumably a mixture of verdigris with some copper salts of the fatty acids from which the soap

was made, and some glycerine. These and many other medieval painting materials have still to be more fully investigated synthetically before their importance can be estimated.

Incompatibilities

One great difficulty with using verdigris was its incompatibility with white lead and with orpiment. White lead was so nearly indispensable to the medieval book or panel painter that he could not comfortably rely upon pigments which could not be mixed with it. Verdigris and orpiment were incompatible with each other and with white lead; so it was very desirable for the painter to have substitute greens and yellows, to avoid the inconvenience of having to replace his white lead with bone white or some such inert substitute. Alternatives to verdigris and orpiment begin to make their appearance a little before the fourteenth century, and during the fourteenth century they develop rapidly. By the fifteenth century there was no reason for painters, at least painters of manuscripts, to use either of these incompatible colours unless they chose to. Indeed, if panel painters had used the manuscript painters' greens in the fifteenth century, the unhappy fate of many landscapes might have been quite different.

Sap Green

The most important of the substitutes for verdigris were sap green and iris green. Sap green is made from the juice of the berries of buckthorn, *Rhamnus*, gathered when they are quite ripe. There are many varieties of *Rhamnus* from which greens can be prepared; but it is evident, from

experiments which have been made in the laboratory of the Courtauld Institute, that some varieties yield inferior colours. We must not suppose that the medieval colour-maker possessed any special knowledge of botany which enabled him to pick out the right kinds of buckthorn; but only that where the good kinds flourished and the art of making this green was known, sap green of good quality was probably made.

To prepare the green, the juice of the ripe buckthorn berries was squeezed out, mixed with a little alum, and allowed to thicken by evaporation. The result was a gummy green colour, generally rather olive, transparent, and rich. The juice of buckthorn berries was used quite early, without any preparation, to temper and enrich verdigris; and probably its use as an independent pigment came about as a development of its accessory function. Used by itself, without alum, the juice is somewhat yellow or green, according to the ripeness of the berries, but its colour is very fugitive. Cennino suggests putting a little of it into a mixed green, a few drops of the "verjuice," as he calls it; but he warns us that the effect cannot be expected to last. The colour made with alum is more durable, though not permanent in the strict modern sense. Some colour of this sort has lasted well in many manuscripts, and is still green and beautiful.

Sap green is somewhat different from any of the other colours that we have considered so far in that it was not dried and mixed with a binding medium. No binder, indeed, was absolutely necessary; for the thickened juice was by nature somewhat sticky. But the addition of a little gum was generally regarded as an improvement. Instead of being

dried and powdered, as other pigments were, sap green was simply allowed to thicken to a dense syrup or a semi-solid mass. In Italy it was called *verde di vescica*, "bladder green," and in France, *verte de vessie*, because it used to be kept in the thick, syrupy condition in bladders, much as oil paints were a hundred years ago. Sap green is still used as a water colour, made for modern painters very much as it used to be made for medieval illuminators.

Iris Green

The chief rival of sap green in late medieval manuscript painting was the iris green. This was made from the juice of iris flowers, sometimes mixed with alum and thickened, like sap green, but more often prepared as a clothlet. Bits of cloth were dipped in alum solution and dried, and then dipped into the juice of iris flowers and dried, again and again, until they contained a sufficient quantity of the colour. The dark-blue flowers of *Iris germanica* or *I. florentina* do not appear to be a likely source of a green colour, and when the juice is first squeezed out its purplish colour is not promising; but as soon as it is combined with alum, a clear and beautiful green is formed. This iris green was very much used in the fourteenth and fifteenth centuries. No method has as yet been worked out for distinguishing between sap green and iris green in medieval manuscript paintings, and we cannot estimate their relative importance in the works of different schools; but it is possible that iris green may have been introduced into illuminators' practice even earlier than sap green, and that it may have been even more generally employed.

Other Colours from Iris

In addition to the many recipes for making greens from iris, there are certain fourteenth- and fifteenth-century rules for making iris blues. The secret, according to a manuscript in Florence, is to take out "the yellow things in the flowers," that is, the yellow pollen. In a fifteenth-century manuscript in Oxford there is a rule for making a yellow colour, "for touching in letters," out of the *granelli* of white lilies. (Whether these "white lilies" were *Lilium*, or *Iris* called lilies, as they generally were, we cannot be sure. In either case the material seems to have been pollen.) This pollen yellow is rarely mentioned, and was probably never important; but it does suggest that anyone who made a green colour from the whole iris, and a yellow from the pollen, might have thought that he could make a blue by leaving the yellow out. Some way of making an iris blue may actually have been known; but it was not generally practised.

Honeysuckle and Nightshade Greens

Besides the greens from buckthorn and iris, many other vegetable greens were known in the fourteenth century, and some of them probably before. Some are recorded seldom, as, for example, a green made from "the flowers of the plant called *aquileia*," which we may suppose was *Aquilegia*, our columbine. Two, however, seem to have been important enough to warrant our passing attention, one made from the berries of honeysuckle, the other made from leaves, especially those of nightshade. The honeysuckle green seems to have been an Arabic tradition; for it is sometimes described as "Saracenic," and in the recipes honeysuckle is

almost always given an Arabic name, distorted in one way or another, and glossed in Latin, as *caprifolium*, and rarely in English, as "goat tree." Processes for making greens from the leaves of *Solanum*, nightshade, go back certainly to the thirteenth century, and possibly to earlier times. Elder and mulberry leaves also yielded greens. Probably in all these chlorophyll, the natural green colouring-matter of leaves and grasses, was the chief pigmentary constituent of the product.

Mixed Greens

Finally, some attention must be paid to greens made by mixture. Cennino mentions that terre verte mixed with white gives a sage green, and that if it is to be made lighter and still kept properly green, it must be lightened with yellow and not with white. Mixtures of blue with yellow provided, of course, a still greater range of value and variety of tone. Any yellow and blue would combine to make some green, and no doubt every sort of mixture was made by medieval painters at one time or another. Mixtures of indigo with orpiment, however, were so much admired that a compound of this sort took on almost the character of an independent pigment. (This mixture was naturally subject to the limitations of the orpiment which it contained with respect to use with white lead.) Cennino recommends a mixture of orpiment with ultramarine, and this would of course be somewhat more intense than a green made with indigo.

We have already noted the regular practice of improving verdigris with saffron. Saffron was mixed also with blues to produce certain beautiful qualities of green; but the

yellow was not reliably permanent, and has not infrequently faded out, as we can tell sometimes by accident or by careful examination, leaving the blue alone. (The phenomenon of blue left by the fading of the yellow element of a mixed green is not unusual in manuscripts, but is most familiar in tapestries.) Sometimes saffron was glazed over blue to produce green, instead of being mixed with the blue in advance. Sometimes in books of blue and now colourless, binding medium remain to show where areas of green and yellow once adjoined, before the yellow faded.

We are justified in believing that mixed greens were common in medieval painting; but we could easily allow ourselves to overstress their importance. In general, medieval painters did not much like to sink the individuality of their hard-gotten colours in complicated mixtures. Mixtures of more than two or three pigments were not popular, and there was a decided preference for achieving effects with single pigments, displaying their characters to the best advantage.

YELLOW COLOURS

Incomparably the most important yellow in medieval painting is the metal gold. Yellow pigments, however, played a significant part in the pageant of medieval technique. One of the most important services required of them was to imitate the appearance of gold. Another of their chief functions was to modify the qualities of greens and, to a less extent, of reds. Of all their uses, perhaps the least important was to represent yellow things.

Medieval Use of Yellow

Yellows in painting present certain difficulties of design which the Middle Ages often avoided by substituting gold for yellow paint. Nothing more easily disturbs the balance of a decorative painting than obvious, conspicuous areas of strong yellow; and yellows tend to be obvious and conspicuous. The abuse of yellow is most easily recognized in stained glass, which becomes tawdry and hot, and loses all its quality of architectural fitness, in the late days when yellow stains take the place of the cooler tones of the best medieval examples. Pinpoints of yellow in stained glass look golden when they are set in areas of deep blue and red and purple and green; but sheets of yellow and white, such as we see in decadent glass painting, have little beauty in themselves and add none either to the wall-opening that they fill or to the interiors that they illuminate. So in other kinds of painting the Middle Ages were wary of the use of bright yellows. They admired the golden, but abhorred the bilious. A greater freedom in the use of yellows marks the approach of the Renaissance; and this is reflected in the palette by the introduction of many new forms of yellow pigment in the course of the fourteenth and fifteenth centuries.

Yellow Ochres

For panels and walls the traditional yellow earths, the ochres, were yellow enough to be widely serviceable. Yellow ochre, like the red ochres which we have already mentioned, was far from a standard product in the Middle Ages. There are ochres which are quite opaque; and these were the most valued in medieval painting. There are others more

transparent, like the yellow earth found near Siena, which takes its name from that city, "raw sienna." Some yellow ochres are pale, bright, buff; others are dark, brownish, or olive. Some have a pinkish cast, others a greenish. It was probably largely a matter of chance, of geographical accident, what ochres any particular medieval painter had. We have no evidence that there was any organized trade in these earth colours in the Middle Ages; but there may, of course, have been some small traffic among painters themselves in choice qualities of these valuable though inexpensive colours. Deposits of limonite, the normal yellow ochre, are found in many parts of Europe, with local, characteristic variations. They are too common, too simple, too well understood for the Middle Ages to have left us any account of the processes of levigation by which they were prepared for artists' use.

For the comparatively large areas of wall painting, yellow ochres produced a colour quite strong enough for any yellows in decoration which the Middle Ages contemplated, short of gilding. Even on panels the yellow ochres found wide employment, and served, if not so completely as on walls, still very largely to supply the painters' requirements for yellow pigment. For book painting on the small scale favoured in the late Middle Ages, it was almost useless. Ochres are the diapasons of yellow, and the miniature painter wanted flutes and harps.

Orpiment

Originally the painter of books turned naturally for his bright yellow to the classic orpiment, *auripigmentum*, the colour of gold. Orpiment is a sulphide of arsenic (the name

of arsenic comes from the Greek word for orpiment, ἀρσενικόν), found in nature as a stone. It was imported into Europe in the Middle Ages chiefly from Asia Minor. Its resemblance to gold was a constant tantalization to the ancients and to medieval alchemists. Pliny reports that a prince named Caius had an enormous quantity of it cooked up, to extract the gold. Pliny says that he did indeed get some excellent gold, but much too light in weight. Painters, more practical than the scientists, used orpiment for its resemblance to gold, and did not concern themselves with futile efforts to extract the precious metal from it. Orpiment was a regular ingredient in most of the many compound colours elaborated in the Middle Ages for painting, and especially for writing, in imitation of gold. Its colour is a light, vivid yellow, sometimes pure yellow, but more often slightly inclined toward orange. In its natural state it has a mica-like sparkle which recalls the lustre of metallic gold.

Realgar

Orpiment has a first cousin, realgar, also a sulphide of arsenic, which is as beautiful an orange as orpiment is a yellow, an orange-scarlet. It does not seem to be at all common in medieval paintings, and references to it in medieval writings about technique are largely confined to its use as a preservative of glair. It was certainly used sometimes as a pigment; Cennino mentions it, though not very enthusiastically. But it is not often that one finds it in book paintings, and I cannot recall that I have ever been sure of finding it on a panel.

Incompatibilities of Orpiment

Orpiment was not good company for other colours. One of the chief uses of yellow was forbidden it: it could not be used to modify the tone of greens containing verdigris because the sulphur of the orpiment attacked the copper of the verdigris. It could not be mixed with white lead, for a similar reason. Furthermore, it seems sometimes to have had a corrosive action on its binding media, and has quite often decayed and come away from panels and parchment. The *De Arte Illuminandi* says, "It is not good to use orpiment on parchment." Cornelius Jansen, in the seventeenth century, summed up the character of orpiment bluntly: "Orpiment will ly faire on any culler, except verdigres, but no culler can ly faire on him, he kills them all." To use it successfully and safely required knowledge and experience and submission to certain annoying technical restrictions; and the late Middle Ages turned gladly to substitutes, though the use of orpiment was not wholly abandoned by painters until about the end of the nineteenth century.

Bile Yellows

We have evidence of the search for substitutes in a rule for making "a colour similar to orpiment" in a most striking way. This orpiment substitute is sometimes called the "Lombard gold colour." Recipes for making it are fairly numerous, and follow the following pattern:

Take the gall of a large fish and break it on a marble stone, and add a little chalk or calcined nitre and a little good vinegar, and grind it on the marble to the consistency of rubric. Write whatever you please with this on parchment, and let it dry. And the Greeks used to make their gilded letters in this way.

Using bile for the sake of its gold colour seems to be a Greek tradition. Even the tortoise yielded up his bile to produce a golden colour for gold writing, chrysography, described in a third-century papyrus from Hellenistic Thebes now in Leyden, and in a similar recipe found in the eighth-century *Compositiones* manuscript in Lucca. The recurrence of this recipe, buried in Thebes in the third century, five centuries later on the continent of Europe, suggests that chrysography with tortoise bile must have been practised or at least reported frequently in the intervening period. Even gallstones were sometimes used as a source of yellow colour in the Middle Ages. Probably the most significant substitutes for orpiment, however, were the vegetable yellows from buckthorn and weld, which will be discussed later.

Giallorino—Massicot

Besides the chief mineral colours, the ochres, orpiment, and realgar, there was one other yellow used in the Middle Ages, particularly in Italy, which may have been of mineral origin, a colour known as *giallulinum*, the "little yellow," a diminutive of *giallus* meaning "yellow." Some fourteenth-century texts tell us that a certain Mount Gilboa is green on one side and yellow on the other; but this yellowness seems to have been attributed to orpiment. Cennino says that this *giallulinum*, his "giallorino," is half natural and half artificial, that it is found in nature as a stone in the places where there have been "those great burnings of the mountains." This seems to mean that it is a volcanic product; and there is a legend that a bright yellow mineral used to be found in Naples, a product of Vesuvius, which gave its name to Naples yellow. There is some confusion about it,

however, for a potter's colour, a yellow glaze, compounded from lead and antimony, was sometimes known as *giallulinum*. This was apparently used also by painters at some epochs, and it has been suggested that it was an artificial imitation of the extinct volcanic stone once found at Naples.

Probably most of the references to giallorino in medieval writings mean massicot, a yellow oxide of lead, prepared in the Middle Ages by gentle roasting of orange lead as an intermediate product in the preparation of white lead. This colour, a pale, fairly intense yellow, was known in classical antiquity and in the Middle Ages, and was certainly too attractive to have been overlooked by painters. There is good reason to believe that the pigment known as *giallulinum* was sometimes, if not always, yellow lead, massicot. In English Renaissance translations from Latin and Italian, "massicot" (or "masticot") is the word used where *giallulinum* is found in the originals. In German tracts on technique, *Plygäl* (that is, *Blei-gelb*, lead yellow) is often mentioned. One of the chief uses of giallorino was to make greens lighter without making them "sagey."

Substitutes for Gold

The medieval preoccupation with gold necessarily brought with it a long train of imitations of gold, and devices for capturing some sort of gilded effect, without the use of gold itself. The "Lombard gold colour" described above, as well as the orpiment which it was designed to replace, illustrate one phase of the medieval search for golden effects. We have seen that white metals, tin and silver, were lacquered yellow to look like gold. There were countless other materials which looked still less like gold, but which the Middle Ages

were content to accept as substitutes of a sort for gilding. We must suppose that medieval eyes were very easily deceived, for most of these substitutes are very weakly like real gold. If they were yellow and shiny, and particularly if they had any sort of metallic sparkle, they were acceptable.

Mosaic Gold

One of the most esteemed imitations of gold was a yellow sulphide of tin, made by a difficult and elaborate process, and to modern eyes not a very convincing alternative to the ruddy metal. This colour was called *aurum musicum*, but why, nobody knows. We have a name for it in English (for the colour is not extinct, even now), "mosaic gold." This, like the *oro musaico* or *musivo* of Italian, and the *or mussif* of French, is of course descended from the Latin name. Why it should be called "mosaic" is a complete mystery.

Recipes for mosaic gold are common in texts from all parts of Europe after the fourteenth century. The Portuguese *Livro de como se fazen as côres* tells how to make this "gold with which you may illuminate, or paint, or make capitals, or write." It calls it *oro de musico*, a variation of the name not so far found elsewhere. In the fourteenth century a new name began to be applied to mosaic gold: *color purpurinus*, and from that came the name that Cennino uses, *porporina*. This comes, perhaps, from some association of the ideas of purple and gold. A *color purpurinus* may have been thought of as resembling the sort of colour used for gold writing in a *codex purpureus*. And if this is so, the idea of these magnificent volumes from the earlier Middle Ages must have been impressive in the fourteenth and fifteenth centuries to cause the word "mosaic" to give way to the word "purpurine."

A whole section of a great compendium in Bologna, written in the fifteenth century, and published in London by Mrs. Merrifield ninety years ago, is devoted to "making purpurine and golden colours, as well as sizes and mordants for laying gold."

We do not know when mosaic gold was invented, but it was perhaps not known in Europe before the thirteenth century. It was well known in the fourteenth century, and has been made commercially ever since. It is a sulphide of tin, made by mixing tin with sulphur under special conditions. These conditions include the presence of sal ammoniac and mercury, and long and carefully regulated heating. Ordinarily the tin was made into an amalgam with mercury, and ground to powder. This powder was then ground and mixed with sal ammoniac and sulphur, to produce a black compound consisting probably chiefly of sulphides of tin and mercury. This mixture was then heated for many hours, in stages, slowly at first, then faster and faster, increasing the strength of the fire until at the end of nine hours, or however long it took, little sparkles of "gold" could be seen on the end of a stick plunged into the vessel.

Mosaic gold made in this way looks a little like a bronze powder. Fourteenth- and fifteenth-century texts are full of rules for making it. Valentin Boltz, in the sixteenth century, devotes five separate chapters of his *Illuminirbuch* to mosaic gold. It seems, by all the evidence of the documents, to have been one of the great stand-bys of medieval painting, especially of manuscript painting. But I must confess that I have only once in my life been quite sure that I was looking at it in a medieval work. MS. Palatina 951, in the Biblioteca Nazionale in Florence, has some capitals written with mosaic

gold, and on folio 125v it contains a rule for making the colour. That is the only medieval example that I can give at the present time of the use of this material. This may be the fault of my observation; it may be the fault of some change in the colour with time. I can only say that I was much relieved to see mosaic gold used in this manuscript in Florence, and to be sure, from that, that mosaic gold was a colour which was actually used in medieval works. It is only fair to add that mosaic gold is so little golden that it might easily be mistaken, in a casual inspection, for orpiment, or even for an ochre. When one knows it, however, he can recognize it surely in this manuscript in Florence, and no doubt also in other medieval works.

Cennino was a practical man, and not given to reporting mere superstitions; and he tells how to make mosaic gold, as if it were a thing worth knowing in his time and not too generally understood. He speaks of it as primarily a manuscript painter's colour, but of some use in panel painting. He warns against a danger of using it in connection with real gold: it may contain a little free mercury, and mercury will ruin the effect of any real gold-leaf gilding. If you had a gold ground, says Cennino, which reached from here to Rome, and as much mercury as a grain of millet seed got on it, it would be enough to spoil the whole thing. We need not weigh the quantitative accuracy of his statement: it is certainly true that a very small amount of mercury is enough to spoil a very large amount of gilding. Cennino goes on (as if he had used enough mosaic gold to be aware not only of the danger but also of the remedy) to say that if a bit of mercury does by misfortune get on your gilding, the best thing to do is to make a scratch around it with a

needle. This little ditch in the gold leaf is too much for the mercury to jump, and the rest of the gold ground will be safe.

Other Imitations of Gold—Celandine—Aloes

Other imitations of gold were even more mercurial. One favourite type (which has not so far been identified in any actual medieval work) was a mixture of egg yolk and mercury, stained strongly yellow. Whipping up mercury in egg yolk produced a sort of metallic, silvery colour, which could be mixed with a little water and used for writing; and if saffron or bile or the juice of the greater celandine, *Chelidonium maius* (which every country dweller knows is strongly golden yellow), was mixed with it, it gave a fair golden effect. This mixture was far from permanent, and we can probably not hope to recognize the results now as ever having looked like gold.

Powdered tin was much used in books in imitation of silver, and possessed the advantage of not tarnishing as silver did. Both powdered tin and powdered silver were sometimes used to imitate gold, either by mixing the white metal with some golden colour such as saffron, or by glazing some golden colour over it. On a larger scale, and in oil or varnish media, a favourite source of the golden colour in glazes of this sort was aloes, caballine, and hepatic. Aloes often entered into the composition of the golden lacquers applied to tin and silver leaf.

Saffron

The indispensable element in compounds for imitating gold was saffron. Saffron is strictly the name given to the

dried stigmas of the autumn-flowering *Crocus sativus*; but probably other kinds of crocus yielded yellows to the medieval painter under this name. Three sorts are mentioned in fifteenth-century Sloane MS. 1698: field, garden, and Oriental. The "Oriental" is presumably the Cilician, which was most favoured in antiquity. Master Peter of St. Omer in Northern France, in the fourteenth century, says:

Not all saffron is to be accepted for painting or writing; for you are not unaware that that which grows in this part of Gaul which is our home, as well as in the rest of France, is not good; and though it does show some similarity with the good kind, nevertheless it really has not exactly the colour or odour or flavour of it. For there is a certain plant similar to the white one in its leaves and roots, the flowers of which we call crocus, but the laity call it saffron. When you observe that these flowers have a certain brightness on one side at the top, you may know that it is not good. When you wet two fingers with saliva and rub the flower between them a little bit and you get your fingers yellow from it immediately, you may know that it comes from Italy or Spain, and it is good. In Sicily, as a certain Ysidius says [*Isidore of Seville, who says Cilicia, not Sicily*], there is a better kind called Corycian. A great deal of the best saffron comes from there, more fragrant in aroma and in colour more beautiful than gold.

A fourteenth-century manuscript in Montpellier has a chapter on the "Nature and Estimation and Tempering of Crocus":

It is imported from Spain, but there are two qualities, the garden and the Oriental; garden, because it occurs in gardens without cultivation; Oriental, because it occurs in Eastern lands, but it does not occur without cultivation. It is the nature of this latter when it bears flowers to bear three or four florets in the centre of the flowers [*the stigmas*]. Those which are uniformly red or orange may be chosen; those with any yellowness about them are to be rejected.

Preparation and Use

Saffron is an important element in Latin cookery,

esteemed both for its colour and for its flavour. Its colour is truly golden yellow, as a tincture, somewhat reddish (like the dried stigmas themselves) when concentrated, but pure yellow, with no hint of green about it, in ordinary dilutions. For use in illuminating, the painter had only to put a pinch of dry saffron into a little dish, cover it with glair, and allow it to infuse. The resulting extract or tincture was perfectly transparent, and strongly yellow. Prepared in this way it was used to some extent for writing, and a good deal for painting and glazing over other colours. Saffron was used to enrich greens all through the Middle Ages; and in the fourteenth and fifteenth centuries it was often added also to vermilion, especially in Germany. Greens for books were compounded with saffron and azures, as well as with verdigris and saffron. The glassy yellow of saffron alone was sometimes used for ornamental pen flourishings around coloured initials, for gold-like frameworks of illuminated panels in books, and for golden glazes and touches in lines of writing in red and black. It was primarily a manuscript colour, and in medieval books, though it has sometimes faded, it has often remained much as it must originally have looked. It was not much used in tempera on panels, and not at all on walls, because of its fugitive character.

Other Organic Yellows

Manuscript painters had two other sources of bright yellow colours which like saffron were largely excluded from the palettes of other painters because of their lack of durability: buckthorn and weld. Weld pigments were used to some extent by panel painters; but the buckthorn yellows were probably reserved almost exclusively for books.

Rhamnus Yellows—Extracts and Lakes

The berries of *Rhamnus*, buckthorn, gathered when they are ripe yield the colour known as sap green. Gathered before they are ripe, early in the summer, they will give a yellow colour. The compound of unripe buckthorn berry juice with alum (corresponding to sap green) was not apparently much used; but Valentin Boltz records it as known in sixteenth-century Alsace as *Beergäl* (*Beer-gelb*), "berry yellow." The fourteenth-century method, attested by several sources, was to use the verjuice alone in its natural state to enrich mixed greens. In the course of that century, however, in Italy, yellow lakes began to be made from the unripe berries, and these lakes were very popular indeed in the fifteenth century under the name of *giallo santo*, "holy yellow." Their popularity continued to increase in later centuries, and in spite of their lack of permanence the so-called *stils de grain* enjoyed a tremendous vogue in eighteenth-century France and England. Rhamnus berries are still sold, dried, under the name of *graines d'Avignon*, or Persian berries.

Weld Lakes—Arzica

Yellow lakes made from weld were possibly a slightly earlier development than those from Rhamnus; but they seem first to have become significant in the fourteenth century. Weld is a *Reseda, R. luteola*, a tall-growing relative of the garden mignonette. It used to be called "dyer's herb" or "fuller's herb." It has a very long history as a yellow dye, a history, indeed, which is even now not over; for welds, as the crop is called in trade, are still grown to a small extent commercially in Normandy and used in dyeing

silk. No synthetic dye has as yet quite taken the place of weld as a means of producing certain yellows in silk dyeing. The whole plant, flowers, stems, and all, is dried and sold in bundles, and for dyeing or colour-making it is broken up and stewed in water or a weak solution of alum.

Medieval colour-makers seem to have considered weld lakes most beautiful when they were somewhat opaque, and for transparent yellow lakes to have preferred the buckthorn products. Weld lakes were often precipitated out of the decoction of the plant in alum solution by the addition of chalk, which gave a mixture of an alumina lake with calcium sulphate, only partially transparent. Sometimes weld lakes were precipitated on a base of egg-shells, sometimes on white lead. When white lead was used, the colour was a pure, light yellow, as brilliant as orpiment. The weld lakes were sometimes called in Italian *arzica* (which Cennino mentions as primarily an illuminator's colour). The word *arzica* is probably a corruption of the old word for orpiment, *arsenicon*; and it seems quite certain that these colours were specifically thought of as substitutes for orpiment free from its chemical and physiological disabilities.

Fustic and Others

This is by no means the full register of yellow colouring-matters used in the Middle Ages. No mention has been made of fustic, the wood of the *Rhus cotinus*, which in fifteenth-century Italy at least had some importance in yellow lake-making as well as dyeing. Lily pollen and the bark of walnut-trees have been mentioned incidentally above. An apple-tree-bark yellow was known in fifteenth-

century Germany, and there are still other minor yellows which need not be dealt with here. The great medieval yellows, apart from gold, are orpiment and ochre, giallorino (probably usually massicot), mosaic gold, saffron, buckthorn, and weld.

METALS

ALL the tastes and purposes that medieval painting served made the use of metals an integral part of its technique. Of all metals, gold was the most significant, not only for its associations, its power to suggest richness and splendour and homage and sacrifice; not only for its colour, valuably yellow; not only for its lustre, the gleaming or sparkling reflections that it could be made to produce; not only for its permanence, its disinclination to tarnish, darken, or become dull; not only for its adaptability, the convenience with which large or small areas could be invested with metal through its use: not for any of these causes alone, but for all of them together, the medieval painter and his patrons joined in an enthusiasm for this precious metal which resulted in some of the most charming effects, wrought by some of the most ingenious devices, in the painting of the Middle Ages.

Tin was used, as white metal, sometimes glazed green for variety with verdigris, or red with lakes, or lacquered yellow as a substitute for gold. Silver, too, was esteemed for many purposes, especially for rendering armour in paintings of battle scenes and pageants; but it has generally tarnished so completely that we often do not realize that it was originally a white metal. (Cennino's warning against its tendency to tarnish shows that even in medieval times that defect had declared itself.) The use of silver followed almost invariably the methods developed for the use of gold; and

we need not distinguish these metals in our summary review, but discuss the medieval painter's employment of metals in terms of pure gold alone. Not pure gold, either; for though the Middle Ages knew a great deal about refining gold, and were able to produce the metal substantially free from all impurities, and did do so for certain purposes, the gold in ordinary use for craftsmen's ends was not of that quality. Medieval painters, or their furnishers, the gold-beaters, seem generally to have taken their gold from the commonest, most convenient source, the coinage current in their time; and though this practice has long been forbidden by law their successors to-day still reckon in terms of the weight of the long-obsolete ducat. The quality of gold coinage varies (as we know very well) according to the time and the condition of the State which issues it; and it is quite possible that we may some day be able to classify the constitutions of golds used in painting and compare them with the constitutions of medieval gold coins. Some useful conclusions might follow from a comparison of this sort, if it were based on a sufficient body of evidence.

Gold in Powder

The most obvious way to use gold in painting is, of course, to reduce it to a powder comparable with the powders of other pigments used in painting, to mix it with some binding medium, and put it where it is wanted. But there is a difficulty in doing this, a difficulty which springs from the character of gold itself. Pure gold, or nearly pure gold, is almost as hard to powder as wax would be, and for very much the same reason: the little particles, as they are formed, tend to weld themselves together under the influ-

ence of the pressure used in grinding them. A coarse powder of gold can be made by sawing or filing; but if this coarse powder is put into a mortar and ground, it tends to stick together and become coarser instead of finer. If the particles of gold can be kept separate in some way, if each can be surrounded with some material which will keep it from sticking to its neighbour, the grinding can be done successfully; and this method was sometimes practised. The coarse powder of gold filings was sometimes mixed with honey or salt and ground fine. Then the honey or salt could be washed away with water, and the powdered gold left behind.

There are many medieval recipes for tempering gold preparatory to grinding it to powder, methods which were supposed to make it harder, more brittle, so that it could be powdered without the addition of any foreign substances. The idea of tempering gold to this degree is probably a will-o'-the-wisp; but perhaps it may not be so. One common medieval prescription for the purpose is to quench hot lead in water over and over, and then to quench the gold in the same water. We may not see any reasonable grounds for supposing that this would have any great success; but experience teaches us to be very slow to conclude that these old rules are, as they often appear to be, unworkable.

Gold can, of course, be hardened, as Robert Browning points out, by the addition of a small proportion of base metal, such as copper. The alloy can then be filed and ground, and then the "spirt o' the proper fiery acid" will dissolve away the base metal, leaving the gold comparatively pure. Strong acids were not bought and sold in medieval trade as they are to-day, and this process, though it seem sometimes to have been adopted, was neither very con-

venient nor very common. A somewhat related method was, however, often used, particularly in the early Middle Ages. This method depends upon the ease with which the metal mercury can be converted into a vapour by heat. An alloy, or amalgam, of gold and mercury can be separated into gold and mercury vapour simply by heating it.

Fire Gilding

Mercury will combine with gold to form an amalgam. It will also combine with silver and copper and many other metals in a similar way. To gild a metal object, such as a bronze, or a silver chalice, the medieval workman would clean its surface and rub mercury on it. This formed a layer of amalgam on the surface of the metal to be gilded, an alloy of that metal with the mercury. The workman might then lay leaves of gold on this amalgamated layer; and the mercury in the amalgam would combine with the gold leaf to form a sort of triple alloy consisting of the mercury, the gold, and the base metal, with the gold and mercury in great excess. If the object was then heated the mercury was turned into vapour, and the triple alloy was converted into a double alloy, consisting of a little of the base metal and the remainder gold. This process could be repeated, adding more gold until the gilding was sufficiently thick. This process is called amalgam gilding, or more generally fire gilding, and it is the best method which has ever been evolved for gilding metals. It is forbidden in this country by law, because of the danger to workmen from the fumes of the mercury, so that electro-plating has now necessarily taken its place.

Amalgams

Instead of laying leaves of gold on the amalgamated surface, it was found more convenient to make up a supply of gold and mercury amalgam, and to rub that on the amalgamated metal to be gilded. If gold and mercury are ground up together, they form a waxy paste, more or less stiff according to the proportion of mercury in the mixture. If this pasty mass is put into a bit of cloth or wash-leather and squeezed the excess of mercury can be forced out of it by pressure, and the amalgam will become hard and brittle enough to be ground to powder. With care the mercury can then be driven off by heat, and a pure powder of gold left behind. This was a method of making gold powders very much used in the Middle Ages; but it seems to have been gradually abandoned as time went on in favour of the easier though more roundabout method, which involved making the gold into leaves and then making the leaves into powder by grinding them with honey or salt and then washing the honey or salt away with water.

Gold in Leaf

Gold leaf is, of course, extremely thin. When a metal is beaten or rolled out flat but fairly thick, we call it sheet metal. When it is much thinner, somewhere about the thickness of paper, we begin to call it metal foil. And when it is much thinner still, thinner than the thinnest tissue paper, approaching the thickness of a cobweb, so thin that it has no strength and as nearly as possible no weight, we call it metal leaf.

Not all metals, by any means, can be made into leaf; they turn brittle, or crumble, or flatly refuse to spread out any

farther after the stage of foil. They are not malleable, that is to say, not hammerable, beyond a certain degree. Gold is almost infinitely malleable. It can be beaten out into sheets so thin that they are quite transparent, so thin that there are literally only a very few atoms of gold between the top surface and the bottom; though of course such very thin leaf has no value in the arts. The beating of gold leaf cannot all be done at once. The gold has first to be rolled or beaten into foil, and the foil then gradually beaten out thinner and thinner. As the metal spreads it is necessary to protect it carefully, for it will stick to anything that is at all moist or greasy. The goldbeaters put a little square of the thin metal in the middle of a square of paper or parchment, and pile up other squares of paper or parchment and other squares of metal above it in order until they have quite a pile; and then they very skilfully hammer it until the little squares of metal have spread out to the edges of the parchment. They are then cut into small squares again and the process repeated. For beating the very thinnest leaf, a special kind of parchment is required, made not from skins but from internal membranes, called goldbeaters' skin.

Thickness of Medieval Gold

There is some question as to just when goldbeaters' skin was introduced, and just when goldbeaters found that they could make the very thin leaf that they can make to-day. The thinnest modern kinds were certainly not known in the Middle Ages; and there is some reason to believe that the ordinary medieval gold leaf was thicker than the ordinary modern leaf.

Cennino tells us that goldbeaters in his day used to beat

145 leaves out of a ducat. A venetian gold ducat weighed 54 troy grains, so this gold leaf weighed 0·37 grain per leaf, or thereabouts. Cennino says that this is too thin for general purposes, that they ought not to beat over 100 leaves out of a ducat, which would make the weight of a single leaf 0·54 grain (if there were no waste). An average modern commercial gold leaf weighs about 0·20 troy grain, and a double-weight gold leaf about 0·40. Presumably, therefore, Cennino's best gold was about comparable with the heaviest modern double-weight gold leaf. The difficulty with these comparisons is that we do not know the size of Cennino's leaves. Sometimes in medieval painting the gilding was done with whole leaves, and they can be measured fairly well. The leaves used by Pietro Lorenzetti in the "Madonna and Child with SS. Francis and John," in the Lower Church at Assisi, seem to have been about 8·5 cm. square, and that is a common size for gold leaf nowadays, about three and a half inches each way. In the contract for his great "Ancona" at Arezzo, Pietro Lorenzetti undertook to use "the finest gold leaf, 100 leaves to a florin." If he used the same quality at Assisi, we have one fairly definite figure for medieval leaf— a leaf 8·5 cm. square weighing about half a troy grain. But all we really know is that medieval gold leaf was on the whole somewhat heavier than the ordinary modern commercial product.

Reflecting Surfaces—Burnishing

Given these powders and leaves of gold, how were they used in medieval painting? A tremendous range of techniques was developed for getting good and varied effects from them in books, on panels, and on walls. Before

examining these techniques, however, a basic property of gold which affects its use must be considered, namely, its power of reflection. Gold, like silver, reflects a large part of any light that falls upon it. If the surface of the gold is smooth and even, it acts as a mirror. If the surface is not smooth and uniform, the light which falls on it is scattered instead of being reflected in a simple path; and if the surface is not almost optically smooth the gold looks simply light and yellow and frosty, and not mirror-like at all. Powdered gold does not look really metallic. It has a certain sparkle or sheen, but it does not look like solid metal. If gold leaf is put on a surface which is the least microscopic bit rough, it adapts itself to the roughness of the surface, and the surface of the leaf, instead of reflecting like a mirror, scatters the light like ground glass, and looks light and dull and yellow. If, however, these slightly uneven, discontinuous surfaces of gold powder or gold leaf are rubbed down with a burnisher, the roughnesses disappear, the little particles of gold weld together, and the surface becomes mirror-like and metallic.

This smoothing of the surface of a metal is called burnishing. When gold is burnished, shadows appear in the reflection as well as lights. The gold, as Cennino says, "appears almost dark from its own lustre," and instead of looking light and yellow, it looks dark and metallic. It has become, roughly speaking, *brown* instead of yellow. The wise painter in planning his composition always counts on burnished gold as a dark and unburnished gold as a light. Etymologically, burnishing means "making brown"; for it comes from the Latin *brunire*. We think of it as "making bright," but it had originally this particular sense of increasing the mirror-like

197

quality of a surface of gold, so that darks show in the reflection, and it looks dark, roughly brown, instead of light and yellow.

River Gold

There is a little evidence, not entirely satisfactory, but still evidence, that gold was sometimes used by artists in the form in which it is found often in nature, that is, gold dust as it comes from the washings of river sand. This suggestion was made many years ago by Professor A. P. Laurie. Dr. Laurie found in certain English manuscripts certain qualities of gilding which he could explain in no other way than that they had been done with gold dust. In the security of my youthful ignorance (which Dr. Laurie did his best for several years to mitigate) I used to argue that this could not be the right explanation, because the medieval cookbooks never mentioned it; but then one day I found that they did mention it after all, not quite specifically as a painters' colour, but still in that general connection. The evidence that river gold was used for painters' purposes is not quite satisfactory; but it is good enough to teach us to believe in the facts which scientific observation puts at our disposal.

Chrysography with Gold Inks

The obvious use for powdered gold in books is to make ink, and it was very much used for this purpose in the Middle Ages, especially in connection with purple parchment. Gold letters on white or even cream-coloured pages are very much less effective than gold letters on the deep reds and purples and blacks of purple-dyed parchment. The

powder of gold needed only to be mixed with a little glair or gum, stirred, and used as ink, to form golden letters. When they were dry they could be polished with a smooth, hard stone, or with a tooth, and they would then look like tiny clippings of metallic gold fastened in place upon their handsome coloured ground.

The expense involved in making books in this way was almost inconceivable. The purple dye, to begin with, was fabulously costly; and the amount of gold required to write a page with an ink made of real gold powder was a very serious consideration indeed. A great many ounces of metal went into these books, and the value of the metal itself was by no means the end of the expense; for, as we have seen, it was a laborious business to convert metallic gold into powder. But the Middle Ages loved with a deep love anything which was at the same time good to look upon, honourable in motive, and intrinsically valuable. Exquisite writing of sacred words upon sumptuous grounds with the most precious of inks was a passion. St. Jerome inveighed against the worldliness and extravagance of the gold and purple codices: "Skins are dyed with the colour purple, gold melts into letters, the books are clothed with gems— and Christ is left standing naked outside the door." But this love of golden writing, well established in classical antiquity, persisted in one form or another throughout the Middle Ages and is responsible for much of the beauty of medieval books.

Unburnished Pigment Gold

Writing in liquid gold, gold powder in suspension, was almost always burnished so that it looked like metal. There

was another use of gold powder, however, as a pigment, not as an ink; and in this capacity it was usually left unburnished, for the sake of its luminous, bright yellow colour. Powdered gold used as a pigment will tell as a shimmering light on any colour, and both in manuscripts and on panels it was used for this purpose with great effect. It was equally beautiful whether used to model the lights upon a field of blue or crimson, or to heighten the luminosity of the light, warm tones of reds and yellows, or as the sole embellishment of a severe grisaille.

In the late days of miniature painting, especially in the factory products, those endless little *livres d'heures* and Testaments and so on turned out by the thousand in Northern France, Flanders, and Holland in the fifteenth century, the use of this "wash" gold degenerated into a pretty formula, charming but tiresome. All the lights in all parts of the painting came in for a little frosty twitter of this dainty material; its significance was lost, and its point dulled by vain, empty repetition. The powder of gold which in the hands of the Middle Ages had been a trumpet became a sort of piccolo in the hands of the early Renaissance book factories of the North. In Italy this technical degradation never became so generally established; but the finest uses of gold pigment in the fifteenth century in Italy are to be found on panels, not in books.

Though inks made with gold powder were often burnished in books, wash gold used in panel painting was never burnished, but used simple as a pigment, without the full metallic quality that burnishing gives. Gold pigment was used, as it was used in manuscripts, for modelling the lights on colour. The supreme example of this technical device is

perhaps the little Mantegna triptych in the Uffizi; but the Mantegna "Gethsemane" in the National Gallery in London illustrates admirably the beauties of which it is capable. In the National Gallery one has an excellent opportunity to contrast the perfect operation of the method as seen in the Mantegna "Gethsemane" with a much less searching employment of it as seen in the Giovanni Bellini version of the same theme. To Mantegna, this gold pigment meant a source of new subtleties in drawing and modelling. He could bring up form out of blank colour with the merest cobweb of this delicate gold, and then go on and strengthen and shape it and sharpen it as much as he pleased. To Bellini, it meant colour and light, and a certain quality of brilliance. He ran strong, rather harsh, rather insensitive lines of it through the hair of his "Christ in Agony," and even under the varnish they still tell their story. But it is a very much simpler story than gold powder tells in Mantegna's hands.

The chief use of gold pigment in painting was to stand alone for light; but it was sometimes mixed with other pigments, so that its colour was modified and an exchange of qualities was effected between the gold and the other pigments. "If you are doing leaves," says Cennino (who recommends this powdered gold particularly for "making a tree to look like one of the trees of Paradise"), "mix with this gold a little very finely ground green, for the dark leaves." This sort of effect, combined with the unmixed quality of wash gold, may be seen in great beauty and perfection in the "Birth of Venus" of Botticelli. The warm colour of the wind-blown hair is laced with threads of gold, and the leaves and branches of the shore glisten with the frosty lustre of this powdered gold, pure, and also qualified with colour.

Wash gold used in any of these ways is a pure embellishment, precious, but not fundamental, except perhaps in its sentimental bearing. We may be very glad that Mantegna liked to use it; but he would not have been powerless without it. Burnished leaf gilding, on the other hand, is a basic element in a very wide range of medieval painting, indispensable both to its conception and to its execution. Gold grounds are the stage upon which a large part of the drama of painting was acted in the Middle Ages, and they were wrought with gold leaf, not with powdered gold.

The Beginnings of Mordant Gilding

Quite early in the Middle Ages, certainly before the twelfth century (when documentary evidence first begins to be common), someone found that if he made a mark with gum or glair on parchment, and clapped a bit of gold leaf on it before the mark was dry, the gold would stick, and when it was dry it could be burnished bright. From this it followed that he could write a letter with some sticky material and put leaf on it and burnish it, and get something like the effect produced by writing with gold ink. And of course the amount of gold used was infinitely less: a whole word could be written and gilded with leaf with the amount of metal needed for the dot on an "i" if it were done with powdered gold.

This method was used, and never, perhaps, wholly abandoned. Instead of writing with plain gum or glair, however, a little colour was usually added to the mixture. Saffron was suitable because it would look golden at the edges, or in any little places where the gold failed to stick; but red colours were often used as well. This

rudimentary technique can never have been wholly satis-
factory, because the edges of pen or brush strokes tend to
dry quickly, and when they are dry the gold will not stick.
And there is great danger, if the strokes are too liquid, of
runs and smudges. This sort of means was used, not long
for writing (in which every least stroke mattered), but
rather for patches of gold of indeterminate shape which
were to be surrounded with colour. The outlines of colour
sharpened up the edges left rough in the gilding, and shaped
them as required. The effect of gilding of this sort is to
suggest that the parchment has been converted into gold.
The effect of writing with gold ink and burnishing it is to
suggest that golden letters have been attached somehow to
the parchment; and this quality was sought in a modification
of the basic process described above, and achieved success-
fully by a variety of methods.

Composition of a Water Mordant

If some glair, or gum, or size was used for strength and
adhesiveness, and some colour was put in to show the
workman where his strokes were put, as well as to qualify
any little defects in the gilding, and then some bulky
material such as chalk was added to make the mixture
stand up a little on the page, so as to suggest a certain
thickness of metal when it had been gilded, the resulting
compound would enable the illuminator to imitate much
more closely the effect of solid gilding with a generous
supply of gold powder than he could do with glair or gum
alone. But he still had to cover his strokes of this mixture
with gold leaf while they were wet, or wet them artificially
with a brush and water, or the gold would not adhere. If,

however, he added a little something which would keep the mixture from drying too fast, something like sugar or honey, which would attract moisture to it, he would have more time for working before he must apply the gold, and the gold would adhere more surely and more neatly. If there was a little honey in the mixture he could just breathe on it and the moisture of his breath would make the surface sticky enough to hold the gold even though it had previously become dry. These, then, were the essential ingredients of a gilding mixture of this sort: an adhesive, such as gum or glair or size; a colouring agent, such as saffron or ochre; something to make bulk, such as chalk; and some hygroscopic agent, such as honey, to keep the mixture from drying too quickly and becoming too hard.

A compound of this sort is called traditionally a "size," a *seat* for the gold. (Sometimes it is called a "raising mixture," but this is rather misleading.) The word size is so overworked that it is perhaps worth while to classify this sort of gold size as a water mordant designed for burnishing. A mordant is a thing that bites; in this case it seizes on the gold and makes it stick. There are two kinds of mordant used in medieval gilding, two general classes, one watery and the other oily. Oil mordants were used chiefly on panels and walls and wood, and seldom if ever in books. Water mordants were used chiefly in books, sometimes on panels, and never on walls. We cannot possibly undertake here to investigate the hundreds of different mixtures which were used as water mordants, but only examine briefly what sort of thing went into them, and what sort of quality each ingredient was supposed to contribute.

Burnished Water Mordant Gilding

Water mordants designed for burnished gilding might be applied with a pen, as for writing, or with a brush. One of their commonest uses was, of course, the production of large golden letters in books. These letters were first outlined with the mordant in a pen, and more of the mordant was fed into the outlined area either with a brush or with a drop on the underside of a pen, provided the shapes were not too large to dry down evenly. Very large letters had to be painted over thinly several times with the brush and then scraped smooth. So, too, did any large spaces of gold in manuscript paintings, such as backgrounds or borders.

For the small, intricate forms of letters written with the single strokes of a pen, it was necessary that the mordant should be sticky enough to hold the gold by itself, without any outside help beyond such moisture as breathing would supply. It was impossible, for example, to damp such small letters with a brush before gilding without damping also some of the surrounding parchment; and if the parchment were moist the gold would stick to it as well as to the letter. The mordant had to be so compounded that it would hold its tack long enough to be gilded, or at least that a little condensed moisture from breathing on it would make it temporarily sticky enough to hold the gold. To make a mordant sticky enough for fine strokes and still strong enough and hard enough to take a good burnish required the most delicate and difficult adjustments of its ingredients.

For larger areas the difficulty was less, for they could often be moistened with water to make the gold adhere. In medieval manuscripts, too, large areas of gold were almost always surrounded by colour, or at least outlined with

colour or ink. This was done partly because a large expanse of burnished gold needs strong outlines to give it force and shape, and partly to avoid the difficulties of making the edges of the gold strong and sharp and convincing. Even small areas of gold look brighter if they are imbedded in colour or outlined with dark; but for pen letters this sort of reinforcement was impossible.

According to the scale of the work a suitable mordant was prepared and laid on the parchment with the pen or brush. It was moistened, again largely according to the scale of the work, either with the breath or with a damp brush; and the gold leaf was laid on it, and pressed down lightly with a bit of cotton. When the mordant had dried, and become hard enough to stand pressure, the surface was burnished with a tooth or stone, gently at first, then harder and harder, until, as a medieval writer says, at the end "your whole forehead drips with sweat."

The Binders

This heavy burnishing means that the mordant had to possess a certain quality of toughness. It would not do if it were brittle, for the pressure of the burnisher would crush and spoil it. The addition of honey or sugar made glair and gum somewhat less brittle; it kept them from getting too dry, so that they retained a little springiness and elasticity. Size is by nature rather tougher than either of these, and it was often used in water mordants. (A mixture of size and glair was very common and particularly suitable, for it dries very smooth and hard, but keeps its indispensable toughness.) There is one drawback to the use of size, and that is that it is liquid only at a temperature higher than workrooms

are usually kept; and if there is much size in the mixture it will not flow from the brush or pen unless it is kept warm. Partly to avoid this difficulty, and partly to increase the stickiness of the size, it was a very usual practice, in the late Middle Ages at least, to let the size become rotten, either before or after the mordant was made up. When putrefaction sets in, the size jelly becomes liquid and grows very sticky indeed. Glair, too, is much stickier when it is old than when it is freshly made; and an English work on these subjects says in general of these adhesives that "the older and more rotten they be, the better they be." When glair was used a little ear wax was usually added to prevent the formation of air bubbles in the mordant.

The Colouring Agents

The mordant mixtures were sometimes left uncoloured; but the white marks were hard to see on white parchment, and gold leaf laid on a white ground was never quite so rich as when it was laid on a coloured ground, so these water mordants were generally given some little colour. The commonest colour is pink, and the commonest material for producing this pink seems to have been a kind of red earth called bole. This earth is rather different from the red ochres generally used as pigments. Bole is a sort of clay, too fat and soapy to make a good pigment, but as smooth as wax, and capable of receiving a high polish, so that it rather increased the smoothness of any mordant to which it was added. In the Middle Ages it was always called "Armenian" bole, presumably because Armenia had once been the source of it; but there is very little reason to suppose that the "Armenian bole" of ordinary medieval practice was im-

ported. There are deposits of it in all parts of Europe. The colour of bole is far from uniform. There are red boles of many shades, from warm light pinks, to deep purplish reds. There are also yellow boles, and grey boles, and even white boles. Ochres, too, were sometimes used to colour the mordants; indeed, some illuminators used ochres for no other purpose. And saffron was sometimes employed. Though pink grounds under gilding are common in all countries, dark reds are occasionally seen; yellow grounds often appear in Italian books, and occasionally in French and English; and there is a light grey ground which is fairly common in Northern French manuscripts of the fourteenth century.

The Bulk-Formers

In Italy the regular material for giving bulk to the mordant was the same gesso sottile, or slaked plaster of Paris, used for grounds on panels. In France and England, and we may suppose in Northern Europe generally, chalk was commonly used for this purpose. In addition to these, however, some white lead was often added to the mixture, probably to give some extra hardness to the mordant, and to enable it to stand the pressure of the burnishing tool better. It would be an error to suppose that the whole of the embossed appearance of a mordant-gilded letter in a medieval manuscript was formed by the thickness of the mordant. On the contrary, most of it is produced by a convexity in the parchment itself. The application of the mordant causes a slight local buckling of the parchment, and the pressure of burnishing increases it. The burnishing stretches the parchment a little, and the increased surface goes into exaggerating the convexity of the gilding.

Other Ingredients

For stickiness, in addition to honey and sugar, the materials most used in mixing these mordants, sal ammoniac (ammonium chloride) was sometimes employed to attract moisture in the same way. Resins such as myrrh were sometimes put in, probably to increase the toughness of the mixture. Gum ammoniac and gum serapin and countless other ingredients figure in the hundreds and hundreds of medieval rules for water mordants which have come down to us. Too few of these rules have been tested to give us any accurate idea of the functions of the exceptional ingredients.

Unburnished Water Mordants

Water mordants without body, used simply for their power of staying sticky long enough to take the gold and then hardening so that they could be burnished, never wholly lapsed. To this type of mordant was added another, fairly popular in and after the fourteenth century. The new type differed from the old in that gilding done with it could not be burnished, and was not intended to be burnished. It was used for producing lines and spots and areas of gold which were to keep their unburnished, unmirror-like, yellow quality. Various sticky vegetable juices, such as the milky sap of the fig-tree, were used for this purpose; but the most important was the juice of garlic. Garlic juice alone, or mixed with a little colour, or mixed with both colour and bulk-forming material such as white lead, could be used for writing or for making lines, dots, or other shapes; and though it dried rapidly it had only to be breathed on to be made sticky again, so it could be gilded with a

minimum of trouble. An elaboration of plain garlic juice in these mixtures became common in the fifteenth century: namely, a solution of gum ammoniac in garlic juice.

Whereas the burnished water mordant gilding was almost wholly confined to parchment and paper, gilding with this water mordants which were not designed to be burnished was quite commonly used in connection with panel painting as well. Whether on panels or in books it was sometimes desirable to lay patterns of unburnished gold or silver leaf over painted areas, and these sticky media made this quite easy to do. Sometimes on panels, and regularly on walls, these determinate patterns of unburnished gold were applied with oil mordants, which are discussed at the close of this chapter.

Gilding by Attrition

Finally, a curious process for gilding in books is often described in medieval texts, to which I have given the name of "attrition gilding." This does not call for either powder or leaf for its execution, but derives its golden surface from a piece of massive gold. The whole trouble of reducing gold to powder or leaf is avoided, as well as all the difficulties of compounding and using a mordant. This method consists in applying, instead of a mordant in the ordinary sense, a mixture containing finely powdered glass, or crystal, or "paragon stone," or something of that sort, firmly bound with gum, or size, or glair. When it is dry this mixture presents a sort of very fine sandpaper surface, and if it is rubbed with gold or silver, the metal catches in the grains of glass or crystal until the whole surface is gilded. It can then, so the recipes say, be burnished. I have

not so far recognized an example of work done by this process in any medieval manuscript; but that by no means proves that I have never seen one. If it was successful, a casual inspection would not reveal the method; and it is quite possible that this procedure was very much commoner in actual use than we have hitherto supposed.

The Background of Craftsmanship

The skill and patience required to handle these gilding techniques successfully are so extensive that anyone who has attempted them has usually gained a new respect for the craftsmanship of medieval book painters and scribes. The number of ways in which a gold size, a mordant, can be unsatisfactory, and the extreme delicacy of the adjustments upon which its working qualities, its beauty, and its durability depend, are almost unlimited. The skill of medieval writers and painters in design is fairly obvious; but it was backed up by technical knowledge and devotion and perseverance which only those who have attempted to match it can comprehend with any fair degree of completeness. Under the example and instruction of Mr. Graily Hewitt, the ancient art of manuscript gilding with water mordants has been revived in this century and brought to a high standard of quality by a good many of the members of the delightful and significant new English school of fine writing; but those who are themselves most able in its performance are most reverent in their appreciation of the sheer technical perfection of the gilding in medieval books.

Burnishers and Burnishing

For burnishing the gold in books illuminators seem

generally to have used a tooth, mounted in a wooden handle. The smooth surface of a tooth, worn down by use, was admirably adapted to the purpose of burnishing the small areas of gold in manuscript work. Dogs' teeth seem to have been especially favoured for this purpose; but cats' teeth, lions' and wolves' are also authorized by Cennino Cennini. Cennino says that in general the tooth "of any animal which feeds decently on flesh" may be employed. The teeth of carnivorous animals are hard and smooth, and were generally preferred; but horses' teeth were certainly used sometimes, no doubt because of their breadth. A rule in a fifteenth-century collection in Munich, which comes from a monastery at Tegernsee in Bavaria, gives directions for smoothing and polishing a horse's tooth to make a burnisher. A dog's tooth could be used without preparation beyond mounting in a handle. Perfect smoothness was, of course, essential; the least little roughness on the burnisher would have been enough to tear the delicate surface of the gold to bits, to scratch it and the ground of mordant under it, and so to destroy the very metallic perfection that burnishing is designed to produce. For burnishing small, irregular forms, in which edges play an important part, the small point of a tooth was convenient; for the point could be forced into the angles that the edges made with the parchment ground, as a larger tool could not. If the shapes were small, they could be burnished very well even with the small point.

But these mordant grounds were not absolutely hard. The burnisher pressed into them a little, and in smoothing the gold flattened and compressed the underlying material. So if a large field of gold was to be burnished, there was

some danger in using a small point that it might make lines and ridges of pressure, which in a large field would be conspicuous. In burnished gilding some slight irregularity of the gold surface is an advantage, and actually increases the brilliance of the gilding by varying the planes of reflection. In a small field of gold this sort of irregularity was best produced by a small tool, in scale with the piece of gilding which was to be burnished. The little ripples which a tooth produced are almost invisible in a single letter, and have only the effect of giving a slight play of light to the surface; but in a large area of gold the same degree of unevenness would be disturbing, and a larger burnisher was therefore used.

Sometimes we see the opposite fault. In some fifteenth-century Italian manuscripts, for example, the burnishing is too good, too perfectly smooth, monotonous, and uninteresting. A large burnisher seems to have been used, which has flattened out the gold too completely, so that it has no life and sparkle. Italian gilding generally reaches a very high standard of technical perfection; but in some of these late manuscripts the perfection is mechanical and inappropriate.

For burnishing the large fields of gold which occur in medieval panel painting, and on frames, and chests, and other furniture, it was most desirable to have large burnishers: blunt points for getting into mouldings, points as big as a finger, perhaps; broad, gentle curves for smoothing down gently curving surfaces; and broad, flat burnishers for working smoothly over the flat backgrounds of panels. Teeth would not do for these large tools, and polished stones had to be used. The red iron oxide ore, hematite, was con-

sidered the most suitable stone for this purpose in the Middle Ages, and is so still by many workmen. Hematite can be shaped in any way and smoothed and polished to perfection. It is not a very hard stone; it can be scratched quite easily. (Cennino warns us that we "must take great care of it, so that it does not get chipped or come in contact with iron.") But it is hard enough, and perfectly smooth and dense and slippery when polished. It slides over the gold like wax, and produces a splendid burnish. I once had the pleasure of using a set of ancient hematite burnishers in Italy, burnishers which had come down from father to son and master to pupil and studio to studio, so the tradition went, since the thirteenth century; and I can well believe it, for they were worn and comfortable and reliable as only old, well cared-for tools can be.

A good set of burnishers is a great asset to a gilder. They do not wear out, and if they are well used they improve with age. There are probably a good many old ones in use in various parts of the world. I saw some once, in the city of Lanchowfu, the capital of Kansu Province in Western China, and spent a fortnight trying to persuade their owners to part with one or two. One of the industries of Lanchow is the manufacture of silver-gilt ornaments, a sort of monopoly of that city. There is one street which is occupied by silver-gilders, and they were all supplied with exquisitely made and finished burnishers which they used in their profession. These burnishers were made not of hematite, but of some sort of agate, beautifully veined and striped, and mounted in delicate ivory handles, with ferrules of silver. Offers even of fantastic prices met with blank refusal from every worker. They would gladly have sold their tools if

they could have replaced them; but not only were these burnishers not articles of trade, not one of the workmen knew where they had come from, or how he could get another. They must have been handed down from generation to generation, perhaps from Han times, perhaps long before, and they were no more for sale than their owners' right hands. The effort to buy them seemed to bring the Middle Ages right into the twentieth century; and it induced a very wholesome respect for the worth of a good burnisher to a man who earns his living at gilding.

The Metallic Ground

The *fondo d'oro*, the gold ground of a medieval painting, was a sheet of gold. It took the place, on a large scale, of the little golden plaques that the enameller embellished with his fired-in colours. Medieval tempera painting on gold grounds may well have grown up in the first instance as a substitute for the enameller's technique, an enlargement of it which could be produced at a tolerable cost. In its early days *fondo d'oro* painting often recalls the methods of enamel painting, the strict *cloison* or the *champ-levé*. Colours tend to be enclosed in circumscribed areas, as in enamels they are enclosed by the little walls of metal soldered on in one style, or left by the graving tool in the other. Little patterns of burnished gold and colour, like the enameller's, are often wrought. It would be rash to submit as anything more than a possibility the thought that gold-ground paintings were ever a conscious imitation of enamels. It would be palpably wrong to suggest that any initial tendency to imitate enamel technique persisted in the developed art. But some basic connection may exist, and the gold ground of panel painting

may be indeed an unconscious heritage from a primitive endeavour to magnify enamel effects in simpler materials.

Gold—The Original Intent

Pure gold is imperishable. We know that it does not tarnish or lose its lustre; and we are perhaps a little too often inclined to discount the effects of age on gilding. These effects are many. Dirt accumulates on its surface; unnecessarily and injudiciously, gilding is sometimes varnished; the grounds beneath it crack and break its even surface; the delicate, thin film of metal gets rubbed and worn, and the under strata show through it here and there. The original, solid, metallic quality of gilding is easily corrupted by any of these accidents, and it is rare indeed for us to see in panel paintings the effect of the gold ground as it was originally intended to appear. The gold has not perished; but its quality has suffered a change. It has acquired a patine, a crackle, often a new beauty which is more acceptable to the refined (if ghoulish) antiquarian enthusiasm of our day than its original blaze of metal. So even many people who know their medieval paintings well do not habitually think of the gold grounds as having been like metallic mirrors. That they were so there can be no doubt. The gold grounds of panel paintings must have shone with no less brilliance than the gold in books. They must have looked like sheets of solid, metallic gold; and it was so that they were intended to look.

We deplore deceptions in the arts. We have rejected the ingenuities of a generation back in making one material look like another. The skilled workman who is prepared to marble slate in imitation of serpentine or verde antico or

porphyry or anything else to order has been demoted from the drawing-room to the public-house. We resent Corinthian capitals cast in Portland cement. We do not admire effects of half-timbered construction wrought on the surface of finished buildings with strips of wood. We have espoused the gospel of frankness in materials along with the gospel of functionalism in design. We will accept gold for decoration; but we refuse to be deceived by a fraction of a millimetre of gold leaf into thinking that an object is made of solid metal. If a man wants to gild to suit us, he must rub the gold off here and there at the corners, so that we can see that it is leaf.

Perhaps we are right. Perhaps it was cheating to pretend that gilding looked like gold. Perhaps it was not quite cheating, either, but only playing. Perhaps no one quite believed it, and was not quite meant to believe it, but liked just to dally with the fond surmise. Perhaps there is something attractively childlike about this game of make-believe; and perhaps we shall fare better in our understanding of the Middle Ages if we accept it as their way of playing than if we condemn it as not our way, or, as we more often do, close our eyes to the fact that there was a game at all.

Those to whom luxury is forbidden must enjoy it vicariously. Hence pageantry, the prestige of rulers, toleration for capitalists, and the gorgeous interiors photographed daily in Hollywood and viewed with satisfaction for ninepence or less in the mill-towns and slums and far-off places of the world. If your own house was a hovel, and you were a medieval man, you were glad to see the house of God well furnished. You liked to go there and to see, as God's guest and worshipper, the fulfilment of your dreams of the

richness, the beauty, the splendours that you personally lacked. More than anything, perhaps, you lacked gold; so in compensation you endowed the streets of Heaven, which you hoped to walk in time, with solid gold paving-stones, and the church in which you heard the Mass with gold vessels, gold embroideries, gold caskets, thrones, mon-strances—and altarpieces. It was an escape, a sweet and tender, rather childlike, rather pitiful, but very lovely little game for people to play; and if some of the gold was tinsel, our only concern should be to hope that it did not spoil the fun.

When we look at medieval gilding we should think of Christmas-trees. There is no equivalent in art history to the date of Twelfth-night, when the Christmas-tree is dis-mantled, so that its beauty may not fade. The needles fall, the ornaments get broken, the tinsel grows shabby; and we come upon these once festive things in the late autumn of their material lives and find in them beauties still, but not the gay, bright, garish beauty that delighted children when their loveliness was new. Left-over Christmas-trees in August must be viewed with sympathy and understanding if one is to see in their battered remnants any reminder of the holidays they graced when they were young.

Preparation of Surfaces

To make the gold grounds, panels were first invested with the perfectly smooth and even white surface of gesso, free from scratches or flaws of any kind. Though this surface was necessarily smooth, it was not necessarily plane; a slight undulation of the gesso, even in the flat parts, was consistent with perfect smoothness, and followed naturally from the

methods used in scraping the gesso down. Actually this slight unevenness of the plane of the surface, which came from hand-scraping with flat tools, increased the variety of reflection in the final burnished gilding, and was a real advantage. The more slight variations of plane there are in the gilding, the more angles will catch the light, and the more convincing the metallic quality of the gilding will appear.

After the gesso was quite smooth and even it was covered with thin layers of tempered bole, to form a coloured ground under the gold leaf, and to provide a sleek, lustrous cushion for the under side of the gold to rest on while the burnisher was pressing on the top. The bole in medieval gilding was ordinarily tempered with glair, quite thin, weak glair, and preferably rather stale. Glair is still used for water gilding by book-edge gilders, and some other modern craftsmen; but most water gilders nowadays lay the bole with size, as it is much less delicate and troublesome to use than a bole ground laid with glair. Size was regularly used for this purpose in eighteenth-century France; but we do not know when it began to be used, or where or how it came so largely to displace glair in this connection.

Application of Gold Leaf

When the bole ground was laid, which meant five or ten coats, with every precaution against unevenness and dust, it was polished with a cloth until it shone. Then it was wet with water, bit by bit, or with water containing a little glair. (Modern gilders usually use a mixture of water and alcohol in connection with size-bole mixtures. This mixture spreads out more evenly than water alone. For gilding with

glair a little glair in the water sticks the gold securely to ground.) While the surface of the bole was still wet the gold leaf was laid on it neatly, and when the water had soaked into the ground the leaf was pressed down lightly with a bit of cotton. Each successive bit of gold was made to overlap the edge of the gold already laid; and the effect of this overlapping can often be seen in medieval gilding.

In modern practice gold leaf is handled on a leather cushion with a long knife, and straightened out on the cushion, chiefly by blowing deftly on just the right spot. It is then picked up on a broad, thin brush, called a gilder's tip, the hairs of which are made a little greasy to cause the gold to adhere to them. And with a quick touch, like testing a hot iron with a wet finger, the gold is transferred from the tip to the wet bole ground. But the tip is apparently a post-medieval invention. The medieval way of applying the gold was to slide the gold into place from a little "shovel" made of card or parchment, a square with two corners trimmed off. The result was, of course, the same, however the gold was carried through the air from the cushion to the panel. The use of the tip probably developed as a result of the tendency to beat gold thinner than the medieval standard. The heavier gold used in the Middle Ages could be handled somewhat more freely and easily than the modern leaf.

Burnishing

When the surface was gilded it was allowed to dry, and in the course of drying it reached a certain point when it was ready to be burnished. At this point it was not absolutely dry, but retained enough moisture to make the underlying

gesso still a little soft and pliable (though not so soft that there was any danger to the surface from the pressure of the burnisher in rubbing over it). In the carvings and in the ornaments modelled in gesso under the gold, the marks of the pressure of the burnisher can often be seen. The direction of the final burnishing strokes can sometimes be seen, too, in the gilding; and these were carefully calculated by the workman according to the position and the lighting which the finished work was to occupy. A side light called for one kind of final burnishing, if the gold was to look its best; a light from the front called for another; and the light from below (which was often most important of all for altarpieces), called for a third. The one type of light for which almost no medieval burnishing was designed is the type of light to which medieval paintings are most often subjected in our galleries—top light. This often makes it impossible to see the original intention of the burnisher, which, in a side or front light, may appear quite clearly; and it often detracts from the effectiveness of the gilding in more important respects.

Separation of Gold and Colour

When the burnishing was done the ground of gold appeared metallic and perfect. It was not usual in the Middle Ages to gild the parts of the panel which were to be painted. It was a waste of gold and labour to do so, and furthermore tempera painting on burnished gold was both troublesome to execute and liable to chip off. But it was necessary, in order to provide a good edge between the gold and the painting, to have the gold overlap a little the areas which were to be painted. To preserve the location of these edges

in the drawing, they were usually scratched lightly into the gesso surface with a needle before the bole ground was laid. These scratches then showed in the final gilding as thin, unburnished lines in the burnished gold. They may generally still be seen. The gilding which came inside them was sometimes scraped off, so that the painting was done directly on the gesso; and sometimes the excess gold was painted over with a white colour mixed with size, which adhered better to the gold than colour mixed with egg. Occasionally a painter would neglect these precautions, and paint directly on the overlapping gold; and the result was sometimes disastrous. There is a Sassetta in Basciano in which there is not much left of the Madonna's face except the tip of her nose, and that is surrounded by the gold upon which Sassetta was in that case so unwise as to paint.

Many people nowadays resent for some reason the suggestion that medieval gold grounds did not lie under all the painting as well as around it. Common sense, documentary evidence, and the evidence of medieval paintings themselves all tell us clearly that medieval painters avoided painting over gold as far as possible. It was wasteful, difficult, and mechanically unsound. For certain effects it had to be practised: for *sgraffito* and glazes of colour over metal. And some slight overlapping of the edges against the background was unavoidable. But no value, technological or sentimental, was laid upon painting over burnished gold.

Tooling the Gold

Before the painting was begun this excess of gold was dealt with, scraped away, or covered up; and then the gold ground was tooled. Some of the most exquisite workman-

ship in medieval art was spent upon this tooling of the gold. Gilded gesso is fairly elastic and any pressure of a point upon it will make a mark. The larger the point the heavier the pressure required. Haloes were swung with compasses, which pressed the circular lines firmly and smoothly into the gold. The breadth and sharpness of the impressed lines was nicely adjusted to the scale of the work, and the rings of the haloes generally provided the fundamental basis upon which the stamped design was built. Occasionally haloes were formed without the use of compasses; but usually they contain several concentric rings which can hardly be made in any other way. Some little indication can usually be found of where the foot of the compasses was placed at the centre of the halo. Often it is the little hole made by the point; sometimes it is a little lump, caused by puttying up the hole. Frameworks of straight lines were sometimes pressed in with a point drawn along a straight-edge.

When the concentric rings of the haloes had been swung and impressed into the gold the internal ornaments were wrought. Little punches of various patterns were made in steel or bronze and used for tooling the gold. The commonest punches are rings and dots of various sizes. These tools were set down one by one in all sorts of combinations. One of the commonest of these is a ring surrounded by six other rings of equal size to form a sort of rosette. Rows of rings, sometimes with dots or cup-shaped depressions in the centre, lines and geometrical combinations of dots, and other simple elements of design were used with the utmost ingenuity to enrich with their resulting sparkle the unbroken surface of a ground of gold. Some fancy tools were used, for stars and leaves and flowers. Elaborate patterns were some-

times drawn freehand on the gold with a smooth point used with some pressure. And finally, the backgrounds of the ornamented passages were usually grained or "frosted" with tiny dots or circles formed either by single punches or by punches bearing a cluster of points. Sometimes these cluster tools were round, sometimes square, sometimes diamond-shaped, and so on.

Delightful patterns were worked in the gold with combinations of these very simple tools, and the impressions in the surface were used, as in all metal work, upon two general principles: either for themselves, as impressed, or for the areas which they surrounded, as thrown up comparatively in relief. A ring punch, for example, might be thought of as impressing a ring, or as enclosing and relieving a disk. All these considerations may still be examined at leisure and with pleasure in medieval gold grounds. The patterns of the impressions remain. But their primary, original function has generally been lost and must be appreciated intellectually. That function was to break the uniform reflection of the metal surface, to change the glow of the unbroken gold into a sparkle in the areas of stamping. Each little stamped impression caught the light and made a new reflection, so that a grained surface looked light when the gold around it looked dark, and dark when the ground looked light. This stamping introduced a play of light, a glitter, a shimmering quality, which has faded with the brightness of the gold.

We know that this glitter, this shimmer of the gold, was originally there. We know that it was deliberate, calculated. But we can seldom see it with our eyes. The little hollows stamped in the gold have often become choked up with

dirt, so that instead of being new sources of reflections in the gold ground they are actually the least golden part of it. There is no technical aspect of medieval painting which requires more sympathetic imagination and understanding from the observer than the gold ground with its embellishment. Its beauty, even aged and faded, makes us forget to wonder what its original quality may have been; and unless we stop to think we run grave danger of misconstruing it quite seriously.

Sgraffito

When burnished gold was covered with tempera paint the paint could be removed in a pattern exactly as the smoked ground is removed from an etching plate, and a design in gold and colour resulted. Often, particularly if the areas of gold uncovered were small, or the design complicated, the gold revealed by scraping was grained to make it sparkle and to distinguish it more sharply from the surrounding colour. Sometimes some modelling was applied in darker colour after the stamping was done, and the shading allowed to pass over both the gold and the painted portions. The effect of a pattern made up of these sparkling areas of gold surrounded by lines or shapes of colour is extremely brilliant and beautiful, and this technique was much practised in medieval panel painting. Tempera colours on gold are apt to come away, and they often have come away in this sgraffito ("scraped") embellishment. But often they have stayed in place, fixed perhaps by a wash of size, and we can see many splendid examples in medieval works.

"Damask" patterns were often wrought in this way; robes, carpets, curtains, and accessories of all sorts were

executed in this method. So, too, were inscriptions and various other ornaments. Probably the most elaborate and dexterous example of this technique is to be seen in the costume of the Angel Gabriel in the "Sant' Ansano Annunciation" by Simone Martini in the Uffizi Gallery. The garment of white and blue and gold, and the floating veil of brilliant coloured plaid are worked and veined and stamped and modelled with a skill worthy of the drawing and the integral design. It is a piece of draughtsmanship to be examined with a magnifying-glass, applied to one of the noblest and most influential compositions in the history of art.

Oil Mordants

The medieval panel painter could make these patterns of colour and gold in *sgraffito*, but he needed also some means of making a pattern of gold on his finished painting. He had to have some way of embroidering his work with gold for the star on the Madonna's shoulder, for the lines of gold around the edge of a robe, for elaborately patterned textiles. The *sgraffito* method largely destroys the sense of form. For these purposes he might have used gold pigment laid over the painted surface. But it lacked force; it did not possess enough metallic quality to distinguish itself from the other colours sufficiently for these important purposes. He could employ water mordants and cover them with gold leaf; and this he did do to some extent, using chiefly those mordants made with garlic juice.

But water mordants were not entirely satisfactory to the panel painter. They had to be varnished and were always a little insecure, owing to the ease with which moisture affected them. And they were troublesome to use for fine-

scale ornament over tempera paint; for if they had to be breathed on to make the gold adhere, the moisture of the breath might make the gold stick to the paint as well as to the mordant. The standard method, when gold was to be laid upon colour in panel painting, and in wall painting as well, was to use oil mordants. These were in effect oil varnishes containing some pigment. They were applied with brushes, often in fine lines and touches; and when they were almost dry, so nearly dry that they would not smear or spread, but still retained a little stickiness or "tack," the gold leaf was laid on the marks made with the mordant. It was pressed down lightly and the excess gold was then brushed carefully away. The gold leaf stuck to the mordant and did not stick to the painting, and the result was a pattern of gold equal to the pattern which had been drawn on the painting with the mordant and the brush.

These oil mordants varied greatly in their physical qualities. Sometimes they were very thin and caused no apparent relief in the gilding. The gold then seems to lie quite flat on the colour. Sometimes they were thick, and the gold stands up quite high. Sometimes they worked in crisp, fine, thread-like lines; and sometimes they worked in broad, coarse strokes. In the hands of a great draughtsman the mordant gilded ornaments are extraordinarily beautiful. They are one of the great technical prides of fourteenth-century Siennese painting, and the most perfect examples are perhaps to be seen in the works of Duccio and Simone Martini. If one had to fix on a single case, and bore in mind the purpose which the technique served as well as the technique itself, he might well select as the most brilliant and effective piece of mordant gilding in the Middle Ages

one of the little panels from the back of the Duccio Majestas;
and perhaps of them all the "Betrayal," in which a milligram
or two of oil and resin and colour and a covering of gold
are transmuted by the painter's genius into an electric line
as telling as a single line can be.

Mordant gilding had other uses and beauties which did
not depend upon this refinement of draughtsmanship and
handling. Oil mordants enabled Benozzo Gozzoli to make
the Medici Chapel ring with gold; they ran gold mouldings
upon architectural forms; they enabled tin to be gilded with
real gold, so that this metal gilded could be used with all
the advantage of its weight and pliability and none of the
reproach of tin merely lacquered yellow in imitation of gold.
Later on, mordant gilding gave a metallic base for certain
richnesses in Venetian and Northern painting produced by
oil glazes passed over the gold.

A Sensitive Compound

One combination of mordant gilding with wash gold must
be mentioned here, though it was worked at the height
of the early Renaissance. That is in the "Madonna della
Melagrana," the "Pomegranate" Madonna of Botticelli, in
the Uffizi. (To comprehend the painting fully one must see
the reconstruction of it in its original freshness, wrought by
Nicholas Lochoff.) Earth and Heaven are in conflict in that
painting in many complicated ways, and the theme of
Pagan and Christian, Body and Spirit, has a reflection in the
technique of gilding which provides a measure by which
the intelligent, discriminating use of technical resources
may be measured.

Around the Madonna's head there shines the faintest,

dimmest shimmer of an aureole, the merest cobweb of powdery, dusty gold, weaving in short, uncertain lines across the blue expanse of the sky. It is a timorous effulgence, dainty, tremulous, and uncertain. And down through it, from the vault of Heaven, shine broad, straight, strong, uncompromising rays of metal gold, which stand up on the panel from the thickness of the mordant, and glow even now with a lustre which points its purpose clearly, and casts a tenderer shadow on the cloudy aureole through which it gleams.

Gold speaks loudly in all medieval arts, and its words vary from the complex speeches that Duccio and Botticelli give it to the simple *Magnificat!* that it sings in every least provincial work. There was a time, and not so long ago, when men spoke not of the Middle Ages but of the Dark Ages. We have learned that their apparent darkness is the darkness of our own understanding. When we contemplate the history of medieval art, and summon up remembrance of what its works were in their day, and see the part played in them by the metal gold, we may well wonder whether we should not do wisely to call them not the Middle Ages but the Golden Age.

INDEX